IMAGES
of America

HINSDALE

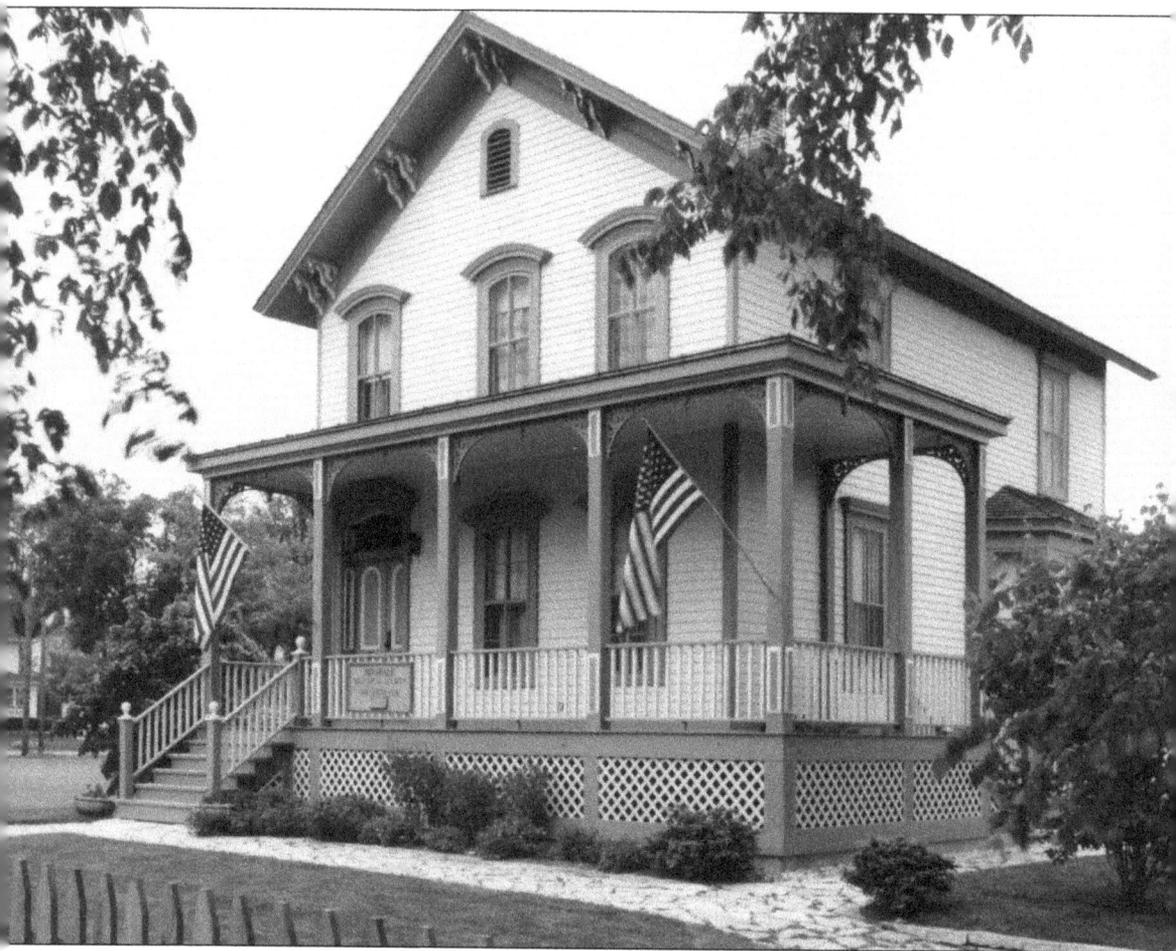

Since 1975, the Hinsdale Historical Society has been collecting, preserving, and promoting the history of Hinsdale. Besides housing archive and artifact collections, the society operates a house museum that reflects life in early Hinsdale. An advocate for preservation, the society rescued and maintains three historic properties: the 1874 history museum at 15 South Clay; Immanuel Hall, built in 1900 at 302 South Grant; and the 1924 R. Harold Zook Home and Studio, relocated to KLM Park. The society also promotes education and awareness of local architecture through its Roger and Ruth Anderson Architecture Center, housed at Immanuel Hall. (Courtesy of the Hinsdale Historical Society.)

ON THE COVER: Hinsdale's Memorial Building is an exceptional example of community spirit and cooperation. Village residents rallied behind the building of this civic center to honor their veterans and house village offices, the library, and the American Legion. The building was privately built, funded through a meticulous community campaign led by Philip R. Clarke that had Hinsdaleans contributing the entire amount necessary for its construction within a single week. The completed building was presented to the village in 1928, "a gift from a grateful community." (Photograph by L.C. Harner; courtesy of the Hinsdale Historical Society.)

IMAGES
of America

HINSDALE

Sandra Bennett Williams

ARCADIA
PUBLISHING

Copyright © 2013 by Sandra Bennett Williams
ISBN 978-0-7385-9432-3

Published by Arcadia Publishing
Charleston, South Carolina

Printed in the United States of America

Library of Congress Control Number: 2012948100

For all general information, please contact Arcadia Publishing:
Telephone 843-853-2070
Fax 843-853-0044
E-mail sales@arcadiapublishing.com
For customer service and orders:
Toll-Free 1-888-313-2665

Visit us on the Internet at www.arcadiapublishing.com

To David, who makes my life wonderful—
in Hinsdale and everywhere else.

CONTENTS

ACKNOWLEDGMENTS

Images in this book, unless otherwise noted, appear courtesy of the Hinsdale Historical Society. Its archive library was created by Shirley Stitt, who also served as custodian of the collection for many years. Inspired by Hinsdale's 1973 centennial, she assembled a committee that collected historical material that later became the heart of the society's archives. Her methods of organizing and preserving this invaluable resource are still followed. I was fortunate to volunteer with Shirley for nearly 30 years.

To those who have donated photographs or ephemera to the historical society's collection, thank you for honoring Hinsdale's past. It is your thoughtfulness and generosity that allow the collection to grow and have made this book possible.

Thanks to Janet Miller and other current society archive volunteers and John T. Ziegweid who volunteered for years as a meticulous home history researcher. Ziegweid's additional work on the buildings in Hinsdale's retail core is priceless. I was also grateful to have as a resource the published histories of Hugh Dugan, Timothy Bakken, and Tom and Mary Sterling.

The number of pages in this book are limited by the publisher's format. There are events, homes, and people important to Hinsdale that, sadly, could not be included. Editing has been difficult, and I apologize for the necessary omissions.

I am grateful to my father for instilling a curiosity and love of history and to both my parents for a willingness to give back to a community from which so much is enjoyed. Most of all, thanks go to my immediate family—to my husband, David, and our adult sons, Brian and Jeffrey, for tolerating my historic passion and time spent over the years at my other "home," the Hinsdale Historical Society. When I was frantic over the image technology required for this book, Jeffrey came to my rescue. When I doubted the book's completion, Brian, as always, was encouraging and supportive. David, thank you for never begrudging my months of work, for continuous take-out dinners, and for editing photographs and text. I am most grateful.

INTRODUCTION

The history of Hinsdale is the history of two distinct communities that became one. While the inspiration for Hinsdale began in 1862 with the railroad's plans, the settlement of Brush Hill, once centered at York Road and Ogden Avenue, preceded Hinsdale's founding by about 30 years.

Long before these communities got their start however, settlement of the area began on the banks of Salt Creek where Native American artifacts dating to 3000 B.C. have been uncovered. Initially hunter-gatherers, the Indians made stone tools and arrowheads, later cultivating corn. On the property now owned by the forest preserve, the Potawatomi tribe assembled a major village that included a chipping station and ceremonial mounds. Today's Ogden Avenue as well as Spring, Plainfield, and Joliet Roads were built over ancient Indian trails.

The first white men to travel the area were fur trappers and traders, whose transient commerce benefitted the natives. Homesteaders, however, were not always as readily welcomed. Indian tribes ceded 15 million acres in the region to the government in the early 1800s but some resisted giving up the land, leading ultimately to the 1832 Black Hawk War. U.S. general Winfield Scott was dispatched via Fort Dearborn (Chicago) to put down the insurrection, focused along the Mississippi River. Passing through this area along a trail that is now Ogden Avenue, Scott dubbed it "Brush Hill," a reference to the unusually hilly terrain covered with hazelnut bushes.

The end of the short war brought treaties that relocated the Indians beyond the Mississippi, ending resistance to white settlement. A flood of pioneers swept the area. "The danger had gone, the land was fertile, climate agreeable, and Chicago was demonstrating its commercial potential," noted Hugh Dugan in his 1949 history *Village on the County Line*.

Most of the newcomers arrived from the east, lured by the abundant, available farmland. Others came from northern Europe, primarily Germany, seeking relief from political and economic repression. Access to the new frontier was enhanced by the Erie Canal and the Chicago harbor, completed in 1833. The first year the harbor was open it welcomed 20,000 newcomers, many of whom were eager to stake their claim on the open prairie beyond. Under federal preemption laws, a settler could claim up to 160 acres and secure a minimum bid ($1.25/acre) when the government offered the land for sale. To be eligible, a settler had to be 21 years of age, the head of a household, a citizen or anticipated citizen, and be occupying or improving the property. The migration westward was relentless. Through preemption and homestead laws, millions of acres across the country were divided into small farms.

Among the first settlers in this area were brothers David and Orente Grant in 1834. They likely selected their claim because it bordered the Southwest Trail. The trail, now known as Ogden Avenue, was one of only three principal roads leading from Chicago. A stagecoach line from the city westward had begun operation along this route the same year. The Grants built a log cabin on the trail near today's York Road that served as a tavern and stopping point for travelers. Uniquely situated a half day's journey from Chicago by coach or a full day's trip by wagon, the cabin was a convenient destination. As the number of travelers increased, the Grants expanded their cabin tavern business in 1836, building a hotel they named Castle Inn.

It was about this time that Salt Creek got its name. A wagon hauling supplies from Chicago got stuck while crossing the stream. Before the cargo could be unloaded, a few barrels of salt dissolved in the water, resulting in the momentary characteristic that became the creek's name.

Early roads such as the Southwest Trail were roughly plowed and graded, making them difficult to travel. Rains turned the roads to mud, rendering wagons immobile. As the roadbed dried, hard ruts formed that made for even rougher journeys. A system of laying planks to pave the roadways, a Russian innovation used in Canada, was enthusiastically pursued in parts of this country beginning in the late 1840s. Eight-foot-long boards, three inches thick, were laid across parallel stringers embedded in the ground, greatly improving the surface of the roads. The Southwest Trail was the first in the Midwest to be covered with planks, in 1850. Initially ending at the county line at Brush Hill, the planking was soon extended to Naperville. The improved road led to significantly increased traffic, and with it, growth for the settlement of Brush Hill.

Toll amounts were legislated by the government, but plank roads were owned and operated by private companies that flourished for a time. Tolls were collected at tollgates built along the routes. The Southwest Trail's tollgate at Brush Hill was often congested with wagons and animals driven daily over the route to Chicago. It is reported that an endless, unbroken line of teams passed through the community, hauling farm produce or building materials, driving cattle and hogs, or carrying new settlers, travelers, supplies, and mail.

The Southwest Trail ultimately led to the Illinois River. As this was the route to the Mississippi, the trail had been heavily traveled since its Native American beginnings. It is hard to imagine the number, let alone the diversity, of those who have passed through this area. Military units marched here, not only during the Black Hawk War, but, surprisingly, during the Revolutionary War as well. The trail saw gold miners headed to California and innumerable wagons carrying settlers to the west. Statesmen including Abraham Lincoln, Stephen Douglas, and (likely) Ulysses Grant used the route to reach their homes, their constituents, and their government offices. It is remarkable that this very same path, Ogden Avenue, is traveled by Hinsdaleans today.

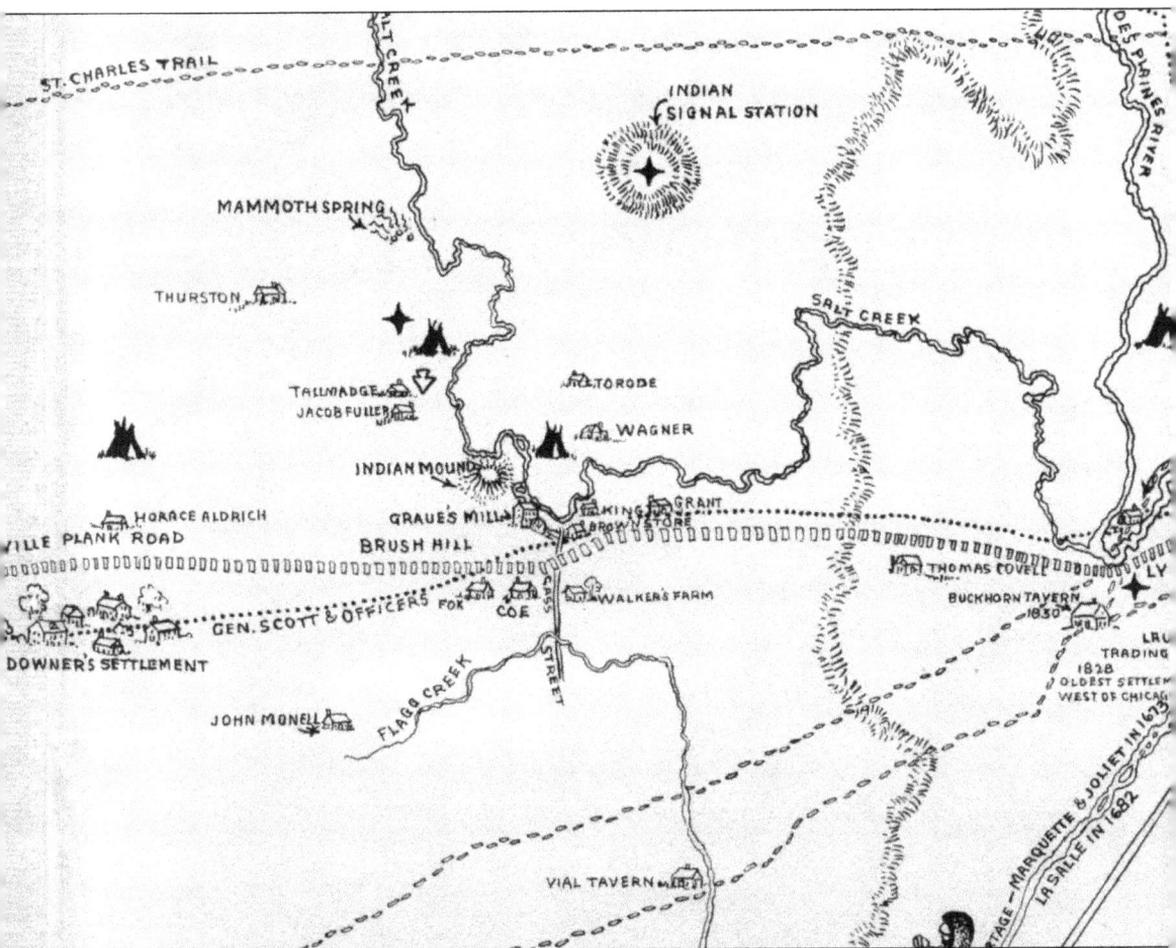

Shown is a section of a larger illustrated map, "Our Neighborhood During Pioneer Times," drawn by Corina Melder-Collier for *Village on the County Line*, a Hinsdale history authored by Hugh Dugan in 1949. At the map's center is what is now York Road and Ogden Avenue. The plank road (Ogden Avenue) is shown running east to west through Brush Hill. The street labeled Cass Street is not today's Cass Avenue, but a narrow road that eventually led to the small community of Cass, southwest of Brush Hill. St. Charles, Plainfield, and Joliet Roads are shown as Indian footpaths. Home locations of early settlers are indicated along with the area's creeks and rivers. The teepees represent Indian villages; the stars symbolize Indian signal stations. (Map courtesy of the family of Corina Melder-Collier.)

One

FULLER'S BURG

In search of land for farming, 24-year-old Benjamin Fuller worked his way west in 1834 from his parents' farm in New York state. After weeks of difficult travel and scouting, he realized his goal some 20 miles beyond the young city of Chicago. Finding rich soil, a small stream, and abundant game, he returned home to gather the rest of his family.

On their son Benjamin's recommendation, Jacob and Candace Fuller, along with their 12 children, left their New York farm in 1835 to stake a claim on the promising prairie. Jacob purchased 160 acres near what is now Spring Road and Thirty-first Street, and the family set about building a house and working the land. The 12 siblings, in due course, married the sons and daughters of neighboring settlers, increasing their numbers until it was said that everyone in the area was, or was related to, a Fuller.

Another early settler at Brush Hill was Sherman King. A soldier in the Black Hawk War, he may have been sent to oversee the remaining Potawatomi who lingered in the vicinity. King was involved with building the first sawmill on Salt Creek in 1837, operated by fellow pioneer Nicholas Torode. The mill served the growing population by providing boards, rather than logs, for better quality homes and barns.

Mary Fuller, Benjamin's sister, was the first local teacher. Before there was a place to hold classes, Mary walked from farm to farm teaching local children, always accompanied by two dogs to protect her from wolves that roamed the prairie.

Brush Hill was gradually becoming a community. In 1844, blacksmith John Coe arrived, hauling his anvil with him from New York. Establishing one of the early businesses in Brush Hill, Coe had a steady supply of work from stagecoaches, wagons, and local homesteaders. In 1845, a general store opened to provide local settlers their basic needs.

Other new communities were also appearing on the prairie. To the west were Pierce Downer's and Joseph Naper's settlements, begun in the 1830s. Cottage Hill, now Elmhurst, and Addison lay to the north along York Road while Cass and Lyonsville were established further south.

Benjamin Fuller, one of the area's earliest settlers, gradually purchased most of the land in the central community. Serving over the years as farmer, storekeeper, innkeeper, and postmaster, he platted the town and changed its name from Brush Hill to Fullersburg.

Over time, Fuller amassed about 800 acres. His acquisition in 1843 of a portion of Orente Grant's property included this building, Castle Inn. The inn, built by Grant in 1836, was located on the south side of the Southwest Trail, today's Ogden Avenue, just east of York Road. In addition to serving travelers, settlers took shelter at the inn while building their homes.

After purchasing Castle Inn, Fuller built this family home just north of the trail along York Road. Some historians believe this 1843 home is the oldest extant example of balloon frame construction in the country. This revolutionary technique used mill-cut wall studs that ran in a continuous piece from floor to roof, a simpler and faster construction method than using heavy posts and intricate joints.

North of his house across the creek, Fuller built a grocery and saloon in 1843, naming it the Farmers' Home. Remnants of this building still stand, significantly renovated and now known as York Tavern. This 1941 photograph shows the tavern with an addition in progress. (Courtesy of Oak Brook Historical Society.)

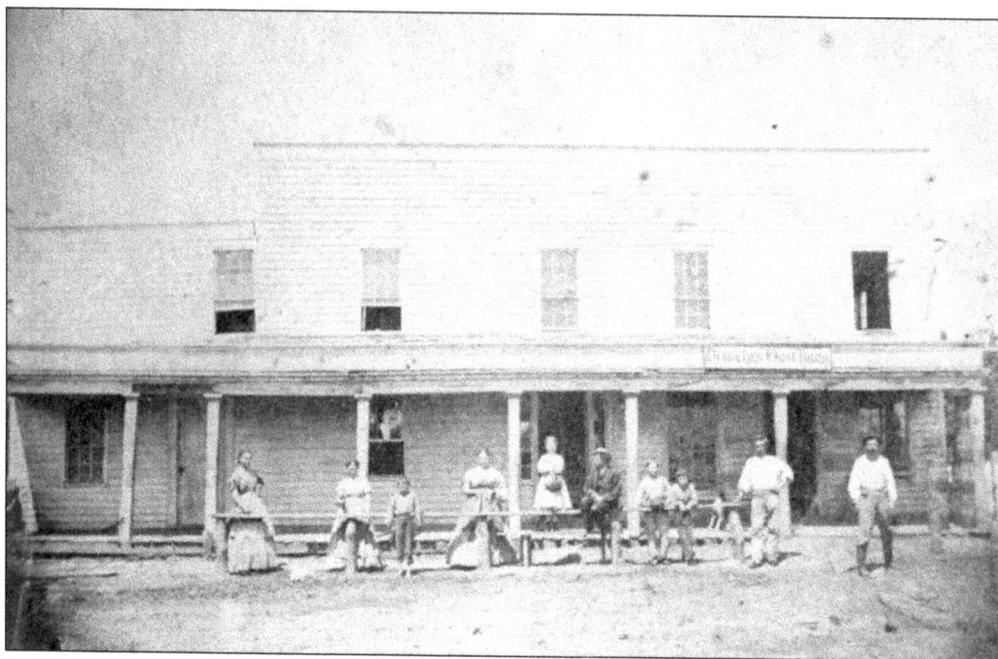

In 1851, with business booming at Castle Inn, Fuller built a second hotel across the street on the north side of the plank road. This hotel, shown here in 1869, was known over the years as Fullersburg Tavern, the Deutches Gast Haus, and the Grand Pacific Hotel. Often both inns in Brush Hill were filled to capacity, requiring some families to sleep outside.

About 1852, Marvin Fox arrived from Vermont with his wife and 10 children. Homesteading 160 acres southwest of Brush Hill, he soon added another 160 acres to his farm, planting the first corn on the prairie that was to become Hinsdale. His home, shown here, still stands on the south side of Ogden Avenue at Lincoln Street, obscured by a fence.

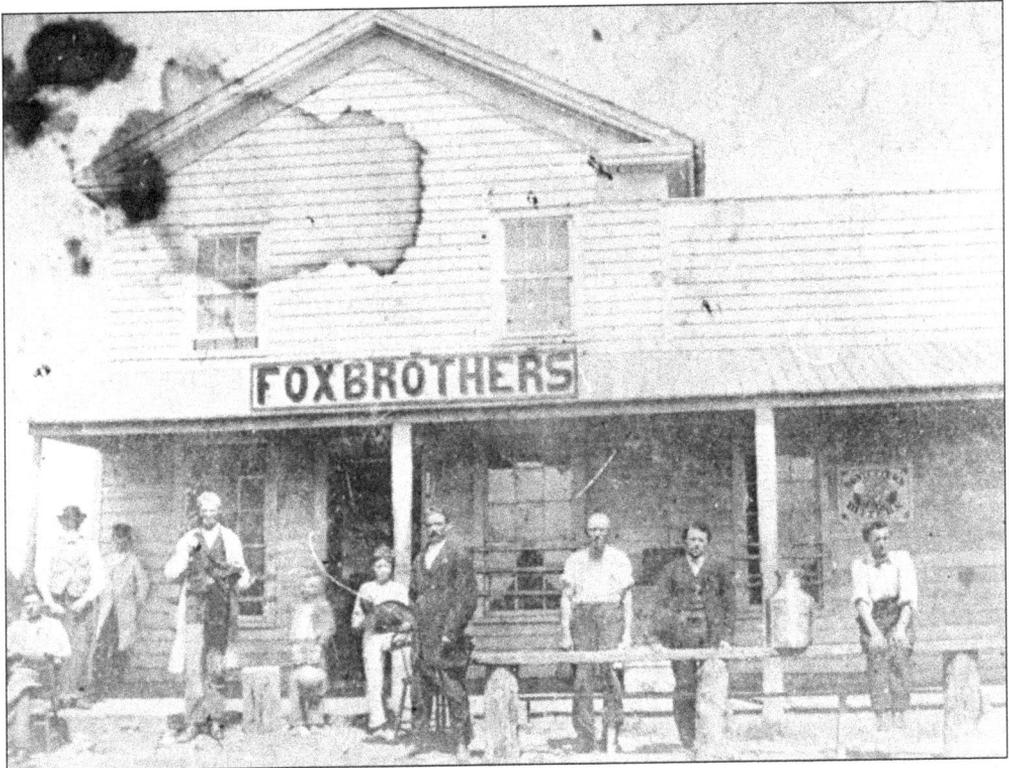

Located on the northeast corner of what is now York Road and Ogden Avenue, this was Brush Hill's first general store. Marvin Fox's son Charles acquired the business in 1866 and was joined by his brother Heman in establishing Fox Brothers. They replaced this building in the early 1870s, continuing the business here until relocating to Hinsdale.

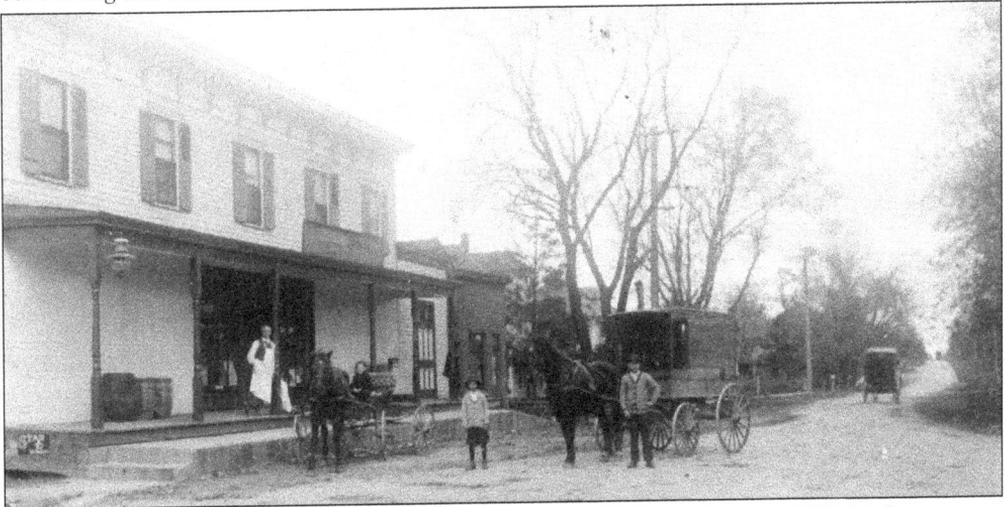

Storekeeper John Mohr purchased the Fox Brothers Fullersburg store in 1877. Mohr came to America from Germany as a child, later serving in the Union army during the Civil War. The photograph shows the store on Ogden Avenue and the view eastward. In 1909, Mohr relocated to Hinsdale, building the store that still stands at 24 East Hinsdale Avenue, today occupied by the Hinsdale News Agency.

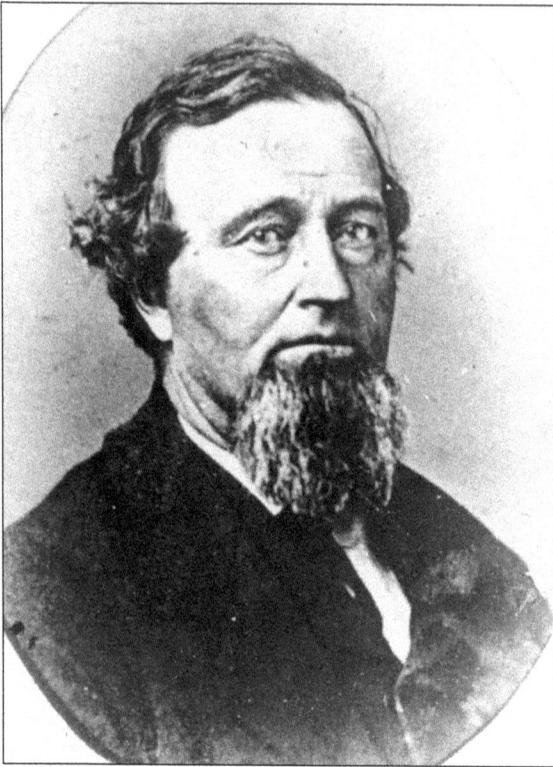

Another settler from the east, Barto Van Velzer was a former boat driver on the Erie Canal. He helped lay the Southwest Plank Road and became the toll collector at Brush Hill upon its completion. Van Velzer had a reputation as a talented horse trader and was well liked by the stagecoach drivers and area farmers.

Located on the north side of the plank road near the county line, this was toll collector Van Velzer's home. Toll rates between Brush Hill and Naperville were 25¢ for a horse and carriage, 37¢ for a wagon with two horses, 10¢ for a horse and rider, 4¢ for cattle and 3¢ each for hogs and sheep. For those who needed to stop overnight, a fenced area was provided where stock could be corralled.

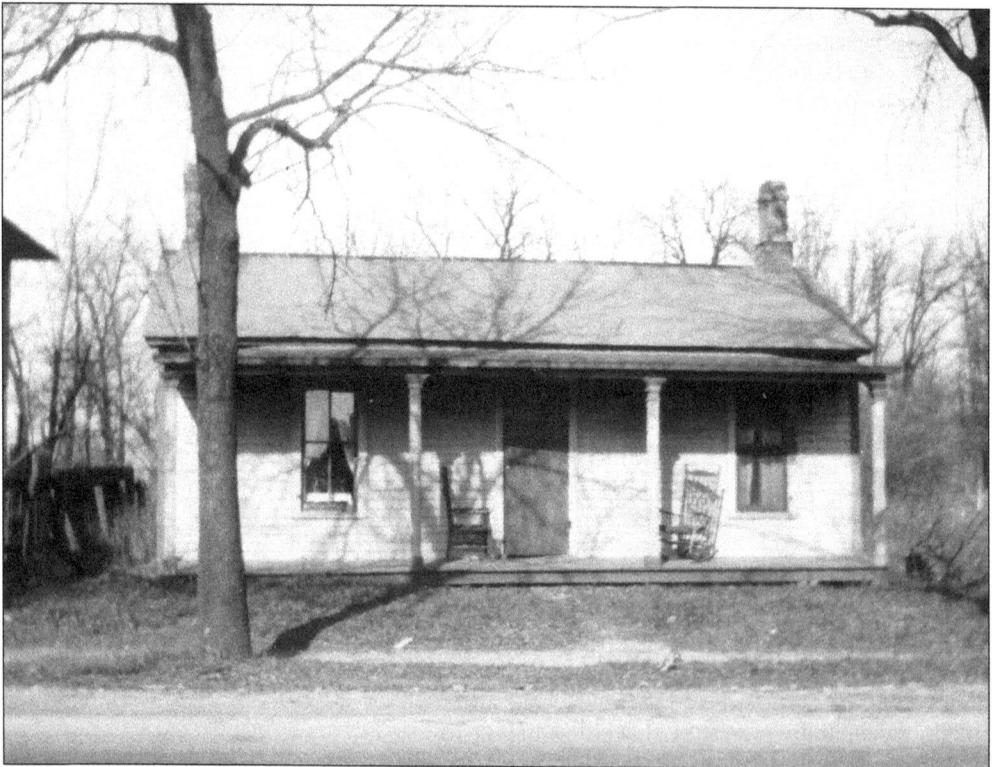

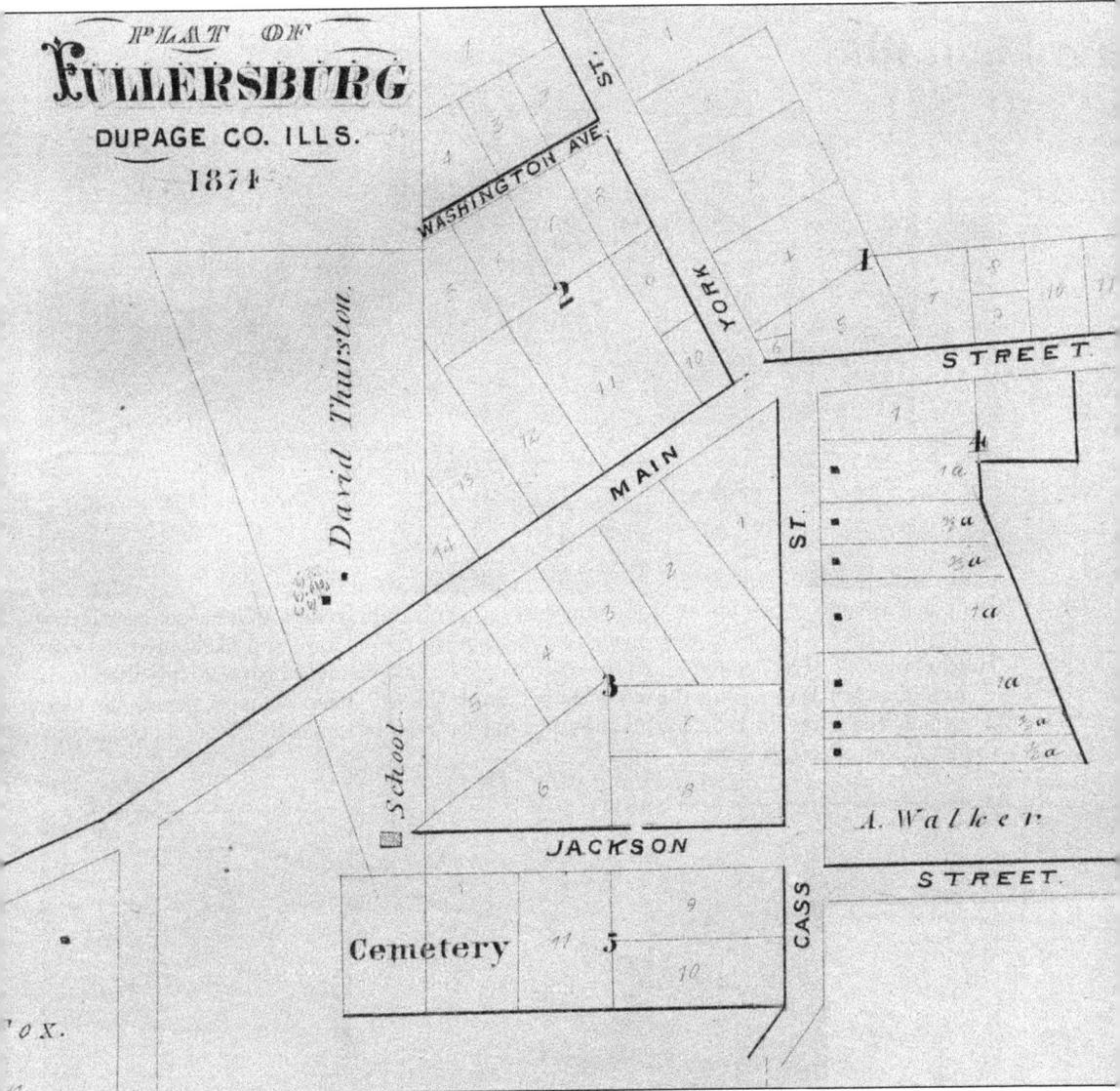

PLAT OF
FULLERSBURG
DUPAGE CO. ILLS.
1874

Owning most of the Brush Hill property and several of its businesses, Benjamin Fuller platted the town he named Fullersburg in 1851. The name was slow to be acknowledged, however, and the community was referred to as Brush Hill for at least another 30 years. The small town extended about two blocks in each direction from what is now the York Road and Ogden Avenue intersection. Cass Avenue shown on the map is today's York Road; Main Street is now Ogden Avenue. Realizing what was important to a community, Fuller set aside land for both a school and cemetery.

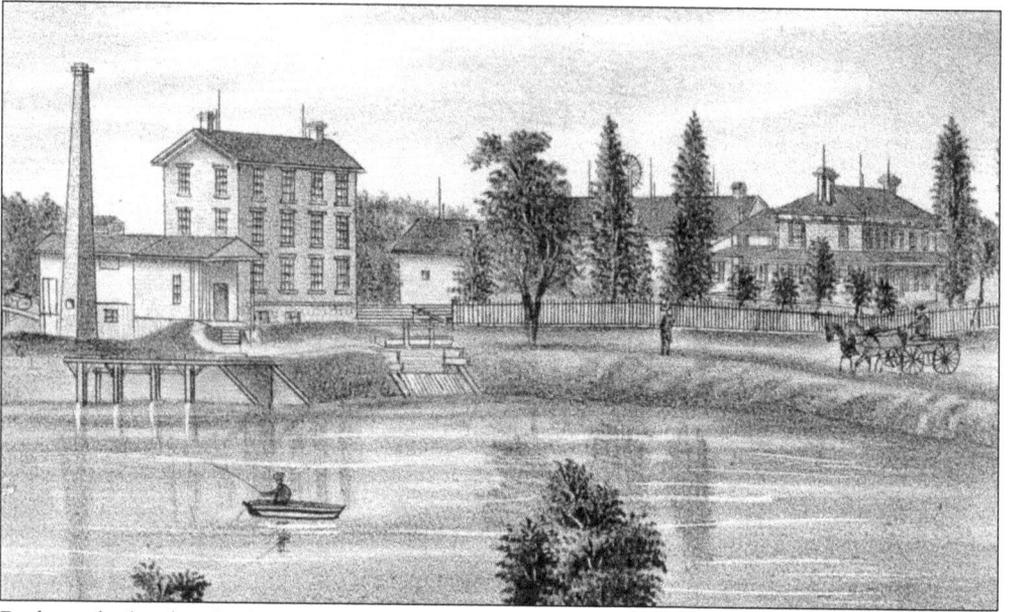

Built on the banks of Salt Creek at the site of an earlier sawmill, Frederick Graue completed this gristmill in 1852. The bricks were made of clay from the family farm and likely fired at Jacob Fuller's brickyard. The one-ton burrstones used to grind the corn and wheat were imported from France. Immediately successful, the mill remained Brush Hill's most important business for decades. The home visible on the right in this 1874 drawing was built by Graue in 1859 and occupied by the family for almost 90 years.

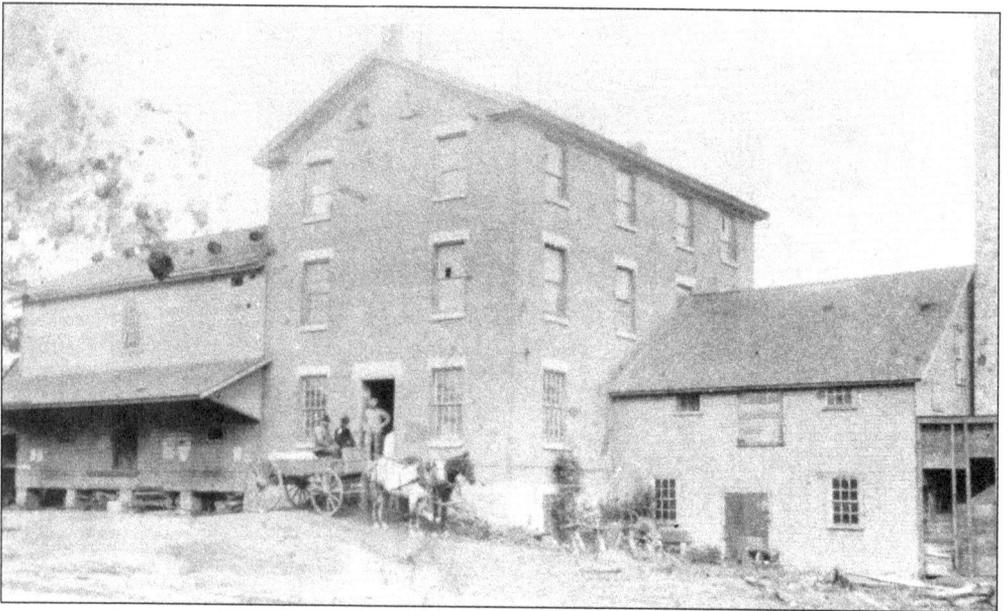

Due to its location, access to transportation, and antislavery sympathies, Fullersburg served as a stop and transfer point for fugitive slaves traveling the Underground Railroad. Graue Mill harbored runaways and it is believed that Castle Inn also sheltered slaves on their journey to freedom. Some residents recalled seeing wagons or sleighs stopping to unload disguised human cargo.

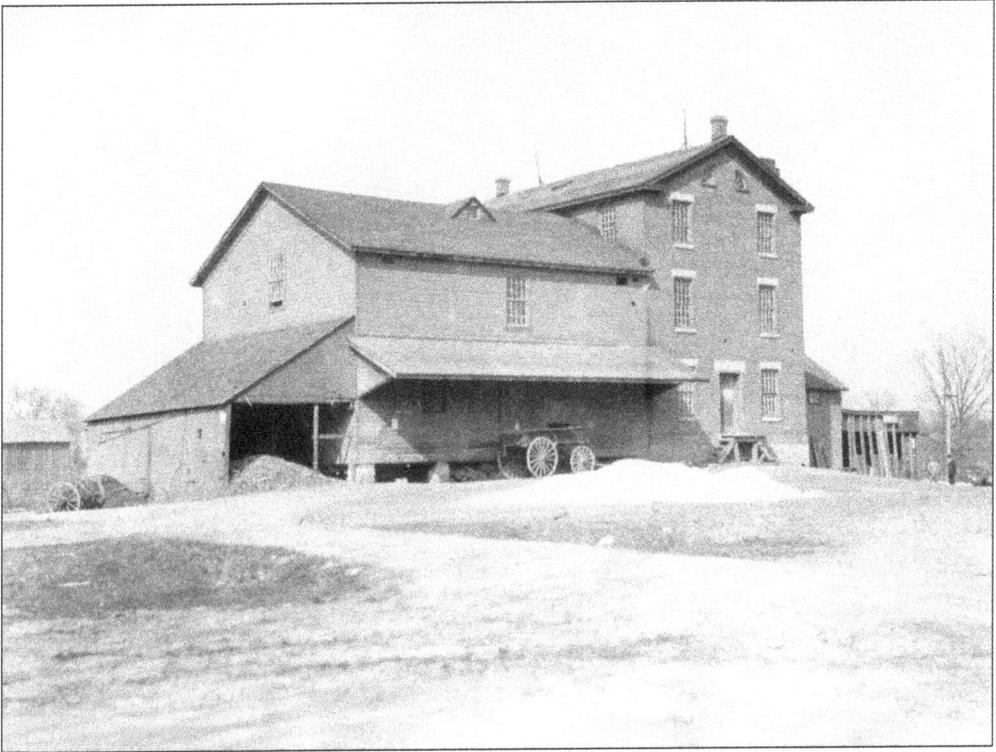

The shed on the right housed a boiler that increased the creek's waterpower. The 1893 addition on the left was used for preparing apple cider and maple syrup, initiated to supplement the mill's income. After three active generations, the mill succumbed to more modern technology.

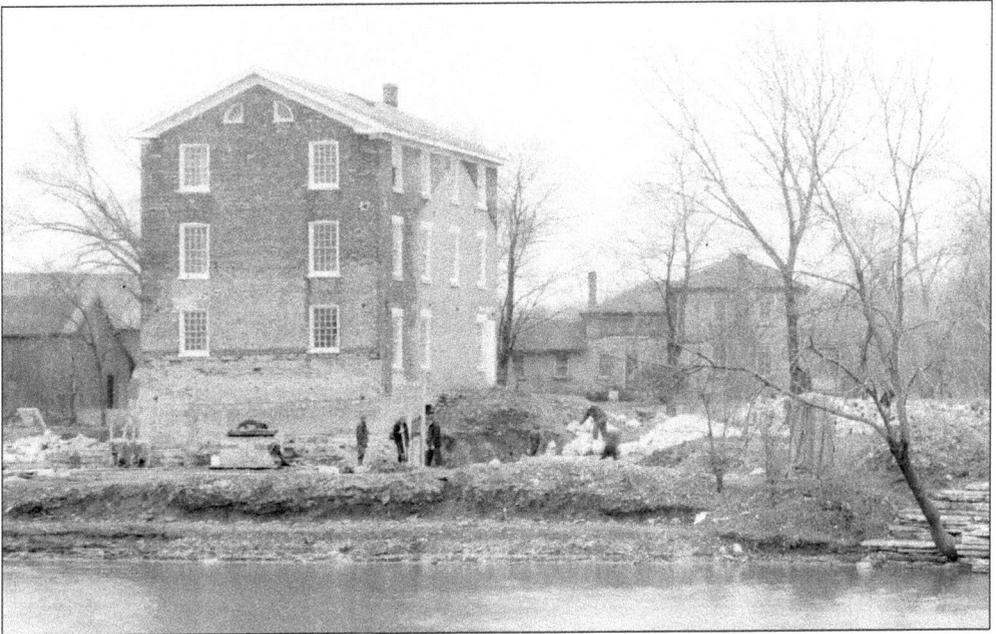

Abandoned for years, the mill's restoration by the Civilian Conservation Corps, shown here, began in 1934. The original section of the mill still stands, operating as a unique and popular museum.

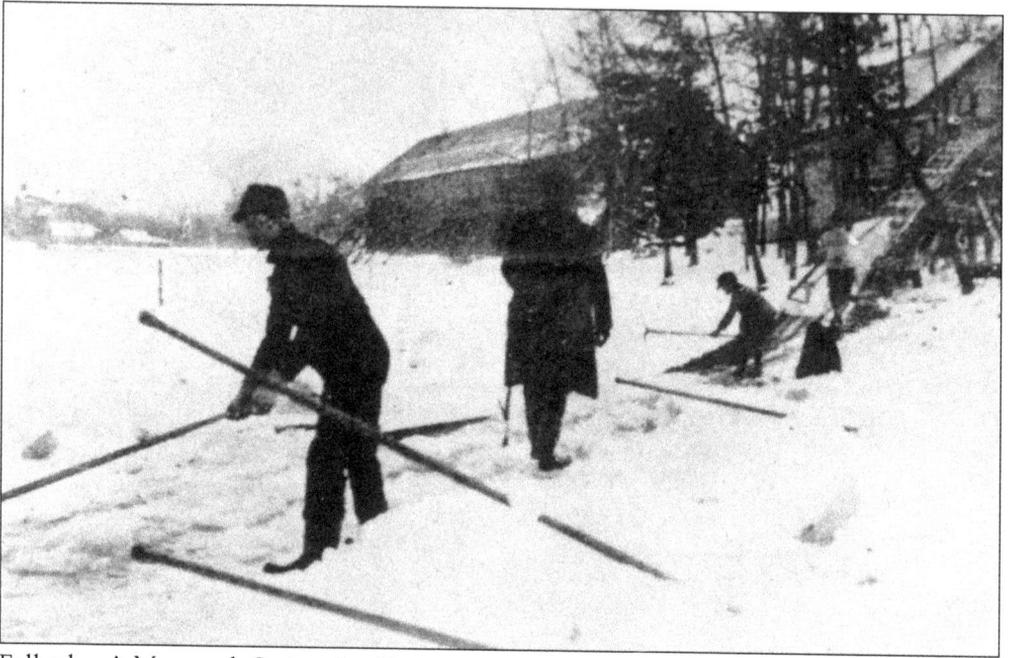

Fullersburg's Mammoth Springs Ice Company, a prosperous natural ice business before the days of refrigeration, was begun by John Ruchty in 1880. When the ice on Salt Creek was about 16 inches thick, it was cut into 24-inch blocks. Workmen are shown maneuvering the floating ice to the horse-powered conveyor belt that carried the blocks to the top of the icehouse.

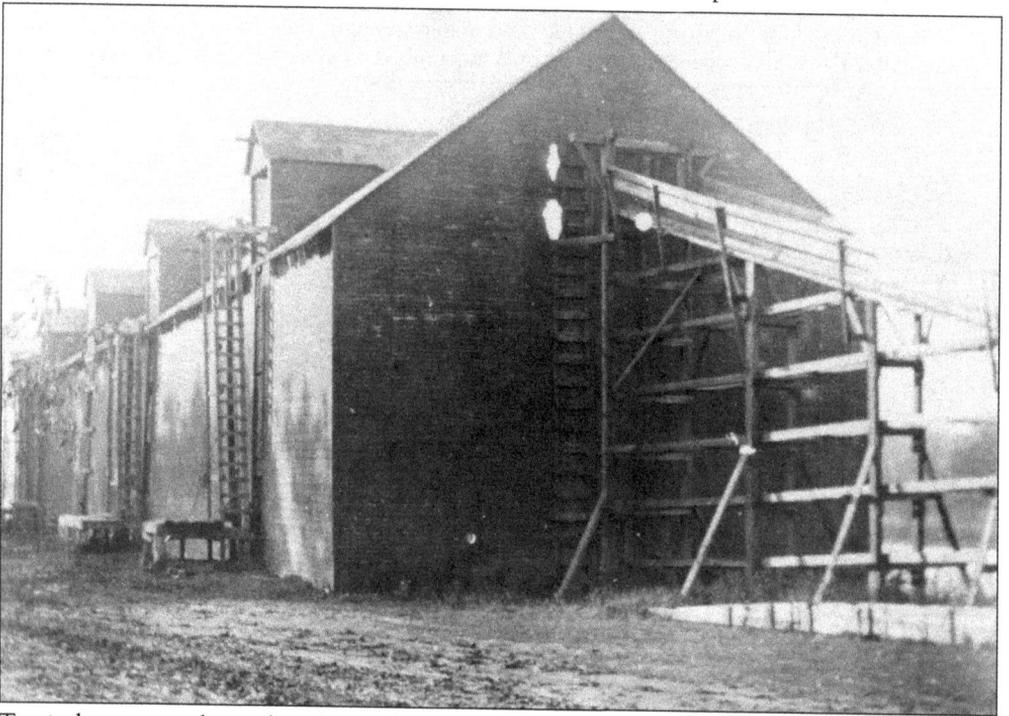

Two icehouses were located on the creek at the end of Washington Street. The building shown here was 100 feet long, 50 feet wide, 30 feet high, and insulated with double walls 18 inches thick.

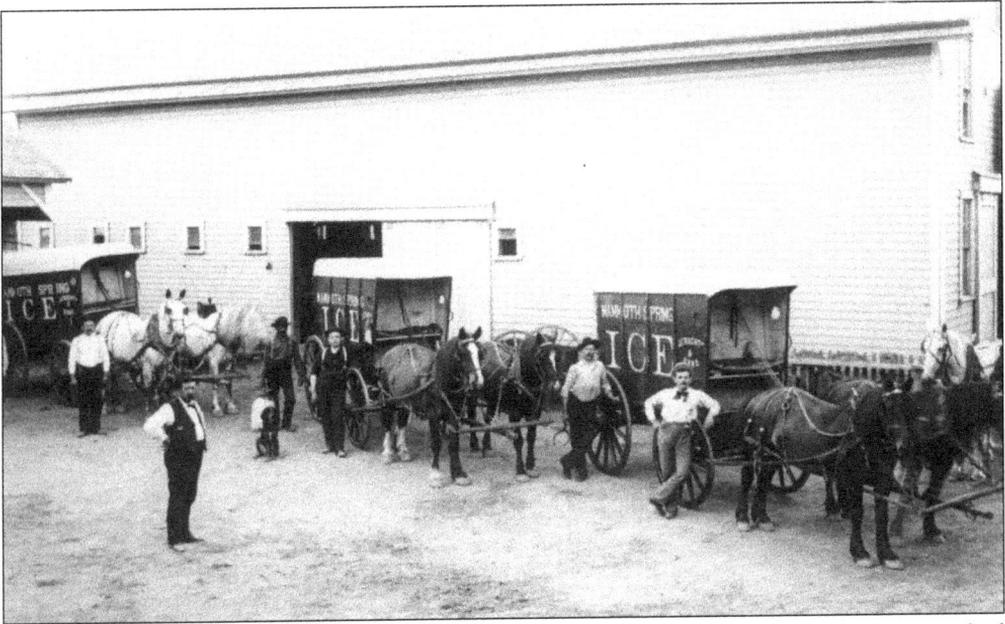

With the help of about 30 men hired for the "harvest," several thousand tons of ice were packed in sawdust and stored for delivery the following summer to iceboxes throughout the area. This barn at 212 East Ogden Avenue housed the horses and wagons used to make those deliveries. Owner John Ruchty stands in the foreground of this 1895 photograph.

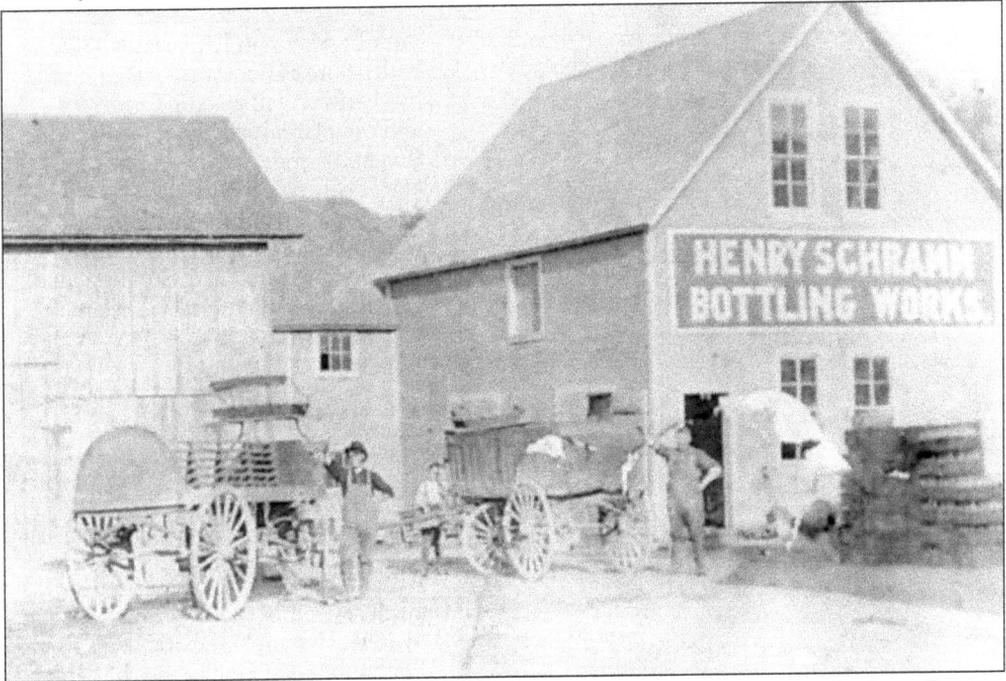

In 1884, German immigrant Henry Schramm started this bottling company in Fullersburg. Dealing in soda and mineral waters, birch beer, root beer, ginger ale, and Weiss beer, he became one of the best-known bottlers in northern Illinois. The sizeable plant and barn burned to the ground in 1905, the worst fire in Fullersburg history. (Courtesy of Oak Brook Historical Society.)

Built by Sherman King about 1853, Fullersburg School was located on the hill between Fullersburg Cemetery and the plank road, where Fuller Road now ends. James Valette of Naperville was the teacher, boarding in Fullersburg during the week and walking the 12 miles home each weekend. Vacated in 1928, the school was destroyed by fire 10 years later.

Alfred Walker, looking for property to farm, arrived in the area from Vermont in 1854. He purchased 300 acres from Benajmin Fuller, including the Grand Pacific Hotel and Castle Inn. Walker operated the inns for a few years, living at Castle Inn while building his house and farm just south of Fullersburg.

Located where today's Ayres Avenue meets Garfield Avenue, Walker's farm stretched to the county line. There were no houses to the south for eight miles, only prairie and a lone grove of trees. The street, "The Lane," was actually the lane that the cows used to reach the barn. Years later, the barn's foundation was broken down and used in paving Ravine Road.

In addition to raising crops and livestock, Walker became one of Illinois's first cheese manufacturers. This barn likely housed the factory, producing 100-pound cheeses that were shipped to Chicago and beyond. Walker experimented with various methods and products and his farm became well known. Recognized by the US government as a "model of agriculture," the farm was visited by Japanese students in the 1870s studying American farming methods.

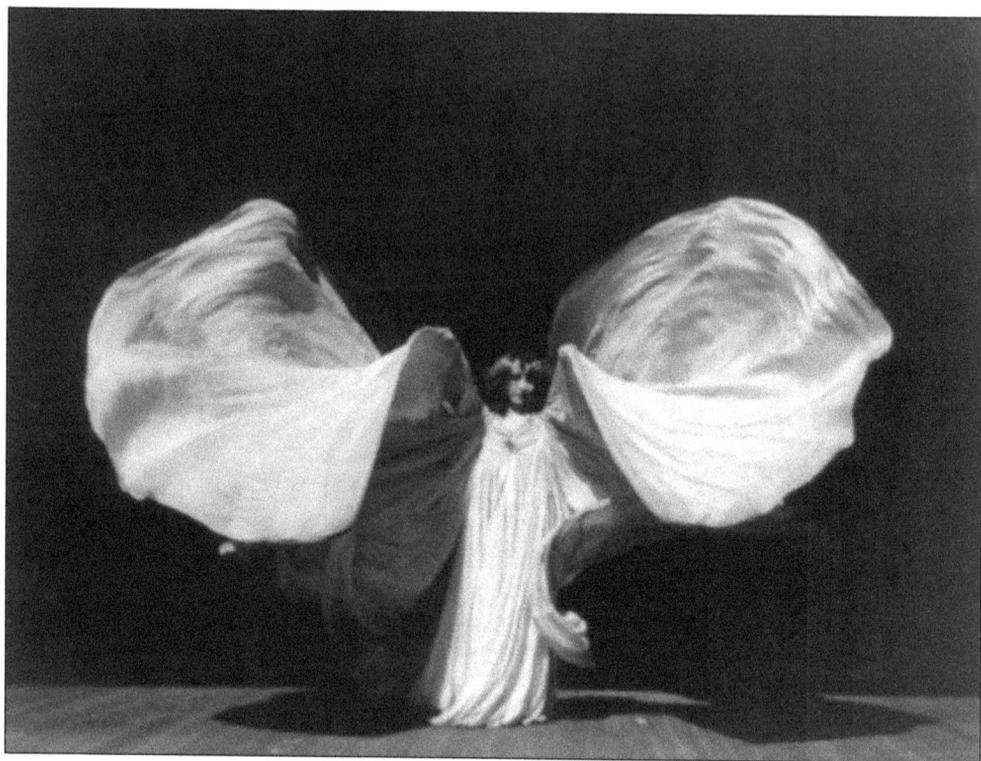

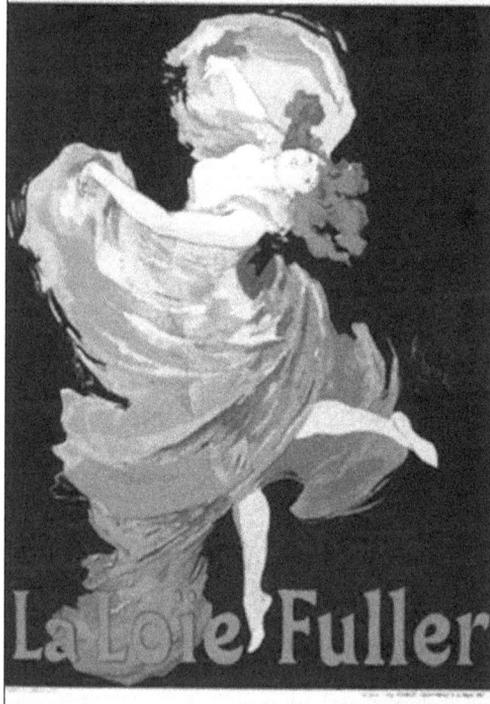

FOLIES·BERGÈRE

La Loie Fuller

Loie Fuller, Jacob's granddaughter, was born in January 1862 at Castle Inn where her parents had gone to escape the harsh winter at their nearby farm. Introduced to the stage as a child reciting poetry, performing became her passion. With only modest success in America, Loie found international fame as a dancer, appearing throughout Europe to rave reviews. Paris, where she was embraced by the artistic elite, became her home.

Famed artist Jules Cheret painted this poster for Loie Fuller's debut at the Follies Bergere in Paris in 1893. Cheret captured Loie's movement and innovative use of colored spotlights, illustrating her mesmerizing performance. Her sensational Follies Bergere engagement brought her tremendous success. Renowned for spellbinding manipulation of flowing silk costumes, her considerable influence on modern dance is recognized to this day.

Two

TOPOGRAPHY, TRACKS, AND A TOWN

"Nothing is more conspicuous in the development of a country than the building of railroads . . . new towns spring up almost in a night . . . and the wilderness becomes a garden of wealth." This observation by Wisconsin newspaper editor J.E. Jones aptly describes the circumstances occurring on the Illinois prairie.

The first railroad out of Chicago was the Galena & Chicago Union, reaching westward through the towns of Oak Park, Elmhurst, and Wheaton. The benefits of the railroad were immediately clear; towns southwest of Chicago also wanted access to this new, faster means of transportation.

In 1858, an enthusiastic petition was presented to the Chicago, Burlington & Quincy Railroad requesting a track be laid directly between Chicago and Aurora, passing through Lyons, Brush Hill (Fullersburg), Downers Grove, and Naperville. Ben Fuller and Frederick Graue signed the petition on behalf of Brush Hill, citing the productivity of the town's mill and the business it could offer the new route.

Eventually, the CB&Q Railroad agreed to the new track and began studying the area topography to determine its exact route. What the land survey revealed was devastating for Fullersburg. "The joy with which the citizens along the proposed line had greeted the arrival of the surveyors was short lived for the inhabitants of Brush Hill," wrote Marion Knoblauch in *Progress on the Prairie*. "The cause of this unexpected turn of events lay in the contours of the land and the recommendation that the roadbed be built, not through Fullersburg, but a mile to the south, cutting diagonally across the open prairie."

With no recourse, Fullersburg's fate had been sealed. The coming of the railroad led to the creation of a new community, Hinsdale, which grew as quickly as Fullersburg faded. Sixty years later, the flourishing village absorbed its pioneer predecessor, annexing Fullersburg in 1923.

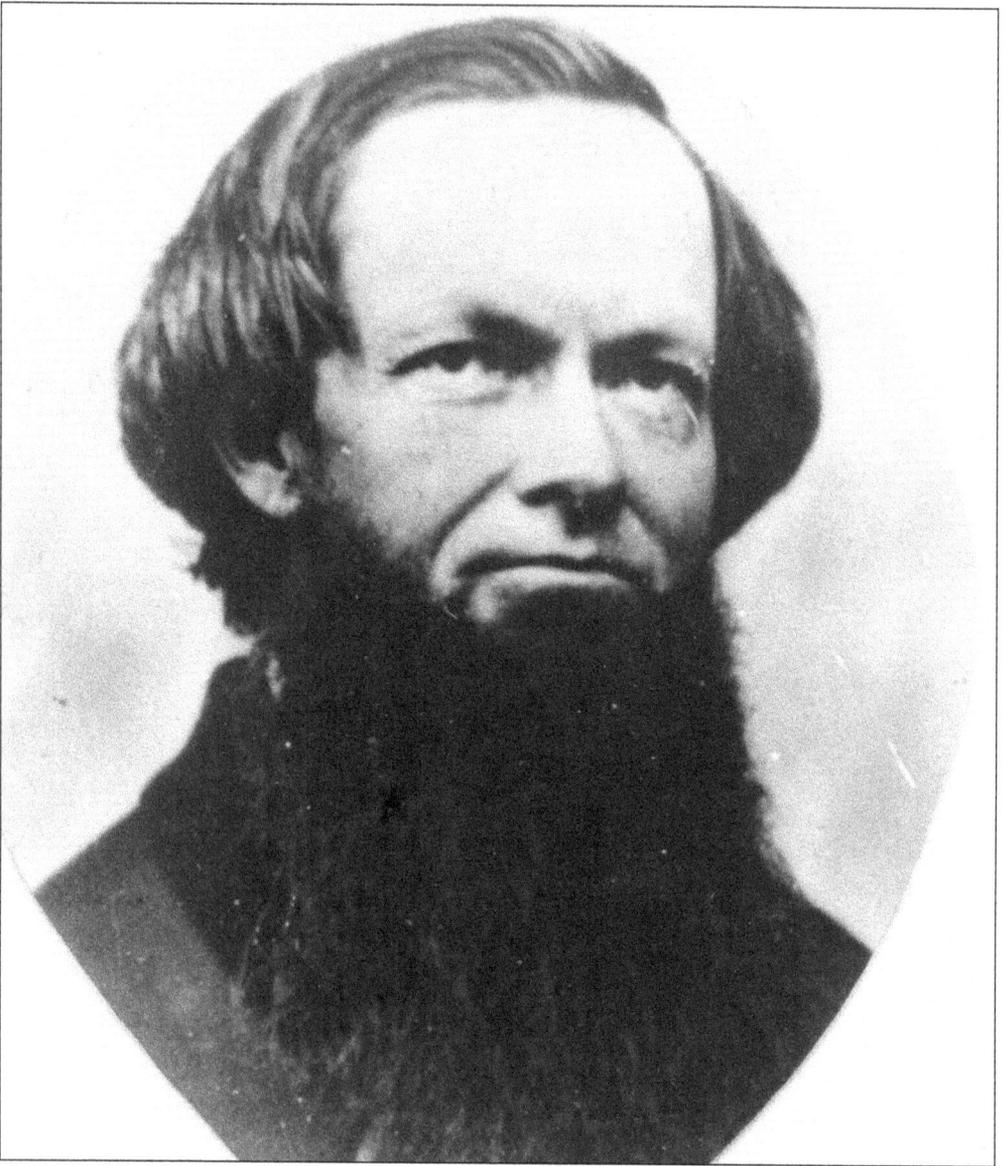

Across the country growth and prosperity followed the railroad. It was the vision of William Robbins that brought it to Hinsdale. Born in New York, the enterprising Robbins farmed and taught school before coming to Chicago in 1844. Working as a store clerk, he was lured by the California Gold Rush and made his way west. Prospecting proved unprofitable, but he found great success in selling mining supplies. By the mid-1850s, the partnership of Bull, Baker & Robbins was the largest wholesale merchandiser in Northern California. By 1860, Robbins was a wealthy man, married with two children. Motivated by family or the possibility of another adventure, he sold his California holdings and moved briefly to St. Louis before returning to Chicago, this time dealing in real estate. Aware of the railroad's plans and the potential of the wild prairie south of Fullersburg, Robbins purchased 800 acres in 1862. Paying $14 an acre, his property included most of the land between what is now Chicago Avenue and Fifty-fifth Street, and from Madison Street to the Tri-State Tollway.

Plat of the Town of Hinsdale
T. 38 R. 11 E. 3d P. M.

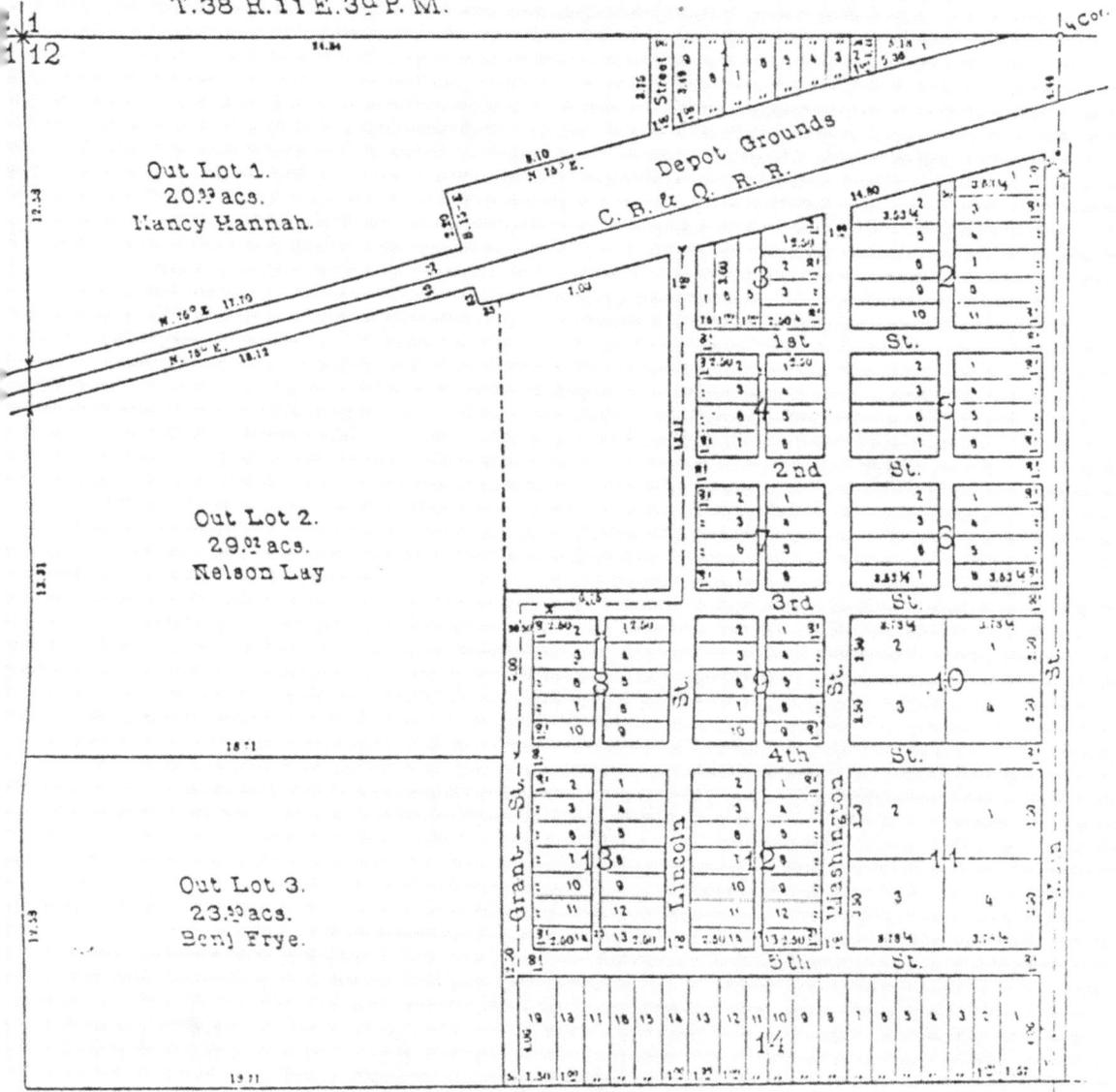

Prairie chickens and sandhill cranes were the only inhabitants of Robbins's property, and other than along the county line, there was not a tree in sight. Thoughts of farming diminished as land values escalated. William Robbins now envisioned this rural landscape becoming a residential community—a commuter's paradise—and set about getting it done. In 1865, Robbins platted the town of Hinsdale as shown here, naming the north-south streets after national heroes and numbering those running east-west. He defined the streets with rows of trees, alternating elms and maples, understanding that the faster growing maples would be dying as the elms were reaching maturity.

To be near his new venture, Robbins temporarily moved his family to Fullersburg. From here, he had direct supervision of Hinsdale's formation, from the street layout and grading to the tree planting and construction of his own estate. In 1863–1864, on property near the grove on the county line, Robbins built the home he named "Woodside," shown here. The house still stands, altered by additions, at 425 East Sixth Street.

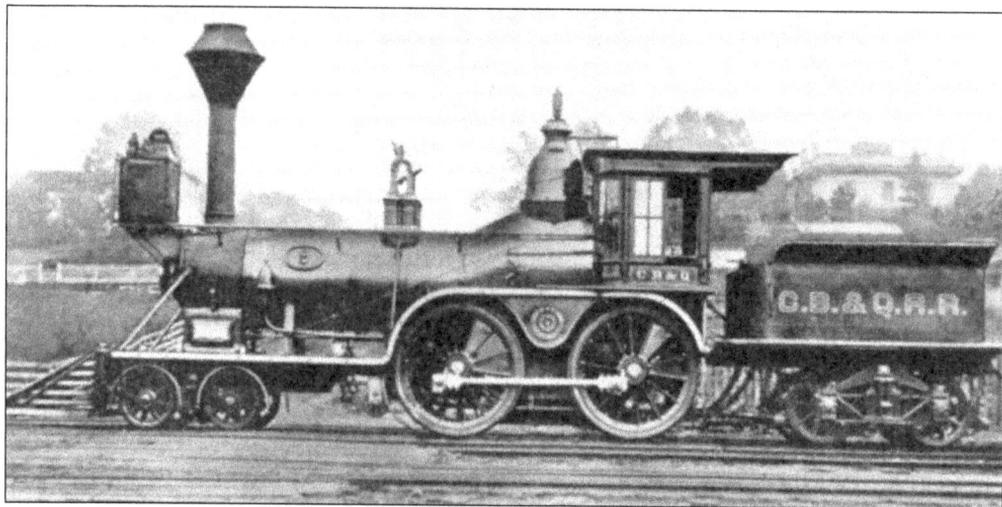

The railroad had great difficulty laying track over the wide, wet marsh between Western Springs and Hinsdale known as "the flats." Carload after carload of rock was dumped into the swamp until a bottom was found. Finally, a 30-foot-wide cut, still evident, was made through Hinsdale's high ground to reach the prairie beyond.

Stations	Freight, No. 13. B	Freight, No. 11. B	Night Express. No. 9. C	Aurora Passenger, No. 7. B	Mendota Passenger B	Quincy Passenger, No. 3. B	Mail, No. 1. B	DIST. FROM CHICAGO
...Central Depot...	9.45A.M.Lv.	11.30P.M.Lv.	5.45P.M.Lv.	4.30P.M.Lv.	3.00P.M.Lv.	7.30A.M.Lv.
..Chicago Station..	10.10	8.15A.M.Lv.	11.50	6.00	4.45	3.15	7.45	2½
.....Cicero......	10.25	8.45	*12.07	6.16	*4.58	‡3.33	*8.00	7½
... Riverside.....	10.48	9.08 Ar. / 9.25 Lv.	12.22	6.30	5.10	3.49	8.15	12½
...West Lyons....	11.05	9.42	*12.33	6.40	5.17	3.58	8.24	15¾
.....Hinsdale.....	11.15	9.53	12.40	6.46	5.28	4.04	8.30	18¼
..Downer's Grove..	11.37	10.13	12.55	7.00	5.35	4.14	8.42	22½
......Lisle.......	11.53	10.30	†1.06	7.10	5.43	4.22	8.52	25½
....Naperville	12.10	10.48	1.18	7.20	5.53	4.32	9.02	29½
.....Aurora.....	12.56	11.30 Ar. / 11.45 Lv.	1.45	7.45P.M. Ar. B.	6.15	4.55	9.27	38¼

Slowed by the terrain, the Civil War's drain on material, and bad weather, the new track to Aurora finally opened in 1864. This 1868 timetable shows both freight and passenger schedules. Not every ride went smoothly. Occasionally in winter, trains would stall in snowdrifts and passengers would have to leave the train and walk along the right-of-way. Nonetheless, the line still functions as the oldest regular passenger service in the Chicago area.

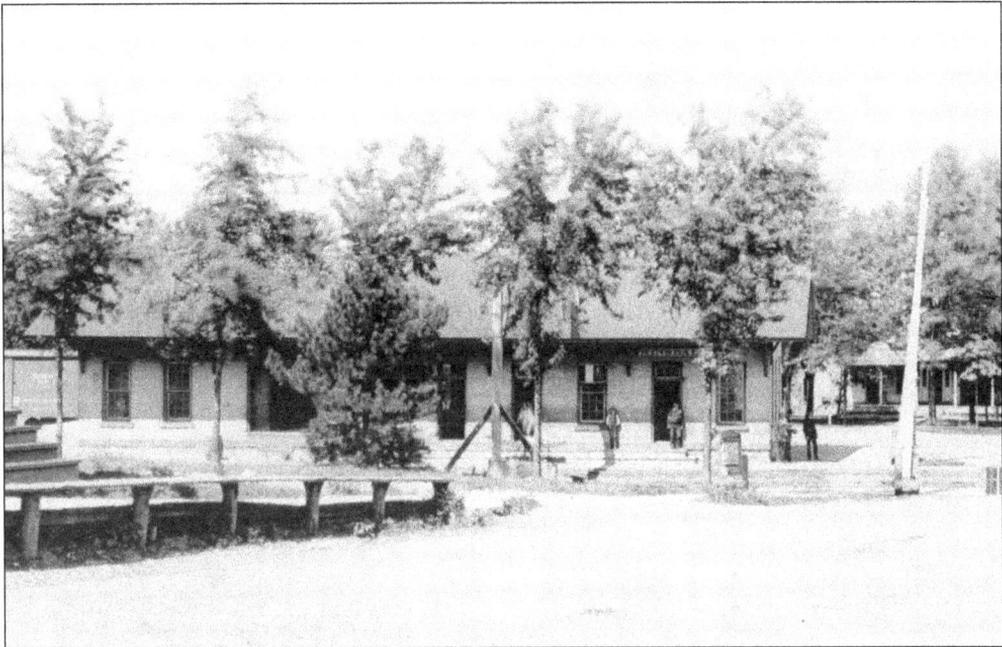

Hinsdale's first railroad station was built in 1864 on the north side of the tracks between Washington and Lincoln Streets, where the commuter parking lot now stands. The station was used for town meetings, social events, and church services until other venues were built. Hinsdale's early hotel can be seen behind the station at the right. The current depot on Hinsdale Avenue replaced this station in 1899.

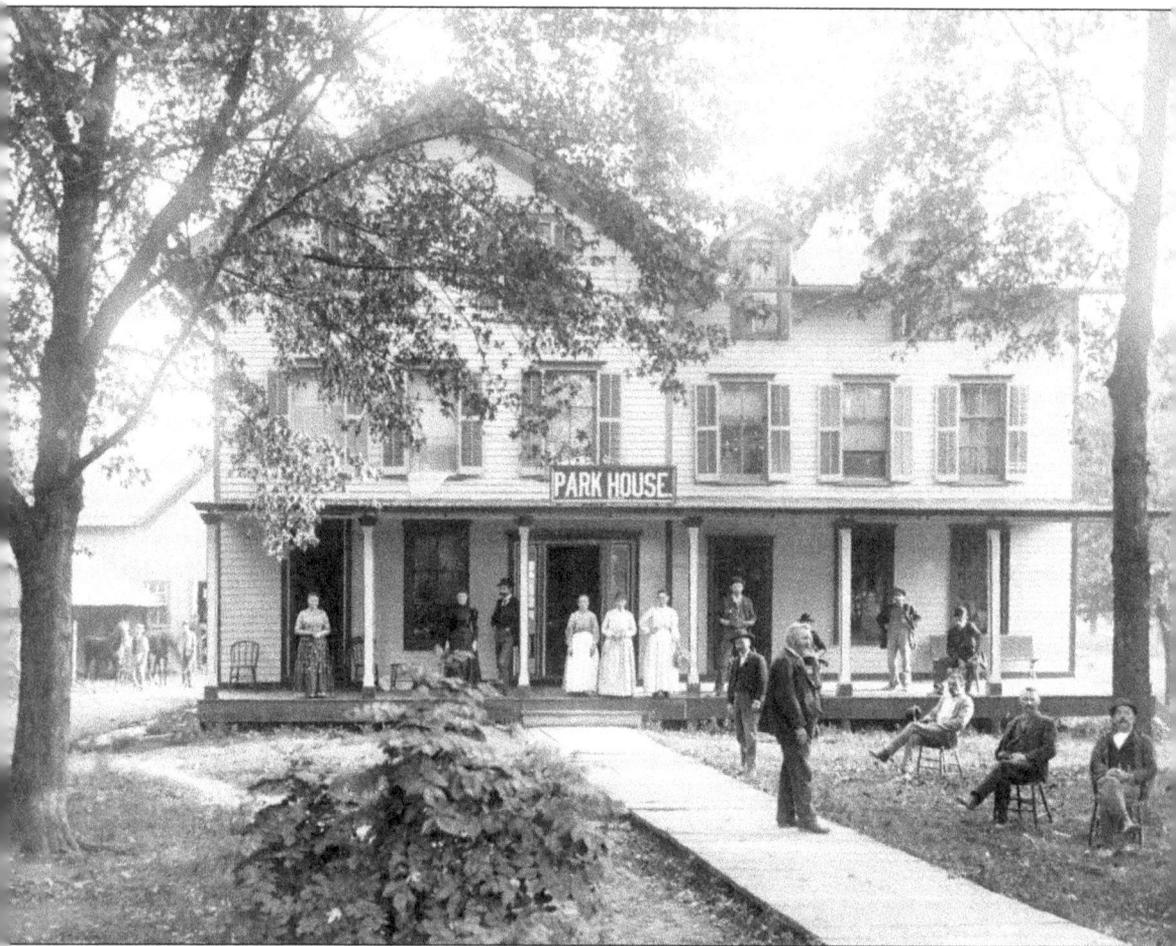

Hinsdale's hotel was built about 1868. It sat north of the original train station on the west side of Washington Street. Having several names and owners over its 42 years, it accommodated travelers and salesmen and served as a temporary home to early settlers as they waited for their homes to be built. After the hotel closed in 1911, it was cut into two sections and moved. As of this writing, both sections still serve as single-family homes, at 549 York Road and 46 South Madison Street. The hotel's watering trough can also still be found on the Washington Street parkway, near its original location.

Rev. Charles Barnes was the first to purchase property in the proposed town, living in this house at Second and Washington Streets. As a sales promotion, Robbins offered a free lot to the first boy born in Hinsdale. In May 1866, Barnes and his wife collected, aptly naming their son William Robbins Barnes. William grew to become an important bookseller, ultimately founding the firm of Barnes & Noble.

Hinsdale flourished and Robbins made two additions to the village. This, his second, "Park Addition," was designed in 1869 by well-known landscape architect H.W.S. Cleveland. Familiar with Olmsted and Vaux's curvilinear plan of Riverside, Robbins sought this new, more picturesque layout for the area that included his own home. Cleveland worked with the natural terrain in planning the curving streets, landscaped medians, and parkway "islands" of green.

Another perceptive real estate man involved in Hinsdale's early development was Oliver J. Stough. He began purchasing land in 1866, platting his north addition from Garfield Avenue to Madison Street two years later. His second addition ran from Chicago Avenue to Fifty-fifth Street and from Madison Street to Jackson Street. By 1871, Stough had bought and subdivided about 1,200 acres.

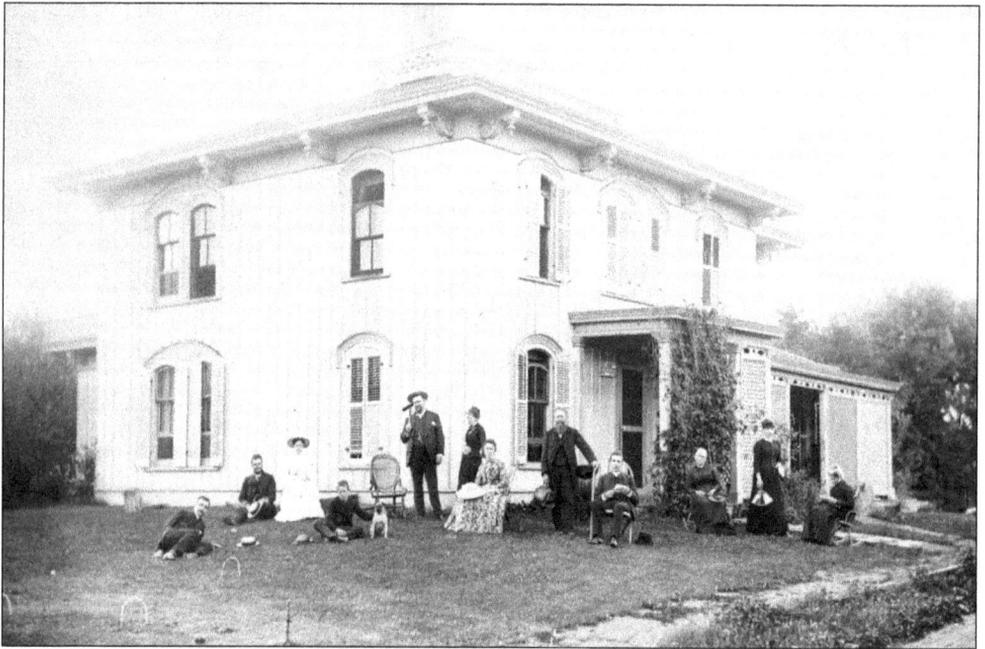

Built in 1867, the home of O.J. Stough stood on acres of well-landscaped grounds that stretched from Lincoln Street to Vine Street and Maple Street to Hickory Street. Here, in 1872, Stough claimed 15,000 pounds of grapes were raised on a one-acre plot, demonstrating the richness of the soil. About 1885, the home was moved to 306 North Grant Street, where it still stands.

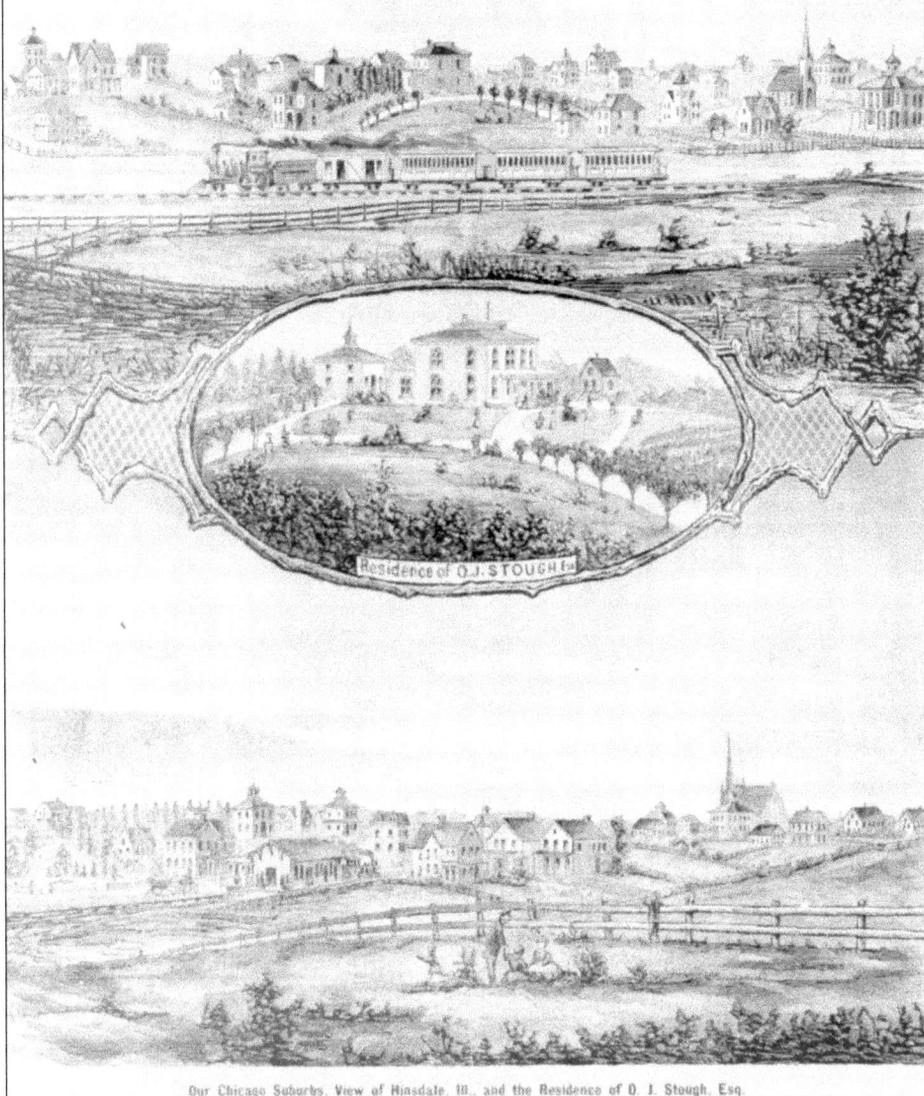

HINSDALE.

15 MILES FROM CHICAGO ON THE C.B & Q. R.R.

Residence of O.J. STOUGH Esq.

Our Chicago Suburbs. View of Hinsdale. Ill. and the Residence of O. J. Stough. Esq.

Stough placed this 1873 advertisement in the *Land Owner*, a weekly Chicago journal devoted to real estate. Perhaps the village's foremost promoter, Stough was interested in anything that would stimulate land sales in Hinsdale. Like Robbins, he laid out streets and planted hundreds of trees. He also donated land and endowed a church on the northwest side along with parks, a school, a meeting hall, and the West Hinsdale train station. (Courtesy of The Newberry Library.)

33

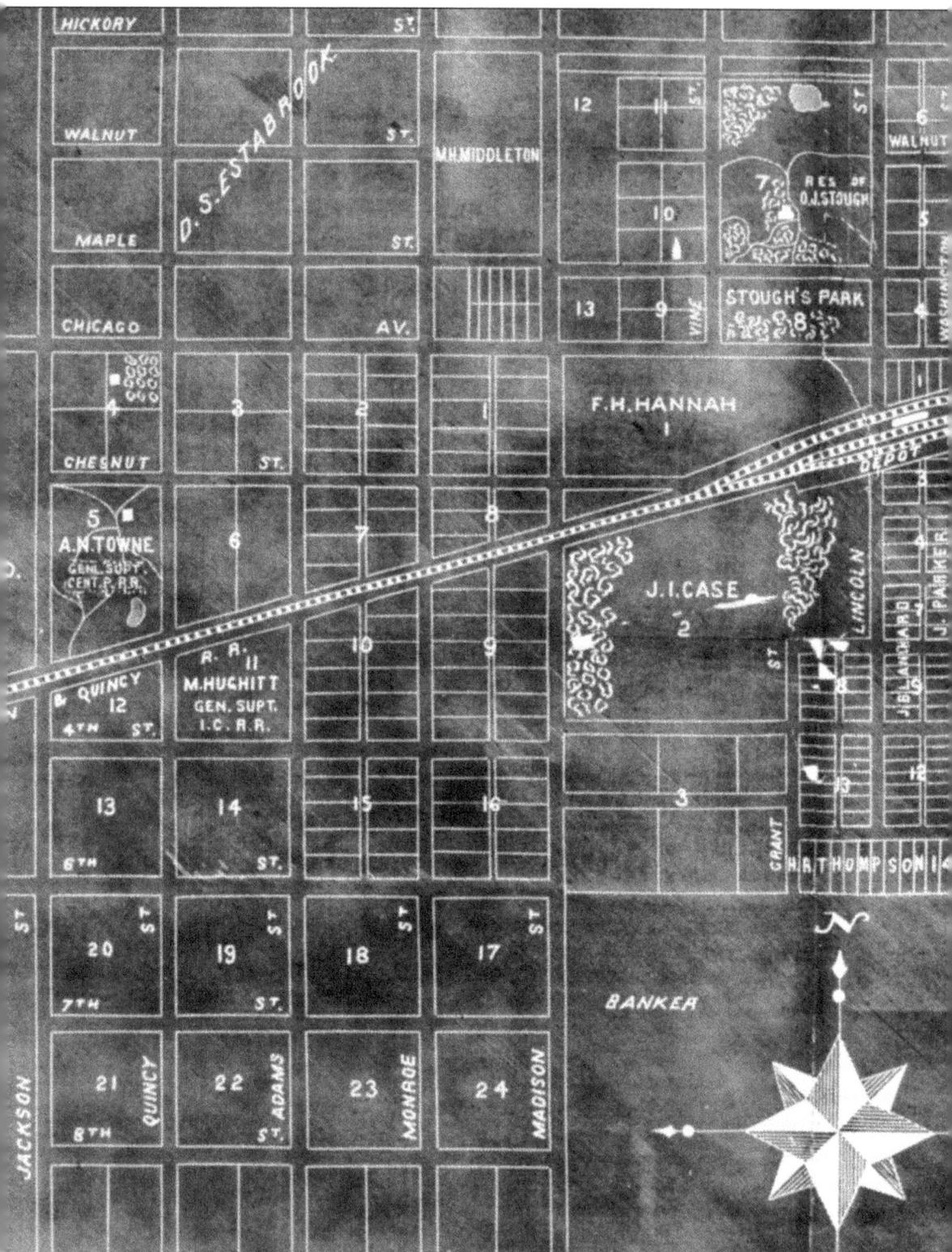

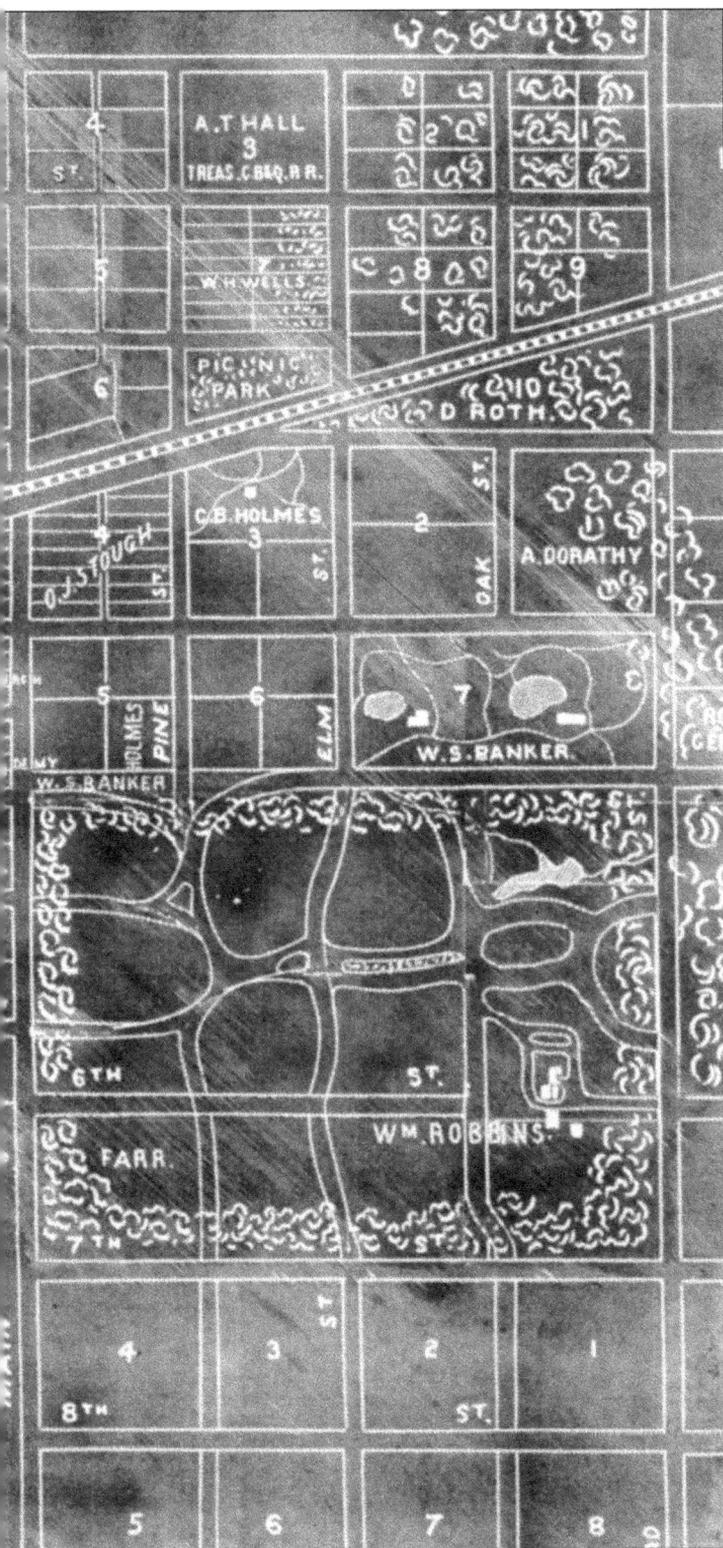

This 1869 map also appeared in the *Land Owner* (see page 33). At the time, Hinsdale's population was only about 300, so some of the detail represents the developers' larger plans rather than reality. The depot is indicated west of Washington Street, its original location, and the estates of Robbins and Stough are accurately marked. The natural line of trees along the county line ridge are included, supplemented by those added to embellish various properties.

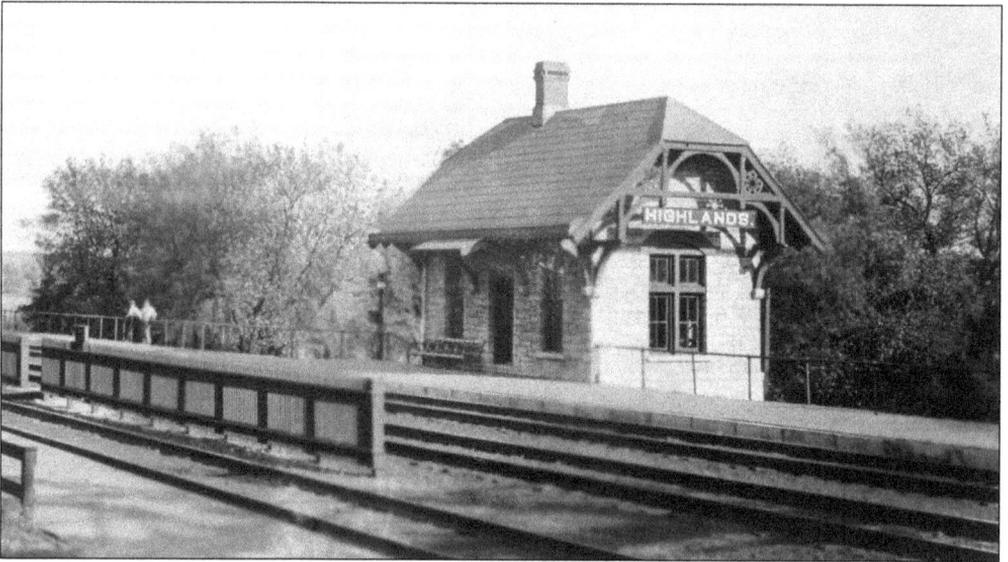

The mature trees along the county line attracted some buyers to Hinsdale's eastern edge. To accommodate the large homes on both sides of the railroad tracks here, the Burlington agreed to stop on signal if a station were built. In 1873, grateful homeowners built the stone station, naming it "Highlands" for its elevated location.

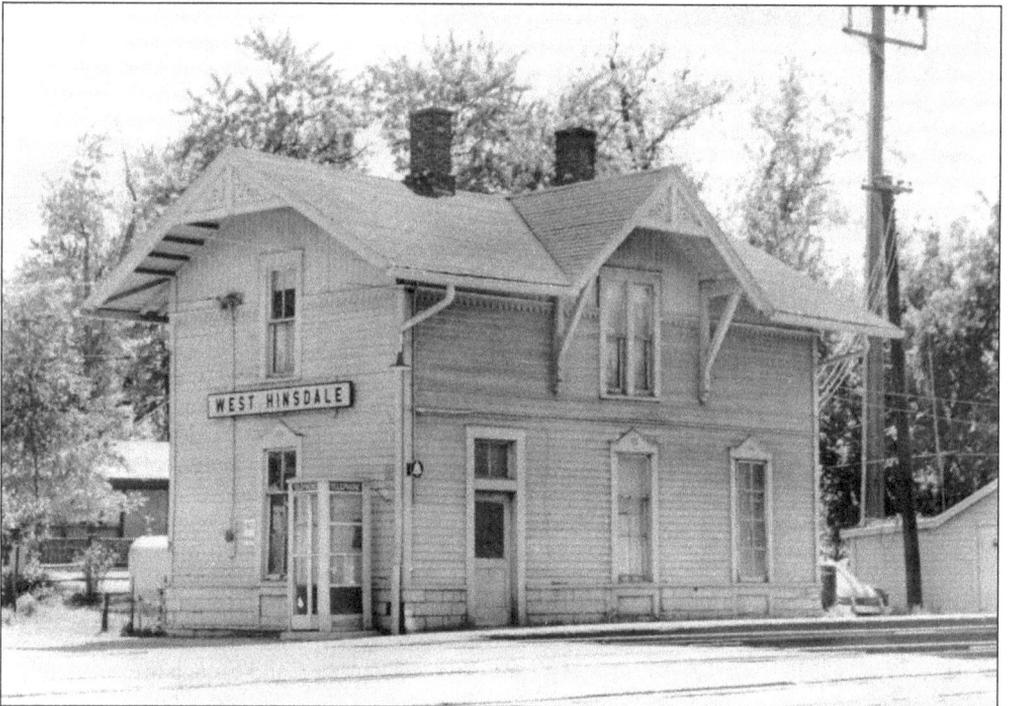

Not to be outdone, O.J. Stough felt his west-side lots would be more attractive to buyers if a station was located on the opposite side of town. He approached the railroad, offering to build a station. The railroad again agreed, and Stough had this two-story station constructed in 1874. A stationmaster, who sold tickets and signaled trains when passengers were waiting, lived on the second floor with his family.

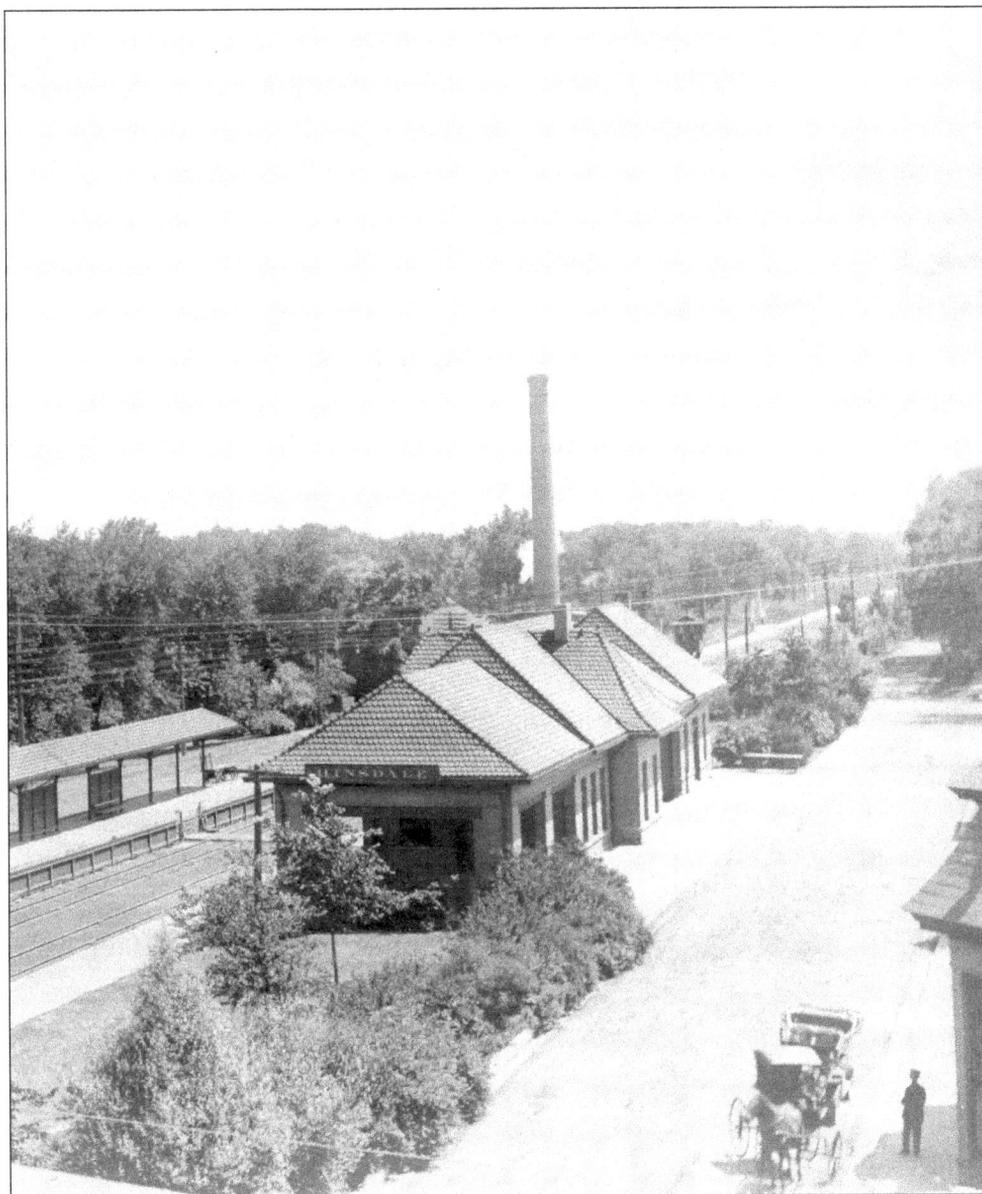

After years of Hinsdale's complaints and requests, the Burlington railroad agreed to replace its aging original Washington Street station. A new site was chosen on the north side of Hinsdale Avenue, one block east of the original structure. The station, still in use, was completed in 1899. Other than the horse and buggy, this c. 1907 photograph looks remarkably current.

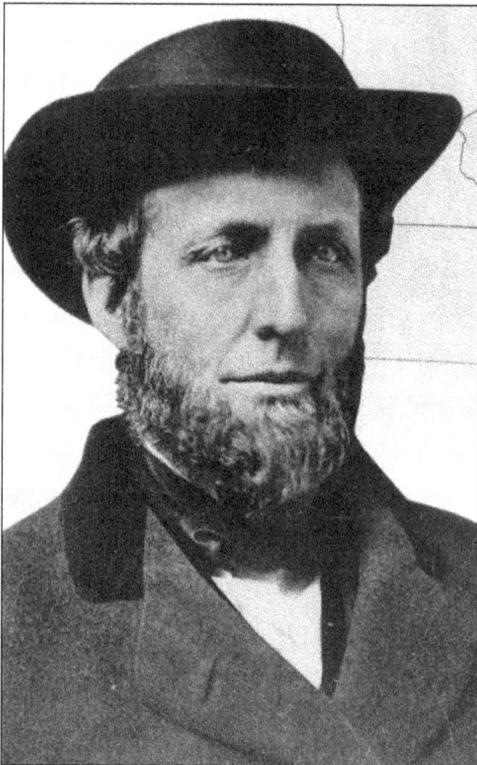

With a wide-ranging background of teaching, farming, carriage building, hardware, harness making, and operating a sawmill, Anson Ayres retired to Hinsdale in 1868. He bought 80 acres and this home on the northwest side and perhaps did some gentleman farming before subdividing the property, his initial goal.

J.I. Case, farm machinery magnate and friend of William Robbins, purchased a large section of property on the south side in 1868, planning to build a "fine villa." Likely too involved with business and politics in Wisconsin to fulfill those plans, Case subdivided the land instead. (Courtesy of Jerome Case III and George Fennell.)

Case's property extended roughly from Grant Street to Madison Street, an area later known as "Dutchtown" because of its predominantly German population. These industrious immigrants, mostly tradespeople, were responsible for the construction of nearly all of the village's early homes and businesses.

East of the county line, the 1924 Woodlands Addition to Hinsdale extended from Sixth Street to Fifty-fifth Street. Designed by George W. Maher, developer William Jordan and noted landscaper R.W. Olmstead collaborated on the curvilinear layout. This Zook-designed home at 566 Woodland was one of the first to be built in the area in 1926.

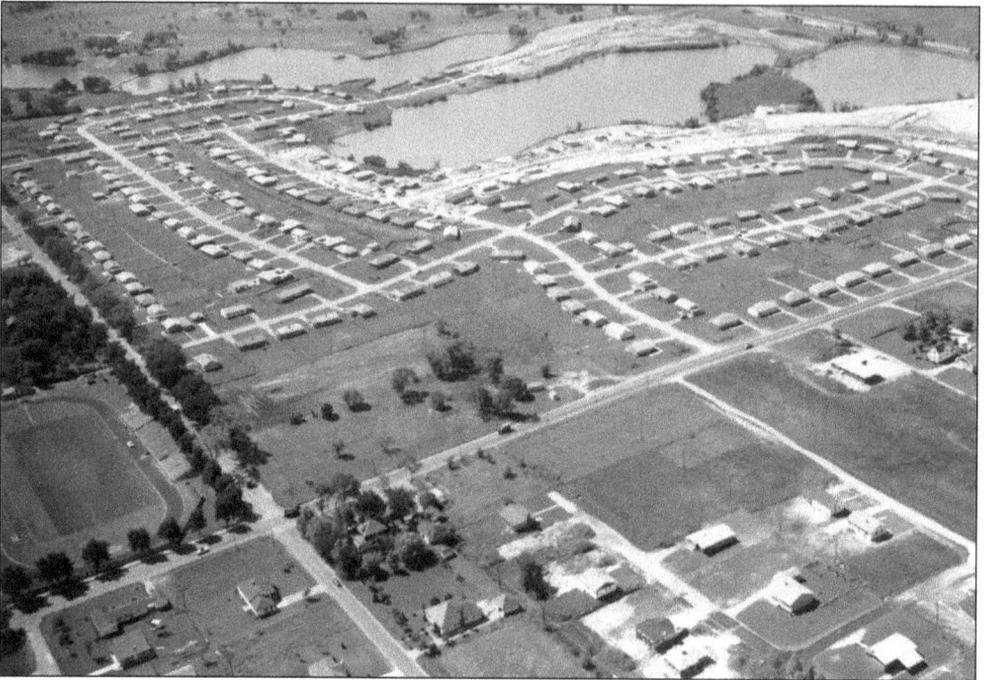

Formerly farmland, Grant Dixon developed the unincorporated area south of Fifty-fifth Street and west of Madison Street in 1952, creating Golfview Hills. This aerial shot, with the high school football field on the left as a point of reference, shows the arrangement of factory-built homes that offered affordable housing after World War II. The homes, primarily ranch design, each accommodated minor customization and included a carport, washer/dryer, and two trees.

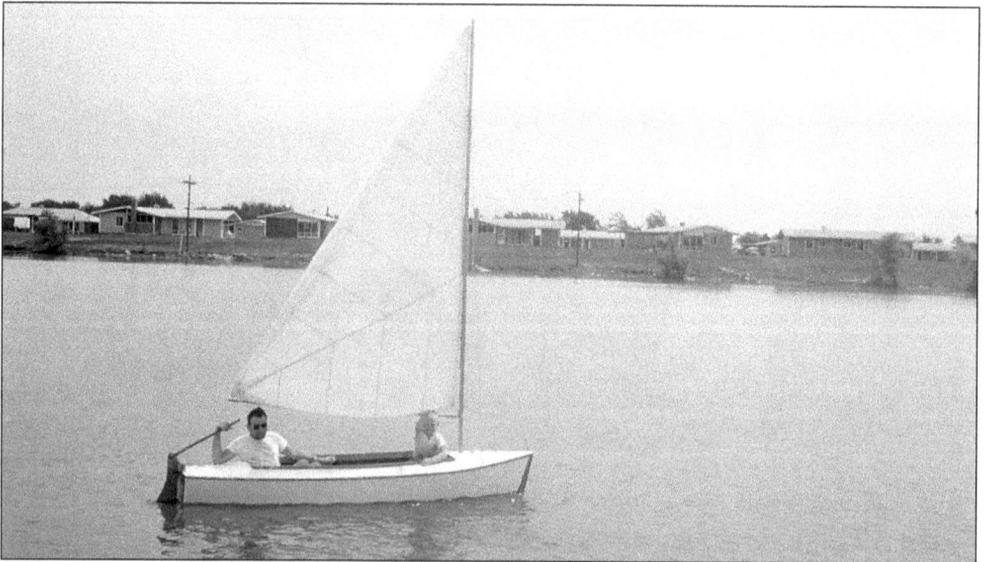

The lake at Golfview Hills was known as Johnson's Slough, named for the farmer who worked the land prior to development. The new residents of Golfview formed the Johnson's Slough Yacht Club to maximize enjoyment of the subdivision's centerpiece lake. This photograph shows homeowner and yacht club member Robert Parsons and his son Dennis sailing in 1955. (Courtesy of Dennis Parsons.)

Three

BUILDING AN
EXCEPTIONAL VILLAGE

Sydney Collins, born in Hinsdale in 1888, lived almost all of his 91 years in the village and was a keen observer of its growth and character. He recorded an insightful, first-hand account of Hinsdale's development:

> The Village was settled by quality people. From the nature of things, it took a man with vision to move his family to the newly platted hamlet on the prairie. This vision was shared by all classes, however, and while the young community included people of means and a number with wealth, it included also the working man. All were people of high standards and intelligence and the ideal they set for their village was extremely high.
>
> Nothing was adopted in the village because it was "good enough." It had to be the best obtainable . . . the best water works, the best schools, the best paving for the streets. With such high ideals, it is not strange that the village grew to be an exceptional place to live. As it grew in beauty, in comforts and advantages, the pride of the people in their village grew, too.

In 1923, the newly enacted plan commission created the first zoning ordinance and "Hinsdale Plan." The village's essential residential character was now protected by strict zoning regulations. The plan dictated that the retail and government core was to be developed harmoniously in the Colonial Revival architectural style. While design restrictions have vanished, the effects of this plan continue to be treasured, visible in the cohesive styling that links Hinsdale's public offices, schools, and retail buildings of the 1920s and 1930s.

The devotion of those who led or participated in Hinsdale's remarkable progress was considerable and offered without compensation, simply "for the good of the Village." Volunteer school boards insisted on quality education. Residents who believed a library was essential for a better educated community organized and donated the first collection. Determined, exceptional leadership also brought about Hinsdale's own electric plant, the Memorial Building, and the site and design of the post office. The village's growth, shaped by willing, capable, and generous hands, developed remarkably well.

John Linn was hired as Hinsdale's only policeman in 1888. One of his duties was to light the downtown kerosene street lamps. Linn, shown above, would make rounds on horseback in the evening to light the lamps and return the next morning to refill them. The number of lamps increased, and by 1899, Hinsdale needed a full-time lamplighter. Linn assumed this role, illuminating Hinsdale each night for over 20 years.

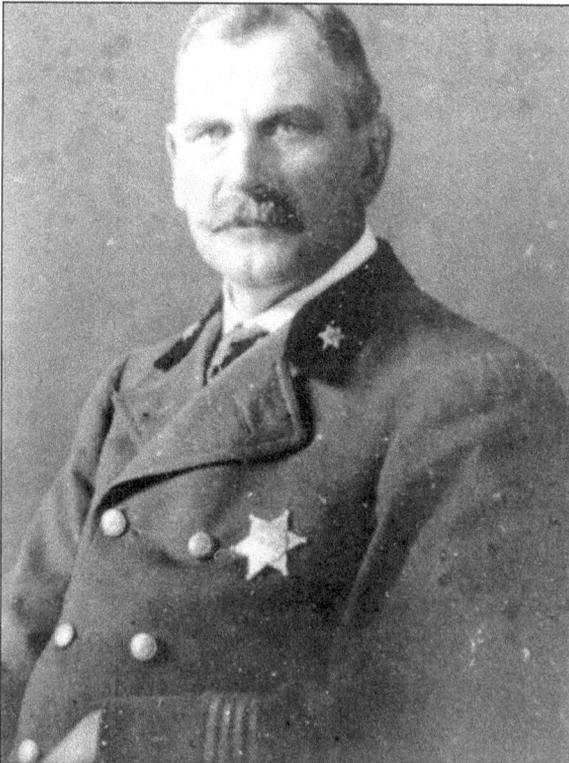

John Nicholson was named chief of police in 1902, a job he held for 24 years. A two-man force walked patrols, using bicycles or Nicholson's own horse when necessary. Automobiles began arriving in Hinsdale about 1903, and occasionally one would be appropriated to pursue a felon. It was not until about 1921 that Hinsdale purchased a vehicle exclusively for police work.

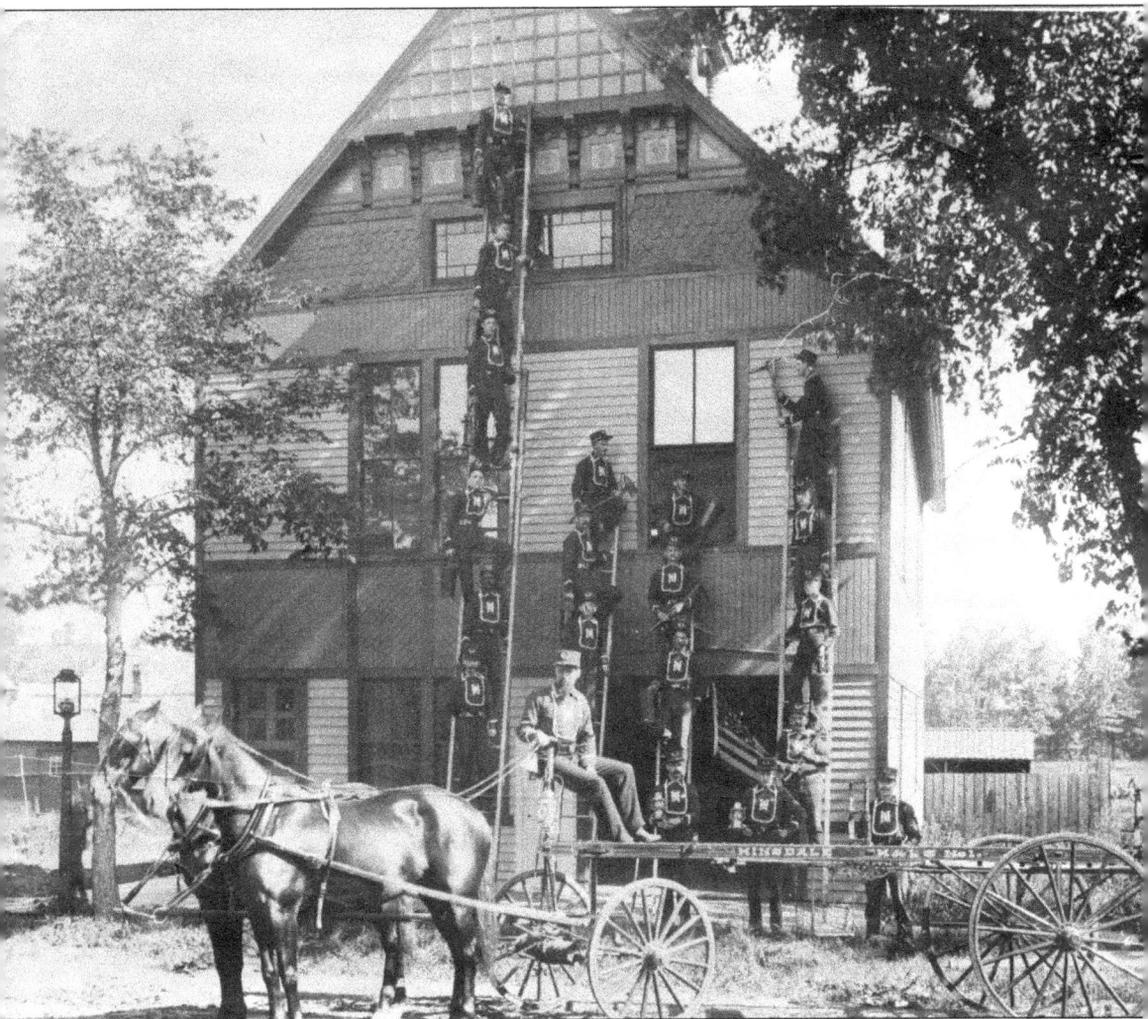

The fire department began as a group of merchants who volunteered to protect the wooden buildings in the downtown area. Later, a hose company and separate hook and ladder group were established, merging in 1893 to form the Hinsdale Volunteer Fire Department. This photograph of the hook and ladder group was taken in front of the town hall at 25 East First Street about 1890. Built in 1887, this building housed the village office, jail, and the fire and police departments. It was moved to the rear of the lot in 1934 to make room for the construction of the new fire and police station that took its place, occupied today by Hinsdale Bank & Trust.

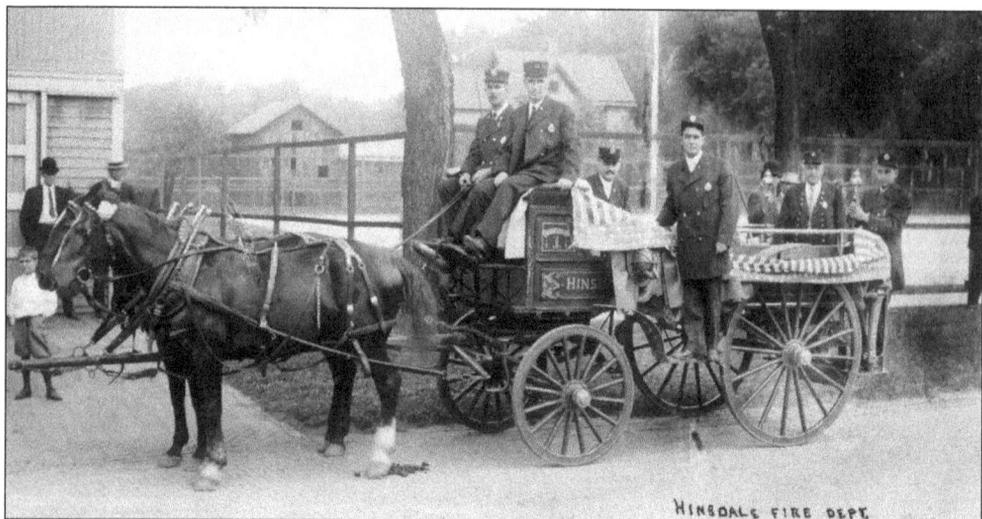

This 1905 image shows the fire department's hose cart ready for a parade. Before 1912, horses were not owned by the department. The first team to appear at the station after the fire bell rang was hired for $5. At the time, Hinsdale's funeral director stabled his horses downtown. Legend tells that these horses, trained to respond to the bell, once took off for the station during a funeral, pulling the hearse behind them.

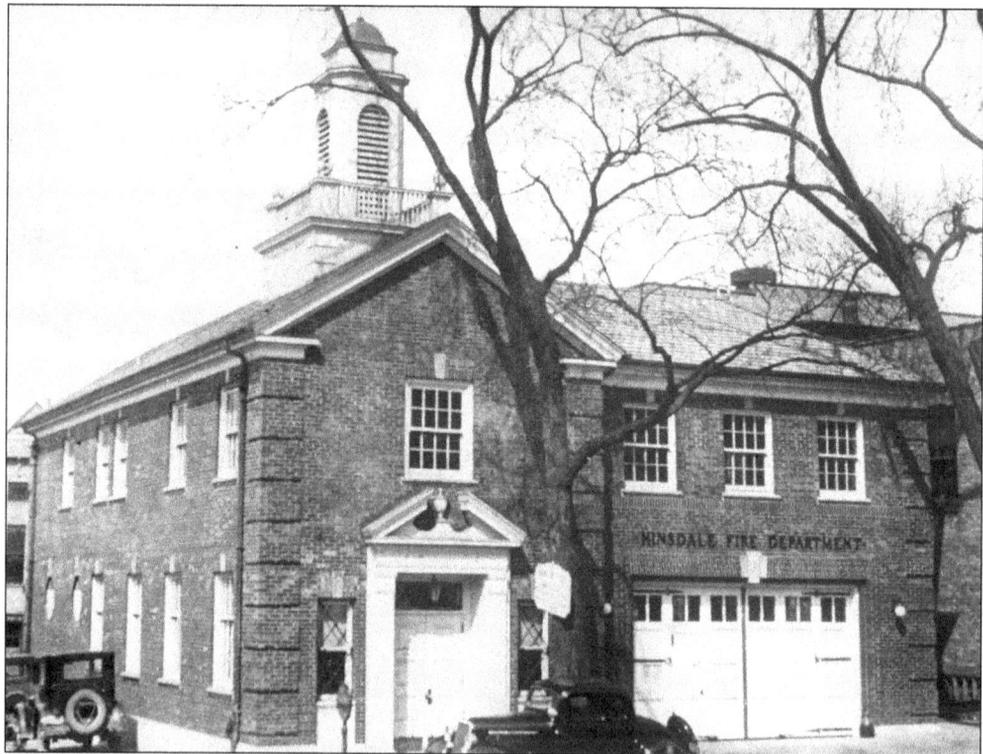

Built as a federal public works project in 1935, the police and fire departments moved into this new building at 25 East First Street designed by Hinsdale architect Harford Field. The building included a courtroom, jail, and an apartment for the police chief. Today the former holding cell's iron bars are used decoratively, mounted in the courtyard at the rear of the building.

While reincarnated over the years, a Hinsdale school has always been located at Third Street and Garfield Avenue. Two years after this building's 1866 construction, William Robbins sold it to the newly created Hinsdale School District. At that time it was renamed South Side School to differentiate it from the Fullersburg School farther north. This photograph shows the school after an 1879 addition, which doubled its size.

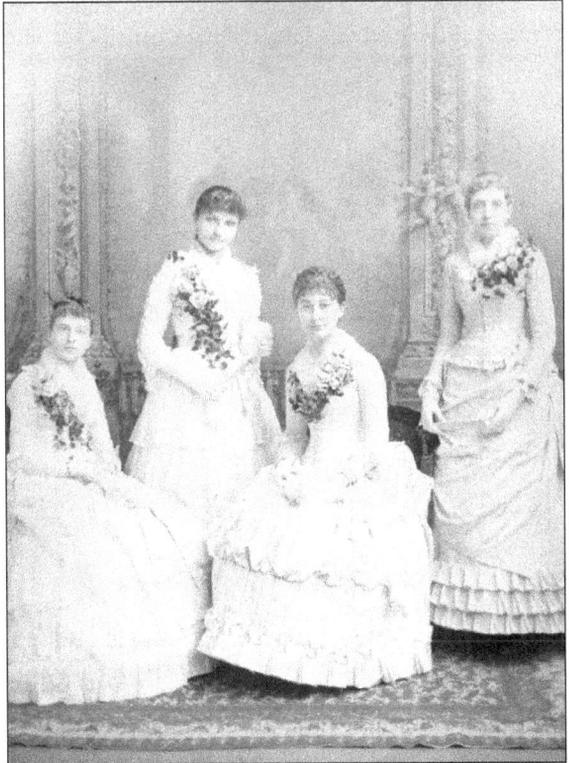

The additional space was needed in 1879 to accommodate increased enrollment and a new high school classroom, one of only four in DuPage County. As high school attendance was not mandatory, this photograph reflects the first, and entire, graduating class of 1883. From left to right are Alice Warren, Grace Redfield, Minnie Hinds, and Florence Webster.

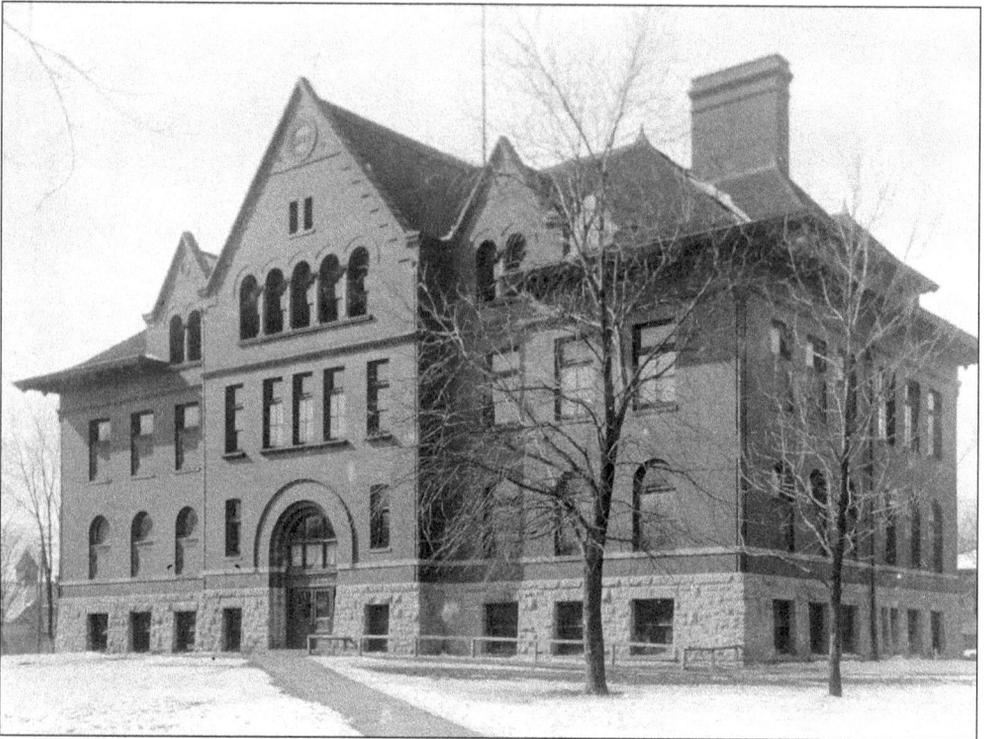

When the South Side School burned in 1893, classes were transferred to various churches and the village hall while this new school was under construction. Located at the same site as its predecessor, this school, later named Garfield, accommodated grades 1 through 12.

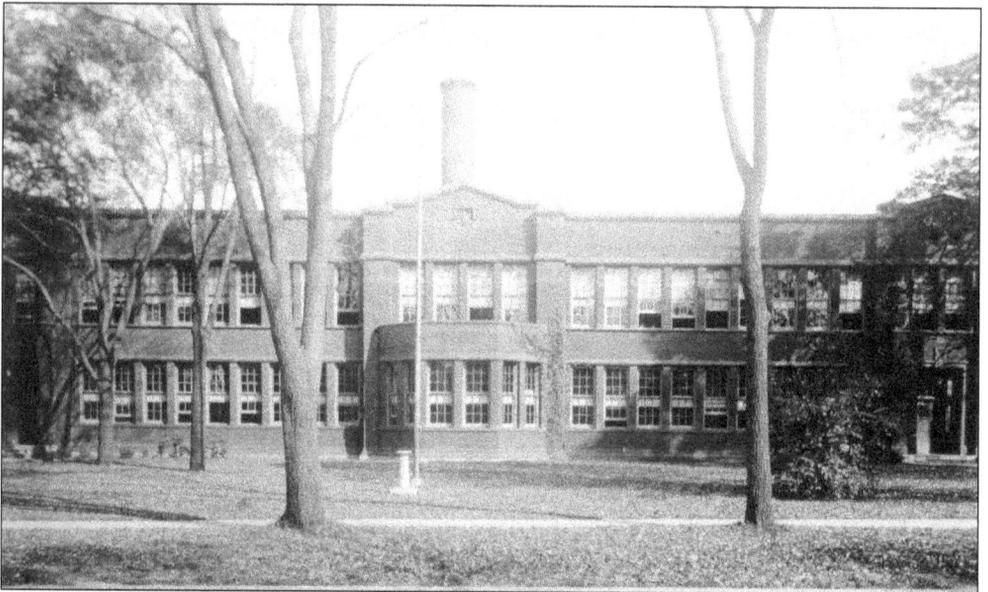

Completed in 1916 on Washington Street at Second Street, this high school building allowed the adjacent Garfield School to be dedicated solely to the lower grades. When the current high school was opened in 1950, this building served as a junior high until today's Hinsdale Middle School was completed in 1976. (Photograph by L.C. Harner.)

The high school gymnasium, shown here, was built in 1921 on Washington Street north of the high school. Spectator seating for 500 was accommodated on a second floor gallery that surrounded the court below. Beneath the stands, on the first floor, were the locker rooms and storage. This building was razed in 1976 along with the adjacent school to make room for the current Hinsdale Middle School.

Maple School, north of the tracks, was built in 1887 to ease crowding at the South Side School. Situated on Maple Street between Vine and Clay Streets, it closed in 1928 when Monroe School was built to replace it. Rehabbed in 1935 to serve as a junior high school, it functioned as such until 1950. It ended its service as the Monroe Annex, holding fourth- and fifth-grade classes. It was sold to a builder and razed in 1973.

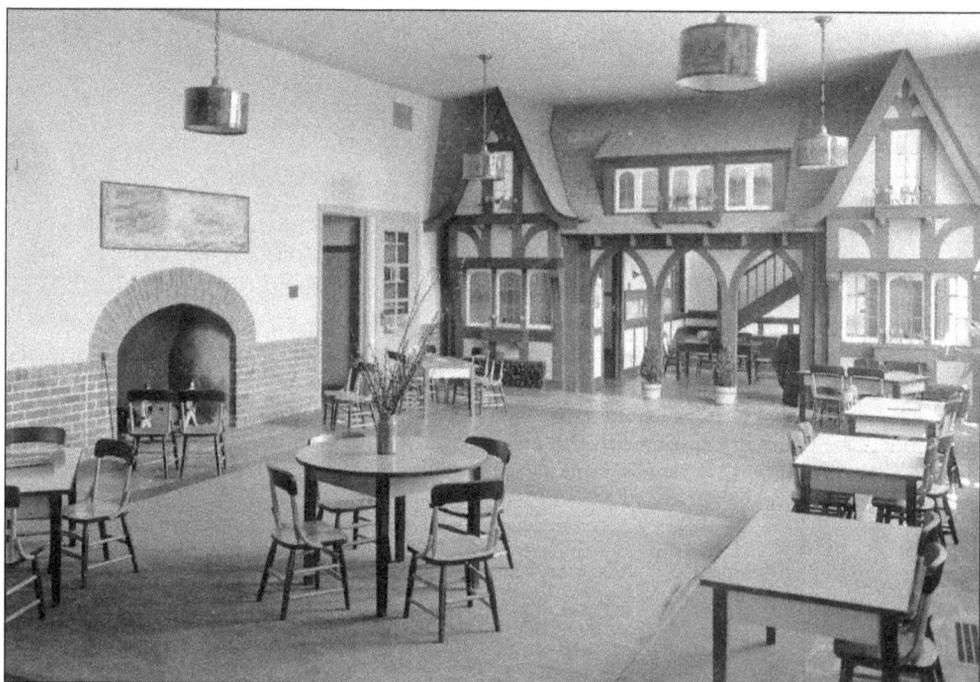

A state-of-the-art Madison School opened on the south side in 1925. Four years later, the equally equipped Monroe School opened on the north side, designed in the Tudor Revival style. Shown is the original, unique kindergarten classroom at Monroe, complete with fireplace and play loft.

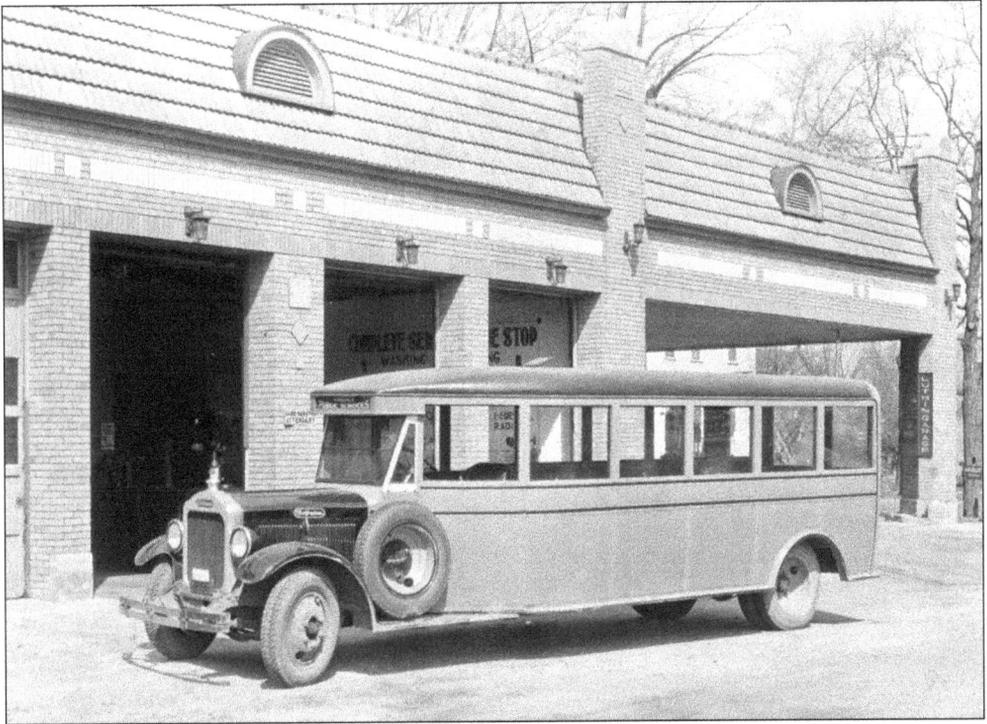

Busing also began in 1929, initially accommodating only the more remote Monroe School students. The first school bus, shown here, was a handsome Gotfredson model, a Canadian brand built in Detroit.

Although not employed by the public schools, teacher Matilda Hiatt, shown here, influenced the lives of many Hinsdaleans. In a small studio behind the family home at 206 North Lincoln Street, Hiatt opened a preschool in 1912 based on Montessori principles and conduct centered on "honesty, courtesy, unselfishness and order." The much-admired school closed in 1953 after 41 years of shaping the youngest Hinsdaleans.

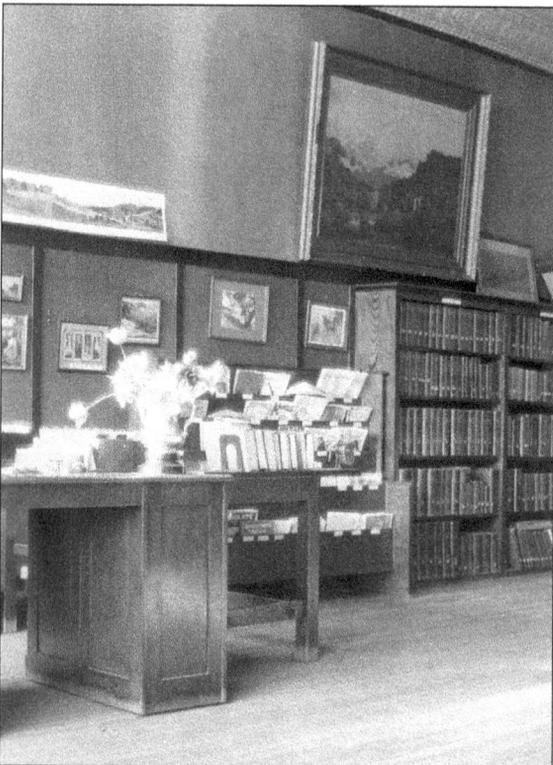

Founded as a private association in 1886, any "reputable" person could become a member of the Hinsdale Library upon payment of $1 annual dues. The original collection, primarily donated by residents, was shelved in this home of C.D. Snow at Washington and Third Streets. Mrs. Snow was one of the library's founders and also served as the first librarian. The photograph shows the Snow home at a later date, after it had been moved. It has since been demolished.

In 1892, the village voted to establish a tax-supported library. In spite of its limited hours of only three afternoons a week, Hinsdaleans borrowed books 6,300 times in its first year of operation. The last of the library's 11 temporary locations is shown here, 104 South Washington Street, where it remained for 12 years before moving to its permanent home in the Memorial Building in 1929.

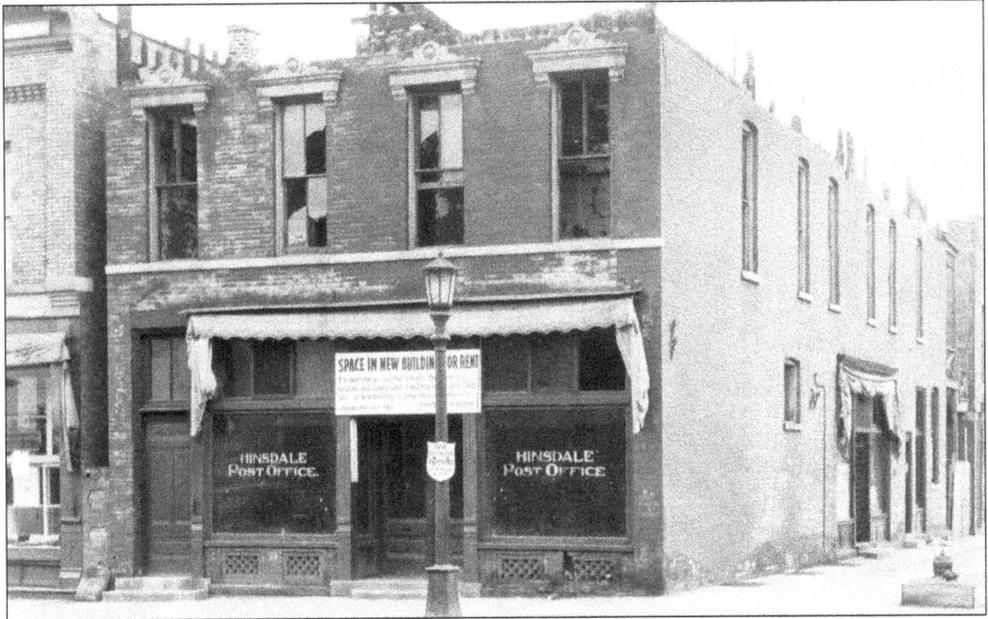

Established in 1867, the Hinsdale Post Office moved frequently about the downtown before settling at 53 South Washington Street about 1894. Residents had to pick up their mail; home delivery did not begin until 1906, when carriers made three rounds daily throughout the village. The photograph shows the Washington Street location after it, but incredibly not any of the mail, was destroyed by fire in 1926. (Photograph by L.C. Harner.)

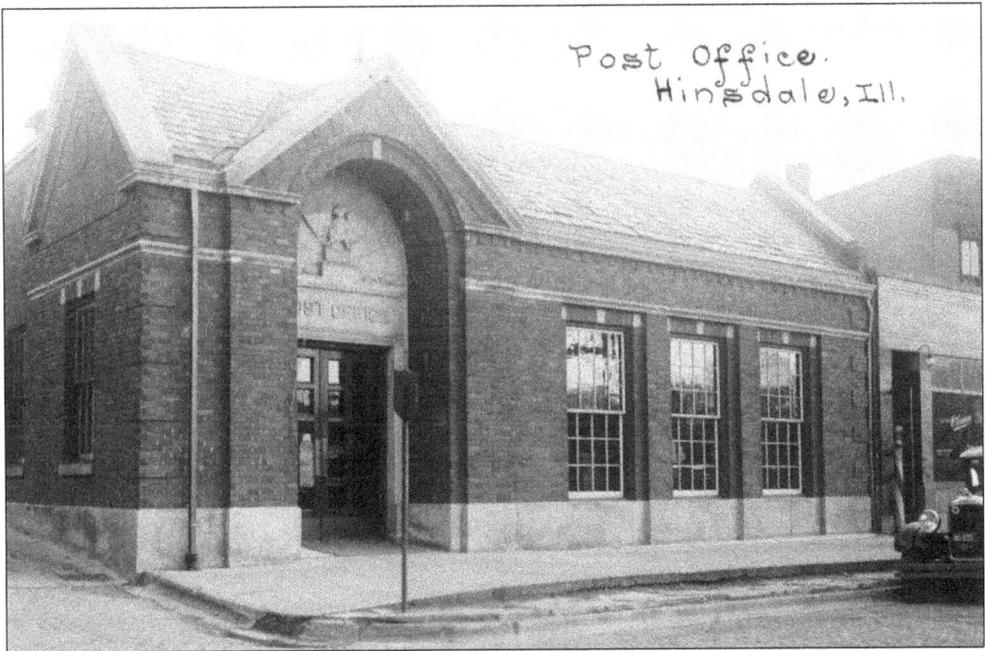

This 1927 post office, designed by Hinsdale architect R. Harold Zook at 14 West Hinsdale Avenue, was built to replace the burned out Washington Street structure. Unfortunately, this handsome site was outgrown about 10 years after its construction. The building still stands, though drastically altered. A remnant of the original roofline can be found in the alley facade.

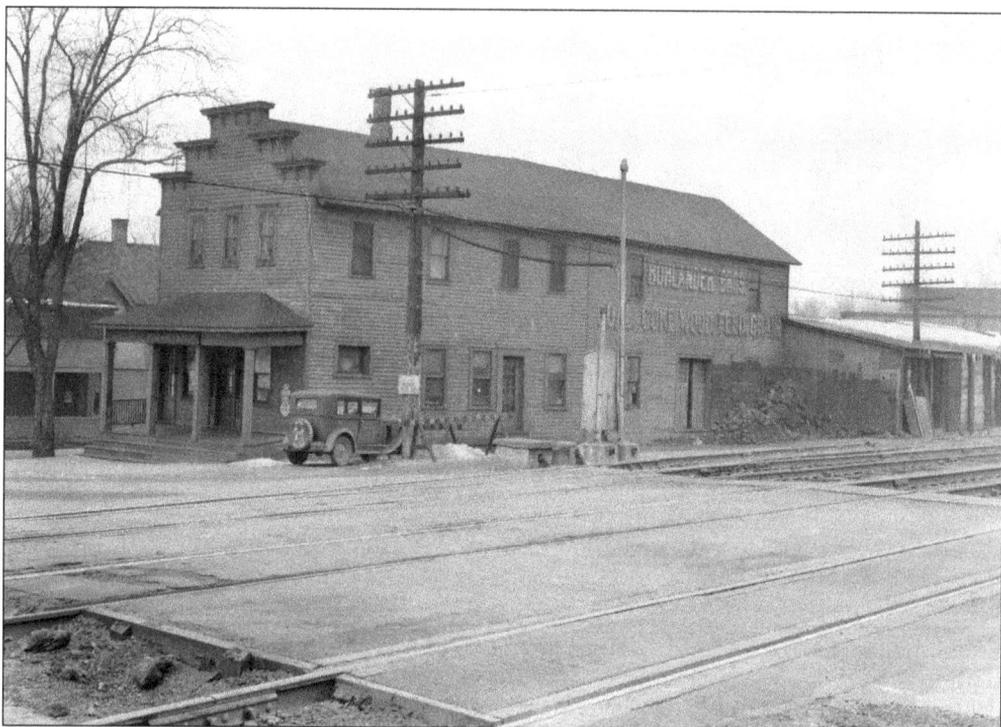

Through some difficult maneuvering, the site of the current post office was secured in 1937. The Bohlander brothers' coal yard, shown here, occupied the property at the time. The project was championed by village president William Regnery, who personally donated a portion of the funds to obtain the site for the new facility. (Photograph by L.C. Harner.)

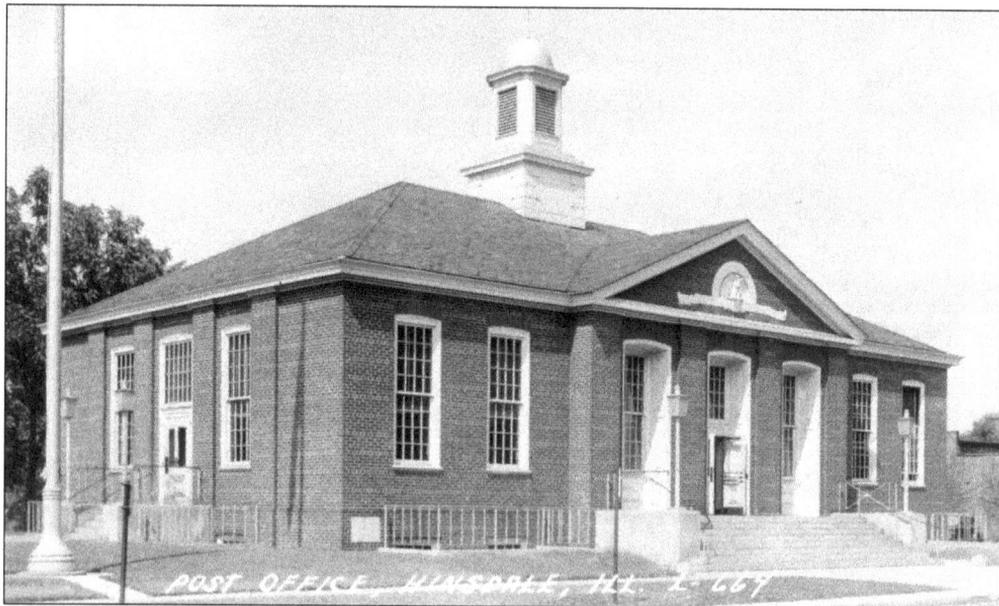

With the blessing of Hinsdale's plan commission, Regnery and others traveled to Washington, DC, in 1939 to persuade the Federal Works Administration to design the building to harmonize with Hinsdale's Memorial Building. With their effort successful, the stately building opened in 1942.

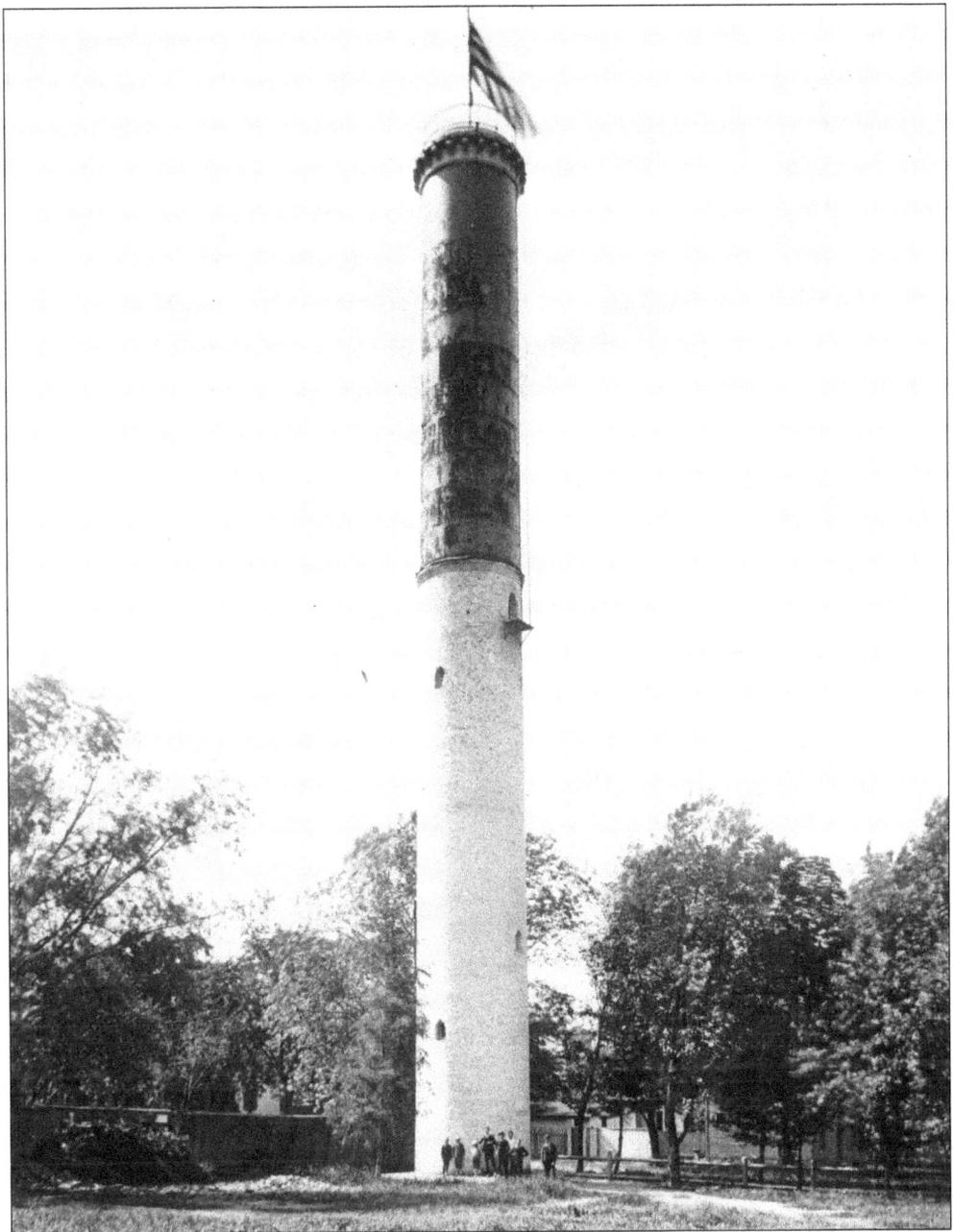

Cisterns, pumps, and outhouses handled Hinsdale's early water and sewage demands. During the 1890s, the village drilled wells, laid 11 miles of pipe, and installed the public water supply system, crowned by this 116-foot tower of brick and steel. The tower was located between Garfield Avenue and Washington Street, north of Third Street. Eventually the tower became obsolete and was razed in 1926. Generous, civic-minded resident John C. Ross donated land just north of the railroad tracks for the first pumping plant. When completed about 1892, the system was commended for its pressure and water purity. A complement to the water plant was Hinsdale's ice company, opened in 1920 as the first municipally owned ice business in the United States. For 20 years, Hinsdale manufactured, sold, and delivered ice to those without electric refrigeration.

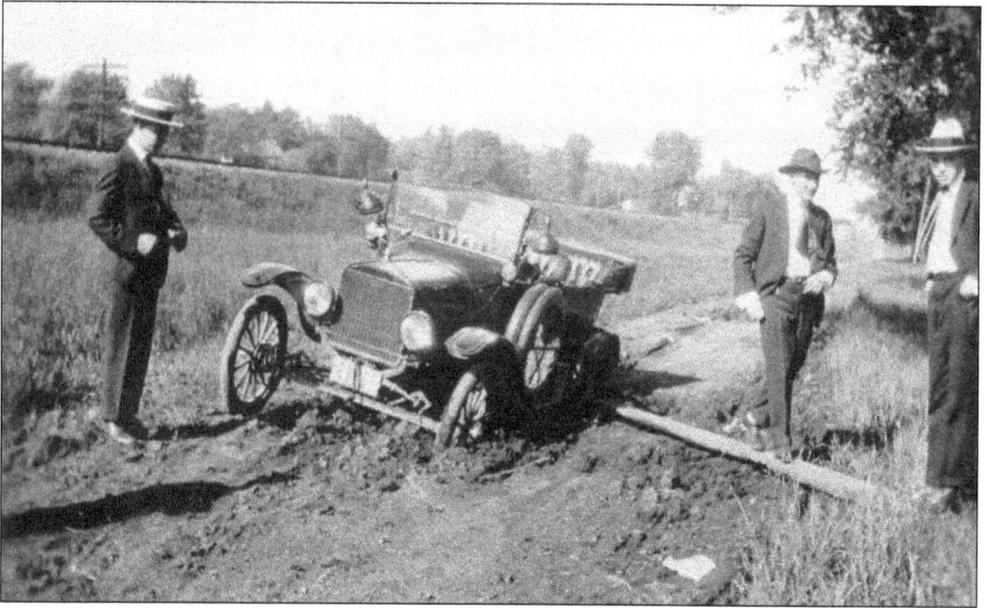

Hinsdale's early dirt roads were difficult to travel. Wet weather buried wheels in mud, dry spells produced clouds of dust, and ruts were a year-round problem. This photograph shows a car stuck on muddy Hinsdale Avenue. The village began paving Hinsdale streets in 1892, using brick or wood blocks. A few of these hand-laid brick streets, well over 100 years old, remain in the village.

Before Hinsdale was incorporated, sidewalks were private projects. If a homeowner wanted one, he had to build the wooden walk himself. After the 1873 incorporation, walks were a popular public improvement; in 1878, the village's largest expense was for sidewalk nails.

54

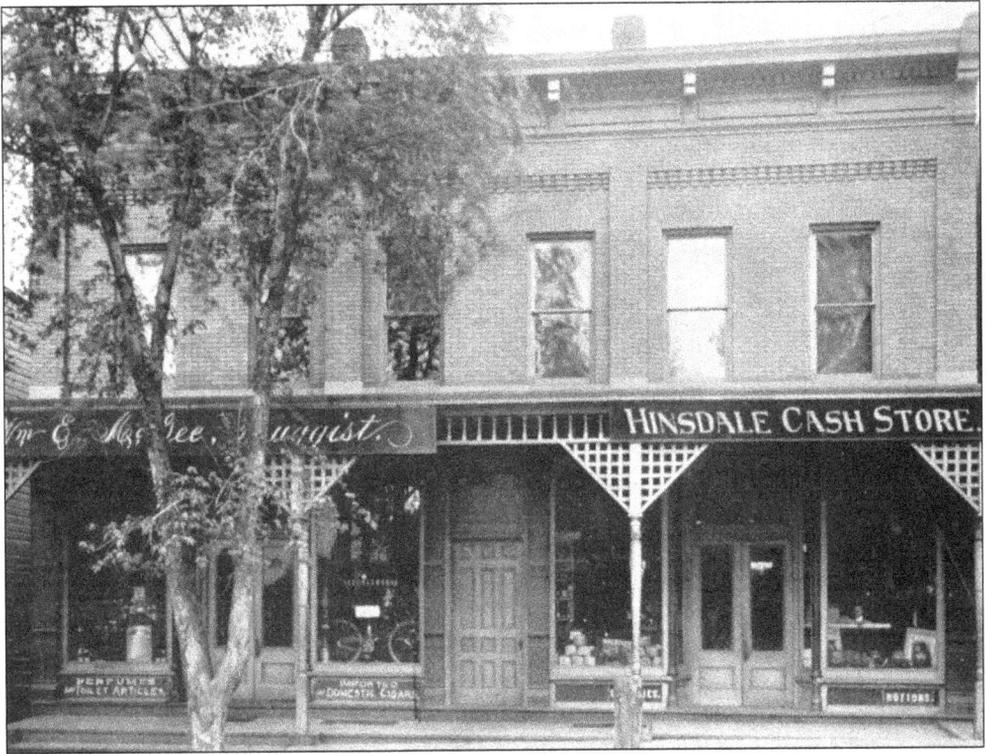

Telephone service had been available in Chicago since 1878, but cautious Hinsdale village boards questioned the telephone company's mandatory long-term contract. Finding agreement in 1894, the first telephone was installed at McGee's Drugstore at 49 South Washington Street, pictured here. Calls would come in, answered by boys eager to deliver messages. When the store closed, phone service was also shut down . . . and this was the only telephone in town.

About two years later, in 1896, telephones were at last available to private homes. The switchboard, however, was open only from 7:00 a.m. until 9:00 p.m. In 1900, one operator was employed to handle the 333 calls per day; by 1909, these operators handled more than 3,000 daily calls.

Early homes and businesses relied on kerosene lamps to provide their lighting. In 1894, Hinsdale wanted to offer its residents electricity, but with several public improvements ongoing, it had issued its statutory limit of public works bonds. In an extraordinary move, village president J.C.F. Merrill, pictured here, organized a consortium of resourceful residents and formed a privately held power company, Hinsdale Light and Power.

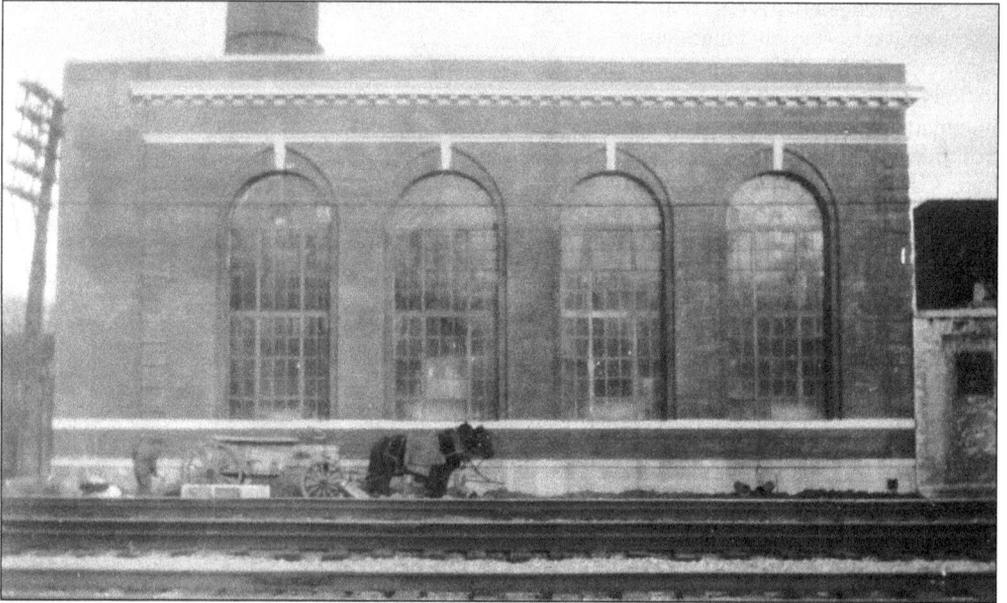

The village granted the power company a franchise and donated land for the plant north of the tracks, east of Garfield Avenue. Western Electric, then chaired by Hinsdale resident Enos Barton, was the lowest and winning bidder on the plant and power line construction. The newly completed plant is shown here in 1896.

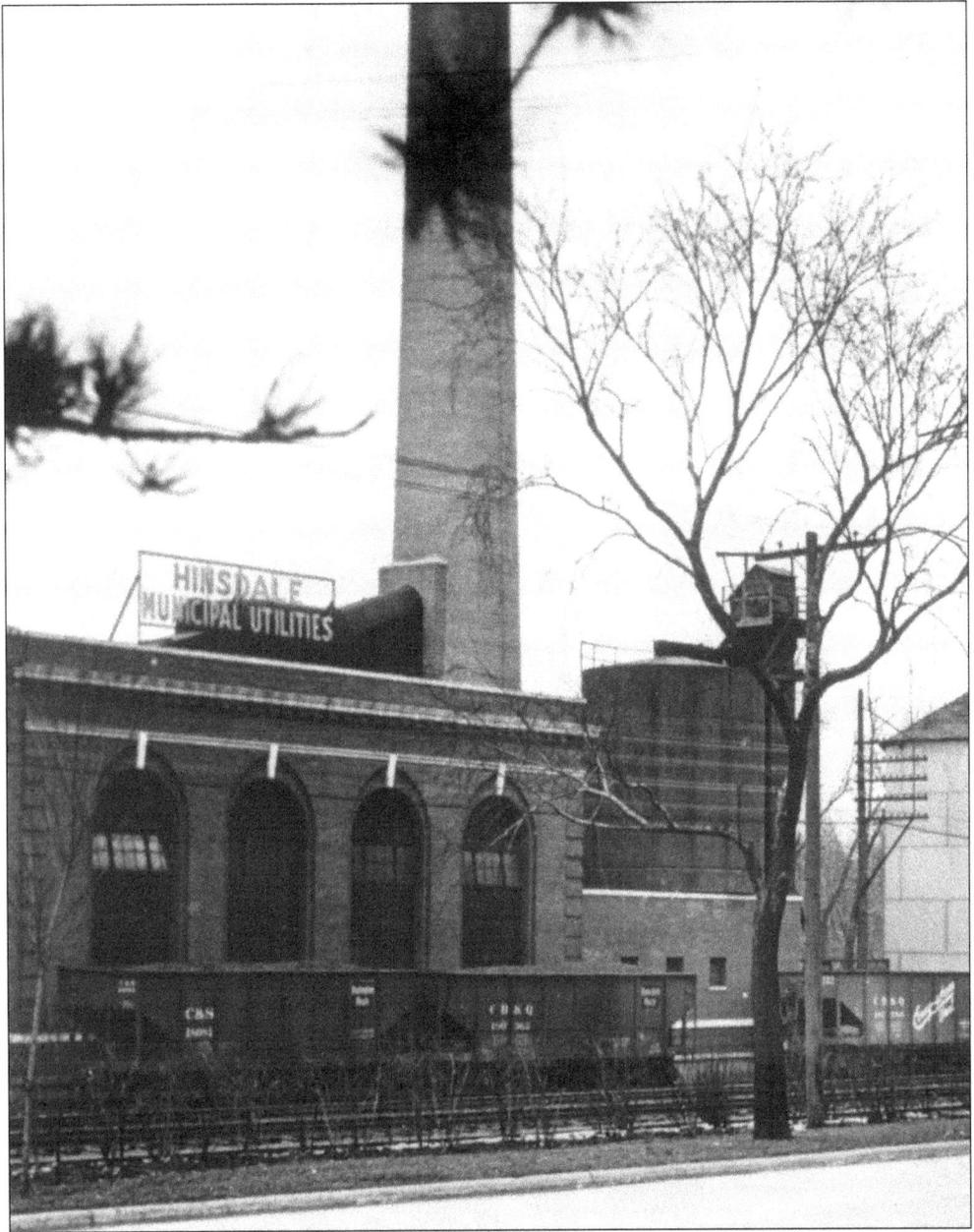

After construction was finalized, the company was sold to the village for the assumption of its debt plus $1. Hinsdale Light and Power began operation in 1896, "the final link in the chain of improvements that brought Hinsdale to prominence as the foremost of Chicago's suburbs." Electricity was available two hours in the morning and three in the evening. After a second generator was installed in 1905, service was available 24 hours a day. Always profitable, the company added significantly to Hinsdale's corporate fund over the years, at times keeping the village in the black. In 1955, needing major improvements, Hinsdale's municipal power plant was sold to Commonwealth Edison for $1,430,000. Five years later, it was demolished.

Hinsdale's first public landscaping endeavor took place at Burlington Park. After the railroad granted use of the site in 1877, fencing and evergreens were installed. When the new depot was built in 1899, the village acquired the remainder of the block, setting the stage for walkways and flower beds to showcase Hinsdale's "front yard." In this early photograph, Flagg Creek, covered in 1934, is still visible on the right.

This image of Burlington Park shows a low, circular fountain installed in 1934. Lit with white and colored lights, the fountain was part of a Public Works Administration improvement project. Removed about 1940, the fountain returned, in a different style, some 60 years later. (Photograph by L.C. Harner.)

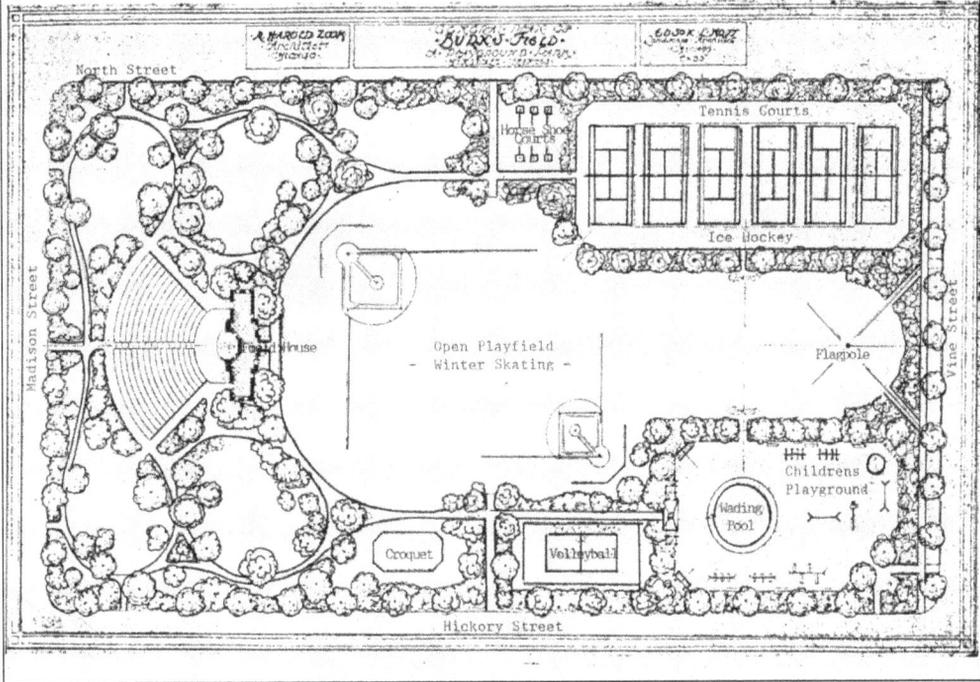

ARCHITECT'S PLAN FOR BURNS' FIELD DEVELOPMENT.

Burns Field, designed by Edson Nott and local architect R. Harold Zook, was built with few changes from this 1932 plan, the first Hinsdale park with recreational facilities. Public Works Administration funds and Works Progress Administration labor were used for its completion with local men hired for the work.

A recently completed Burns Field is shown in this 1938 photograph. The park was named for village president Randall Burns who died in office, stricken at a village board meeting.

Alexander Legge, president of International Harvester, and his wife Katherine purchased 52 acres on south County Line Road in 1915 for use as a summer residence and farm. After Katherine died suddenly in 1924, Legge dedicated this property in her name for use as a retreat by the female employees of Harvester.

The K.L.M. Lodge, a dining and recreation hall for the women's retreat, was built in 1926. It was designed by Hinsdale architect R. Harold Zook based on an earlier plan for the Legge home intended for the site. A dormitory followed, along with tennis courts, swimming pool, and a convalescent cottage. In December 1973, International Harvester donated the retreat property to Hinsdale for use by the general public.

Four

THE NECESSITIES AND LUXURIES OF LIFE

Hinsdale's first retail business opened in 1866, a general store located at the southeast corner of Washington Street and Hinsdale Avenue, the site of the current Starbucks. Soon to follow were shops providing residents' needs, grocery and general stores predominating. Early commercial areas typically developed opposite railroad stations, and Hinsdale was no exception with its original Washington Street depot.

"When the automobile became a significant force in the early decades of the 20th century, car dealerships and gas stations opened on the edges of this core," notes the 2003 Hinsdale Resources Inventory. "Next, the need for larger government service buildings resulted in development crossing the tracks to the north where these uses are now clustered." Fortunately, these expansions left the historic downtown undisturbed. Hinsdale enjoys a quaint, well-maintained retail atmosphere with a majority of storefronts dating to the late 19th and early 20th centuries. More recent commercial developments also spared the original core: Grant Square north of the railroad tracks in 1954 and Gateway Square in 1985, off Ogden Avenue within what was once Fullersburg.

What were not to be found in Hinsdale were taverns. Liquor sales by the glass were prohibited in the village since 1878. The laws and ordinances were challenged numerous times over the years, and illegal beer peddling and clandestine beer "depots" appeared in spite of heavy fines. The majority of villagers were steadfastly against liquor sales, reinforced by the editorials of the *Hinsdale Doings*: "Saloons would depreciate the value of property and injure the village as a suburban residence . . . contaminate the moral atmosphere and hinder the progress of the community."

To circumvent the law, a beer seller set up shop just outside the village limits on Chicago Avenue across the county line. At times, his customers would wander back into Hinsdale to consume their purchases, getting rowdy and disturbing the quiet neighborhood. Irritated County Line Road resident Ralph Peirce arranged to have the area around the shop annexed to Hinsdale in 1917, eliminating the problem. Beer, therefore, is the reason Hinsdale has the unusual distinction of straddling two counties. It was not until 2001 that liquor sales were permitted within the village limits.

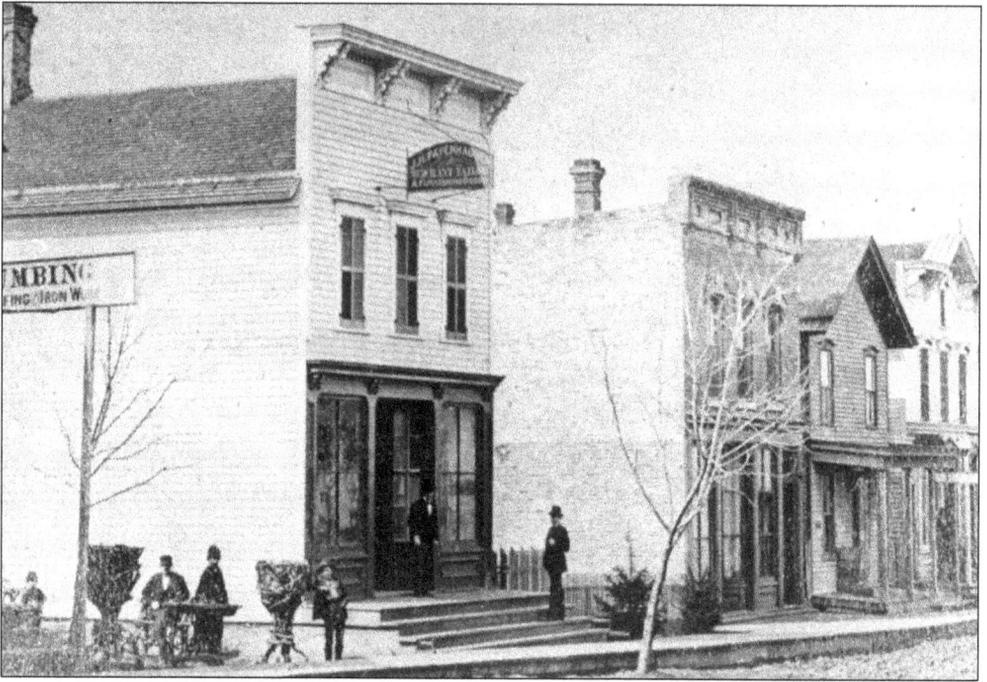

Long, narrow 25-foot lots accommodated Hinsdale's early storefronts. Most were built of wood and some had false fronts, characteristics of retail buildings across the country before 1900. This photograph, taken in the late 1870s, shows the west side of Washington Street from First Street, looking north. None of these buildings are standing today.

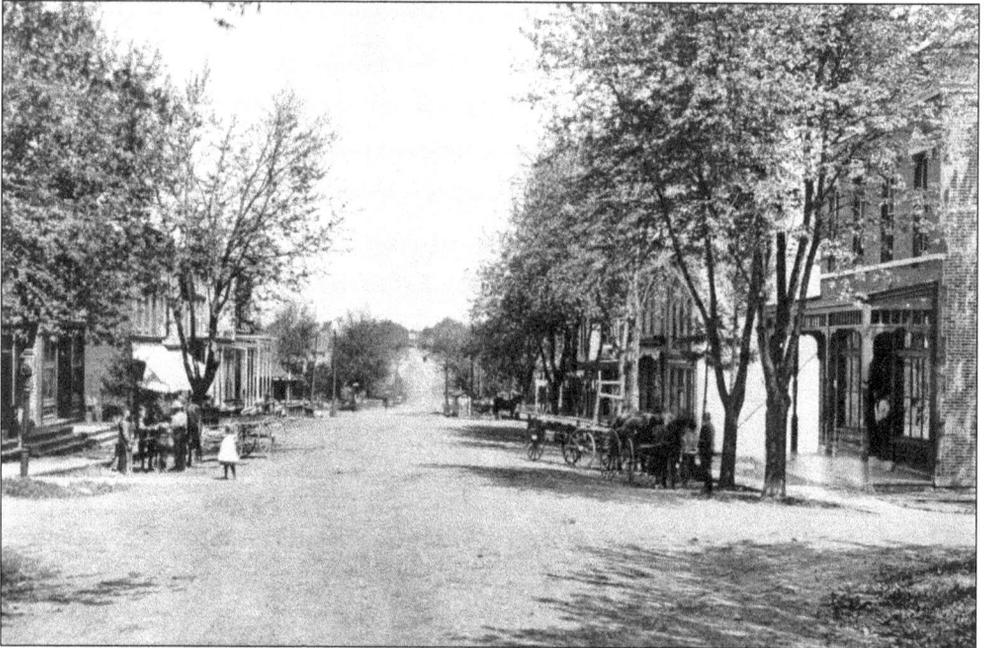

This scene, also looking north on Washington Street, was taken about 10 years after the previous photograph. The trees are the most obvious change but also the number of buildings and general activity on the street. On the left is one of the downtown's kerosene streetlamps.

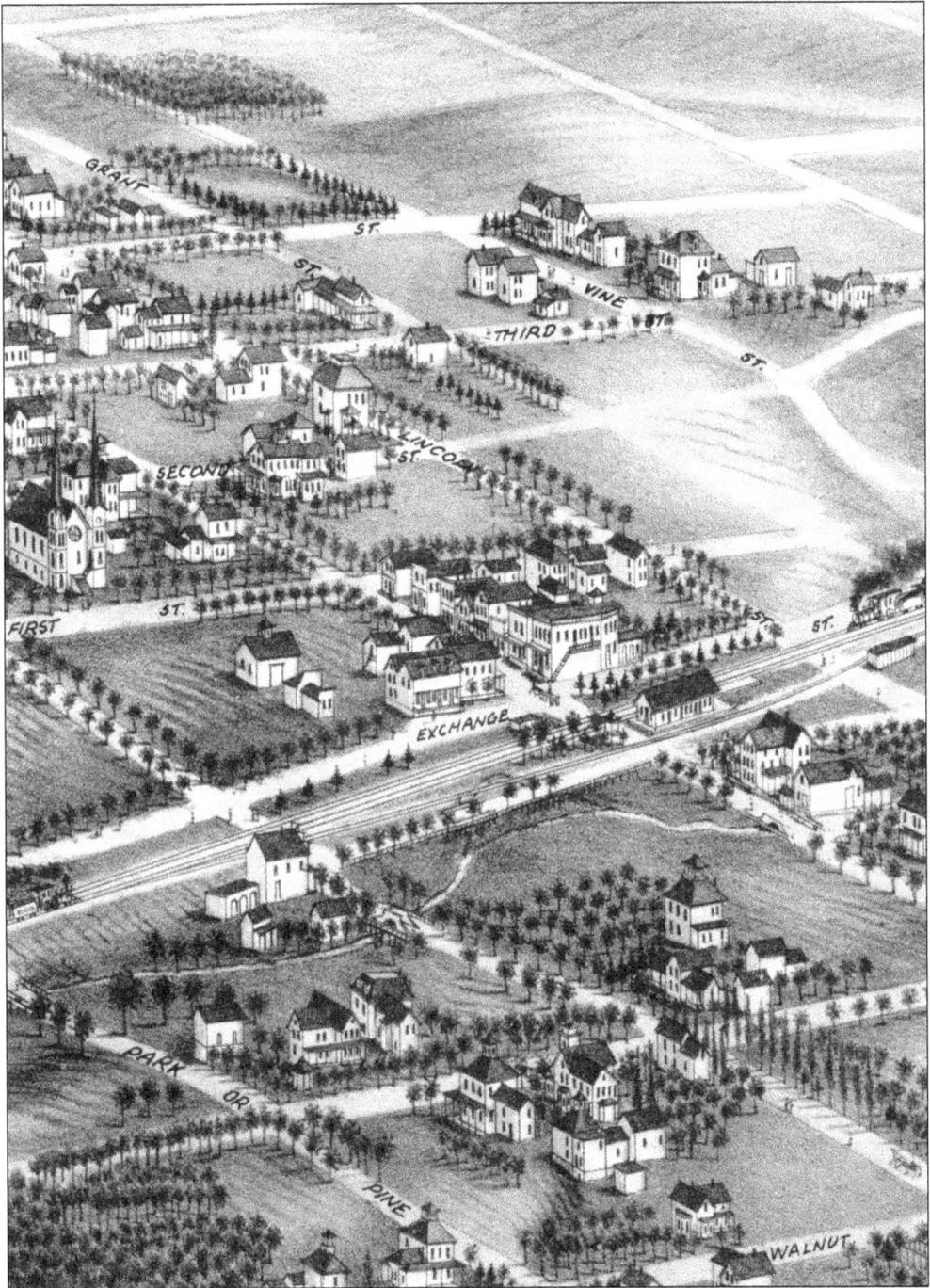

To promote real estate sales in Hinsdale, developer O.J. Stough published an amazingly precise pictorial map in 1882. While the map includes the entire village, this enlargement focuses on the downtown area. Configured looking south, the train station is at its original Washington Street location with the hotel directly north on the same street. Flagg Creek runs through what is to become Burlington Park, and Exchange Street is now Hinsdale Avenue. The Baptist church is at the far left.

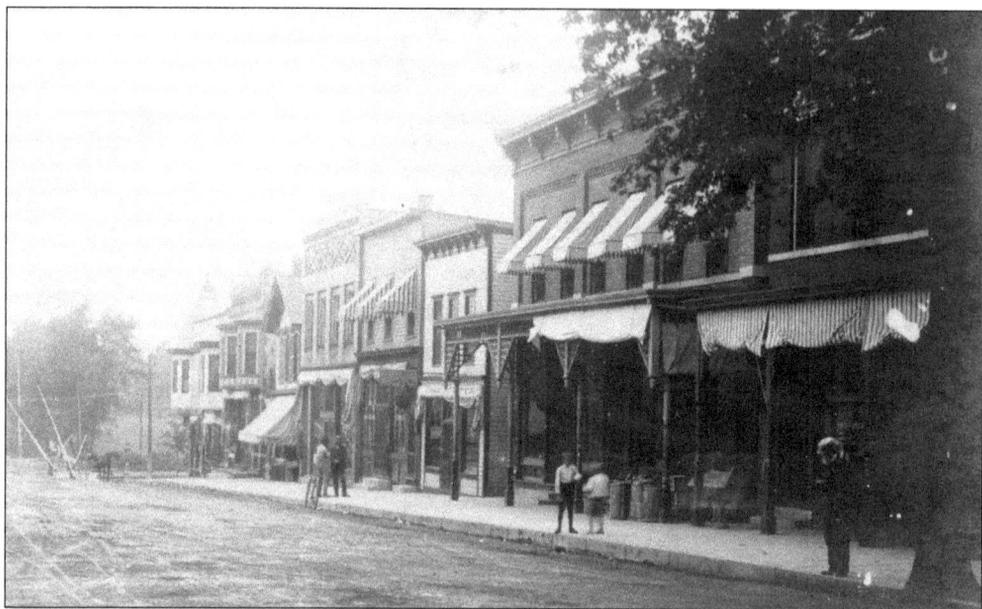

The east side of Washington Street around 1902 reveals several stores still familiar in 2012. The shorter, light-colored frame building in the center of the photograph was built in 1881. It is the oldest building standing in Hinsdale's downtown, now the home of Phillips' Flowers, at 47 South Washington Street.

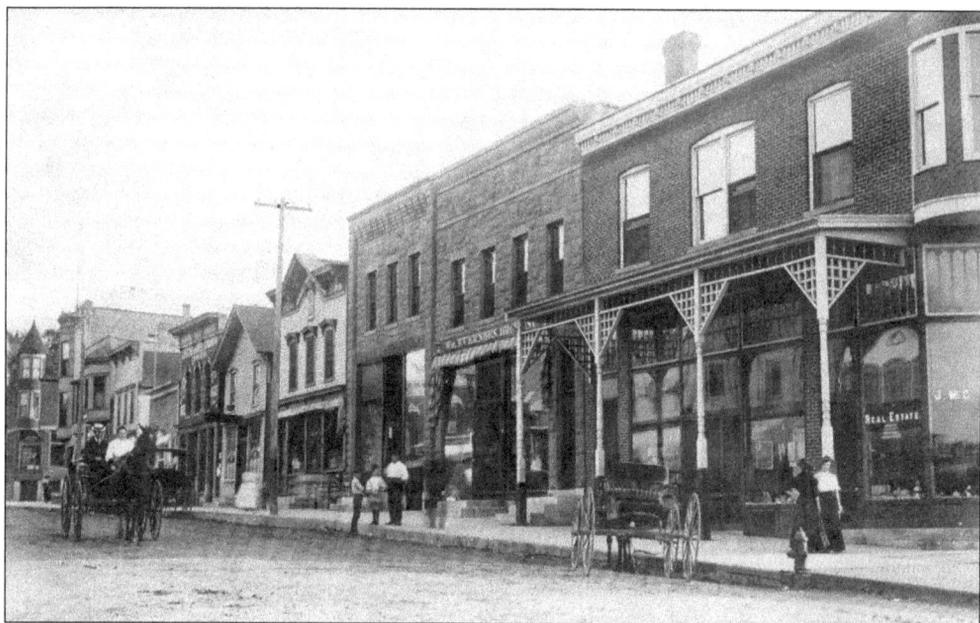

The west side of Washington Street around 1895 includes several buildings still standing in downtown Hinsdale. From right to left, the 1891 corner building remains, although remodeled; the two adjacent Joliet limestone storefronts, both built in 1894, also stand today. Barely visible at the south end of the block is the familiar round oriel bay window of the corner building.

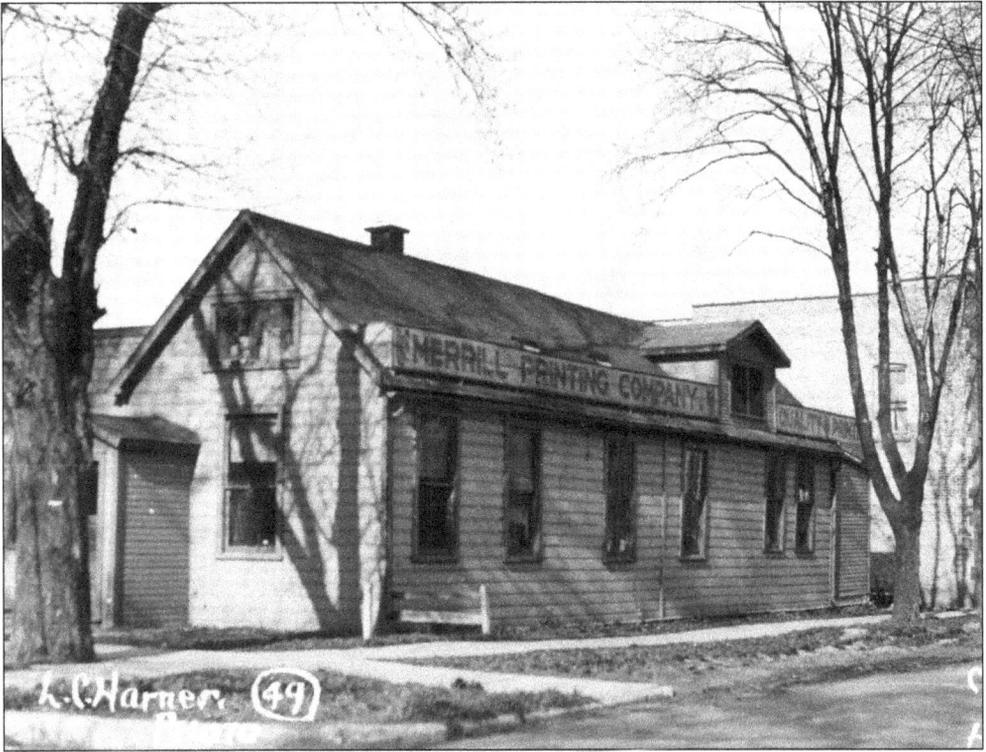

While Hinsdale had seven newspapers over the years, the one with longevity was the *Hinsdale Doings*. Started by precocious 17-year-old Dan Merrill in 1895, it remained privately owned until 1999. Merrill's *Doings* was printed at his father's company, shown at Lincoln Street and Chicago Avenue. (Photograph by L.C. Harner.)

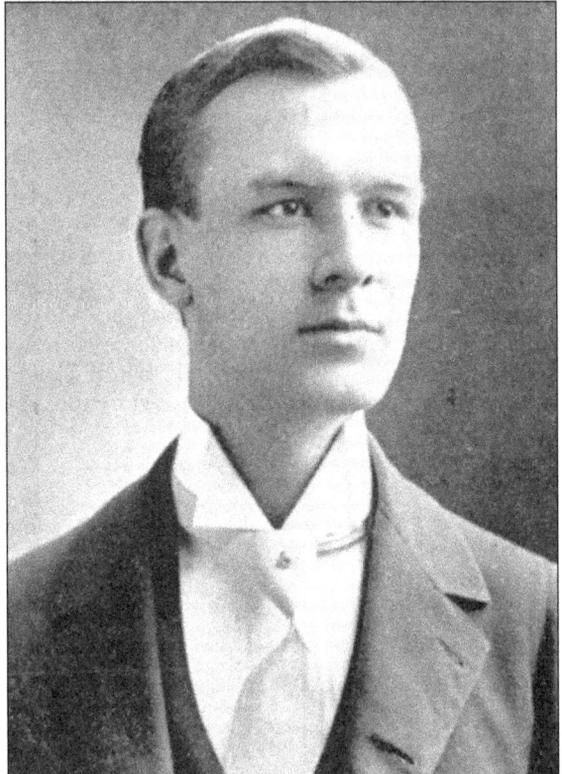

Merrill's first editorial read, "With this number, *Hinsdale Doings* begins its existence. How long and how successful that will be, the publishers do not know. Bold, fearless and independent is our battle cry . . . ever on the right, never catering to wealth or power, ever the champion of the people." Merrill, shown here, ran the extremely successful newspaper for 35 years until his sudden death of a ruptured appendix.

65

Centered in this c. 1935 photograph of east Washington Street is a frame building constructed in 1872. That year, Hinsdale's first physician, Jerome Merrick, established his practice at this location with his family living above his office and drugstore. Too busy with his growing practice to continue the store, Merrick sold the business to his clerk, William Evernden, in 1875. In the 1930s, the building was moved to 210 South Clay Street where it still stands, remodeled as a residence. King Keyser Sporting Goods currently occupies the site.

Evernden, standing on the far right in the c. 1900 photograph above, completed a pharmacy course at Rush Medical College and operated the drugstore for 45 years. In 1894, he built the store shown at right that still stands at 40 South Washington Street. The store became a haven for the young men of the village, with Evernden always ready to offer conversation and fatherly advice. Upon his retirement in 1920, many of the men who grew up spending "more time in his store than at home" honored him for his lifelong friendship.

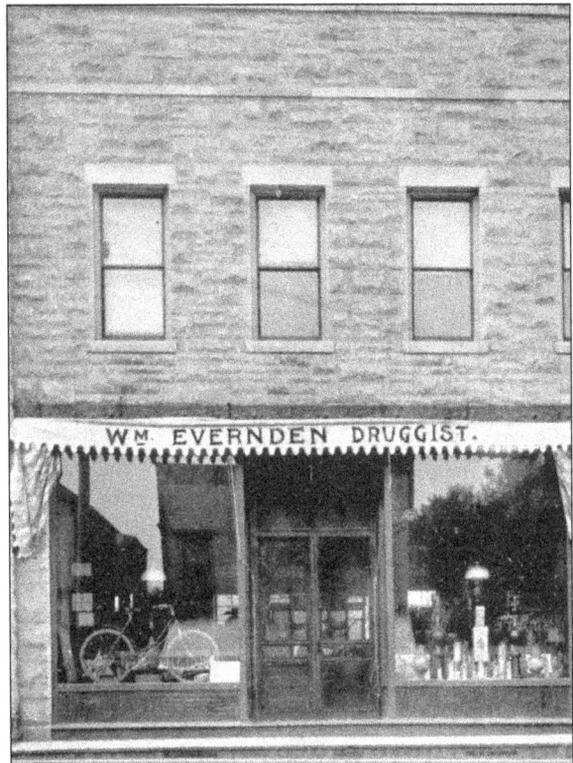

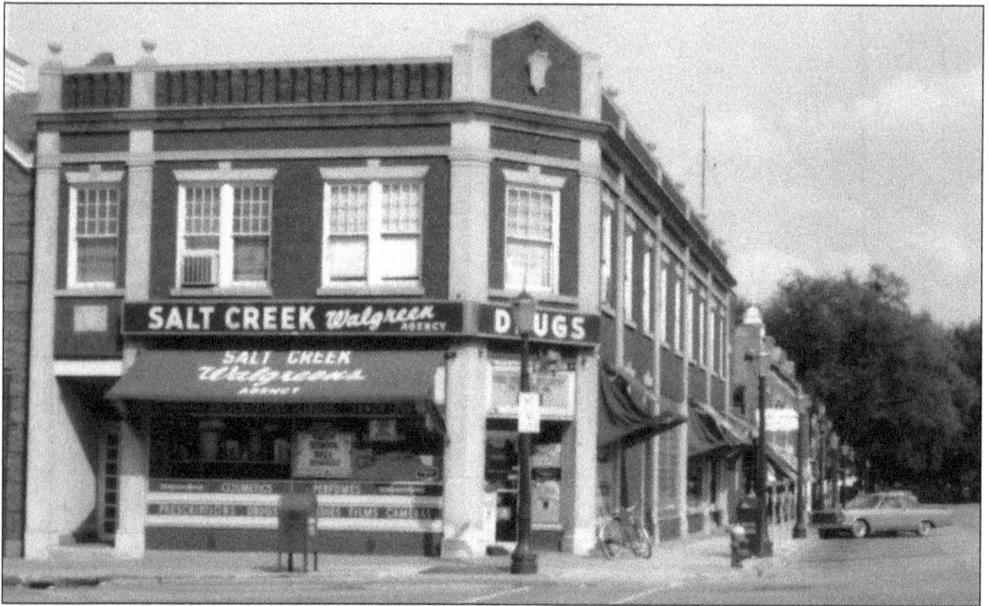

Dr. Merrick's and Evernden's original 1872 drug store changed ownership and locations twice before Walgreens bought the business in 1935. It remained at this First and Washington Street location until closing in 1973. It was not until 1986 that Walgreens again had a presence in Hinsdale.

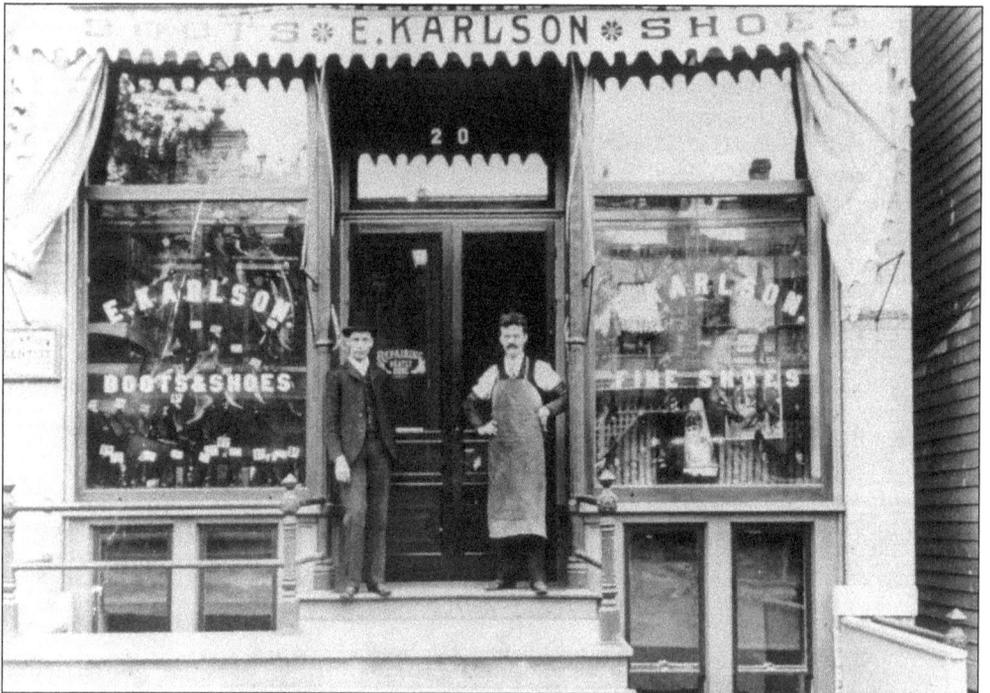

Swedish shoemaker Emanuel Karlson established his boot and shoe business in Hinsdale in 1895. Three years later, he moved to this newly erected storefront at 52 South Washington Street where the family business remained for over 80 years. Known for fine custom, handmade shoes, Karlson's was one of the first shoemakers in the Chicago area to also sell national brands. With a subsequent tenant continuing the tradition, this location housed a shoe store until 2009, for 111 years.

In 1888, German-born John Papenhausen had this building constructed to house his successful tailoring business. The second floor was home to the Papenhausens and their six children. This was the first commercial structure built on the south side of First Street.

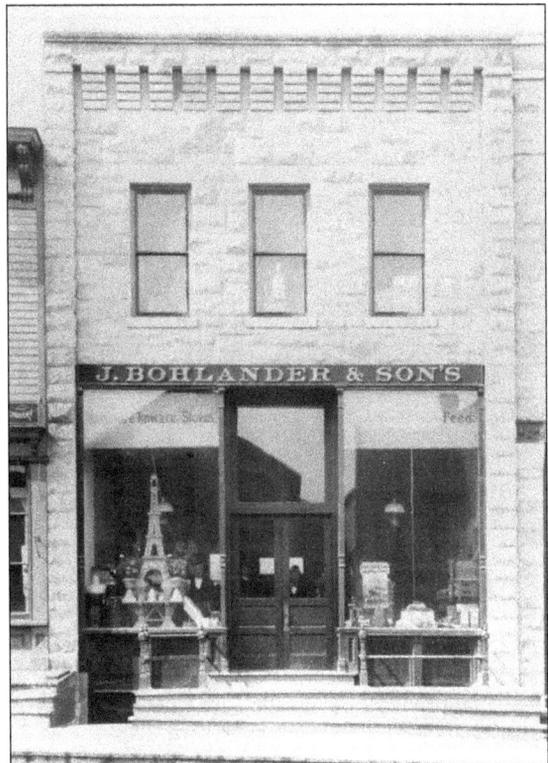

One of the area's first merchants, John Bohlander opened a grocery and tavern in Fullersburg before moving to Hinsdale in 1871. Here, he operated a general store at 42 South Washington Street before his business turned to hardware in 1877. Shown is Bohlander's second building at this address, constructed in 1894 of Joliet limestone. The business eventually changed hands, but hardware was sold in this building for over 100 years.

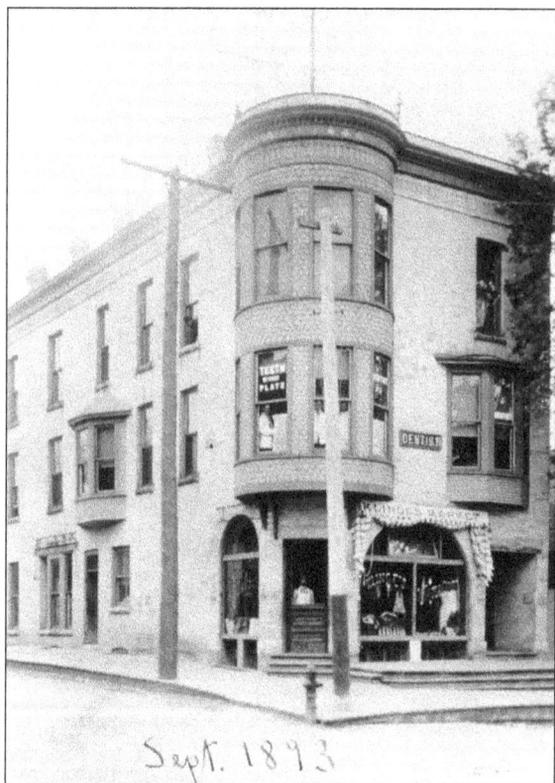

This building at 54 South Washington Street was built in 1892 replacing an earlier blacksmith shop. Reineke's Grocery occupied the site from 1904 until closing in 1974 as one of Hinsdale's oldest and most popular businesses.

Sept. 1893

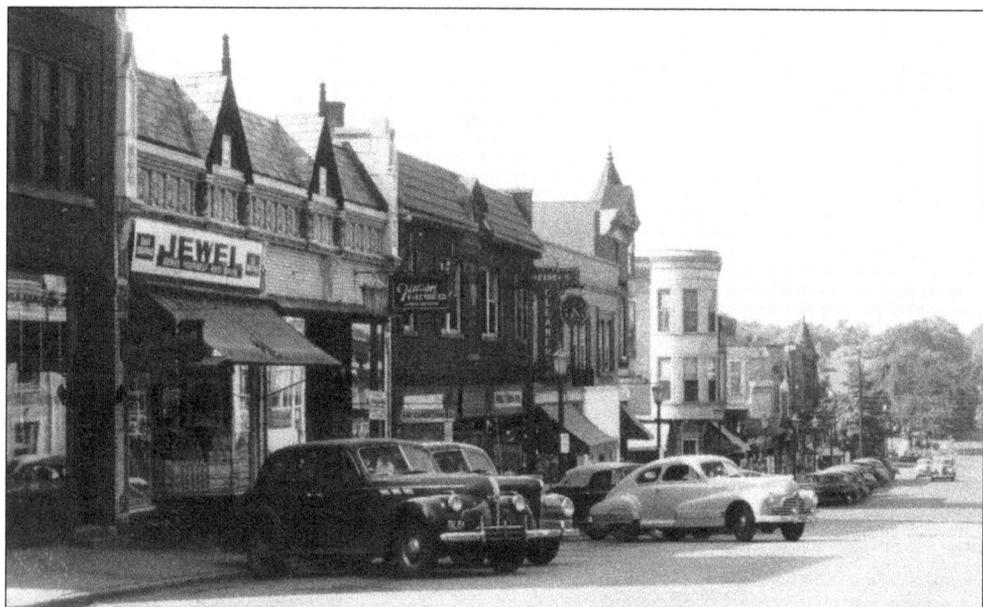

Built in 1929 at 114 South Washington Street to house the Loblaw Groceteria, this later became one of the first Jewel food stores in the chain. Loblaw stores featured a new concept of "self-serve" rather than clerks gathering orders to be delivered later that day. With customers browsing, selecting their products, and carrying them home, costs were significantly reduced. The original "groceteria" name was derived from "cafeteria," a new self-serve restaurant format.

The building still standing at 108–110 South Washington Street was built in 1925 by tailor Carl Theidel for his business, Hinsdale Cleaners and Dyers. The north side of this building housed this establishment where every sartorial need was satisfied in these tropical surroundings. Pictured are, from left to right, Carl, Harry, and Edwin Theidel in 1925.

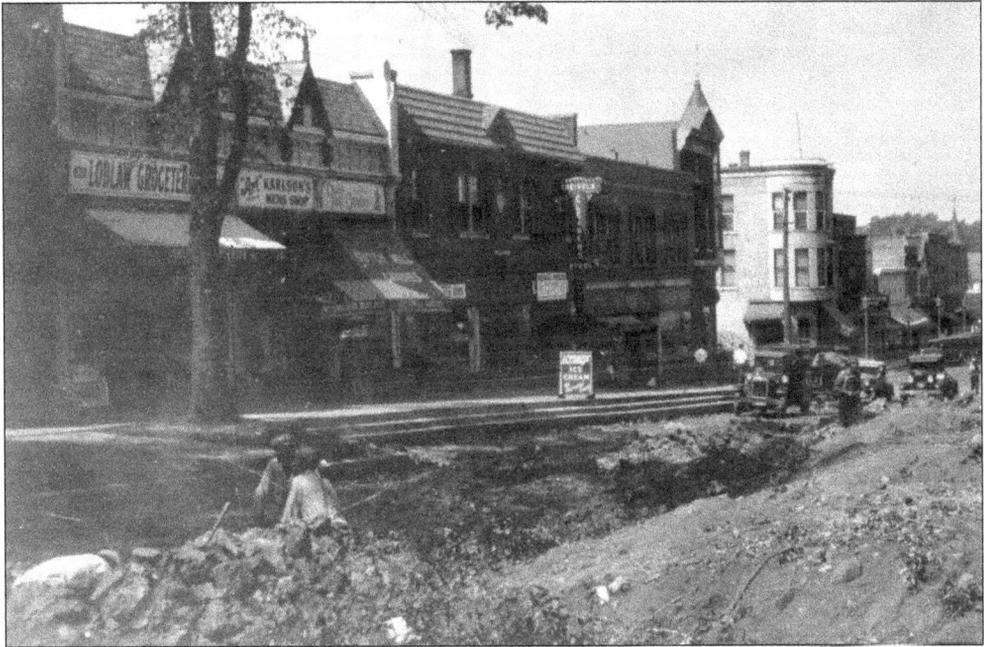

Washington Street south of First Street was widened and raised in 1930. Trees were removed, the brick paving replaced with concrete, and new (current) street lighting installed. This work resulted in diagonal parking on the street, greatly increasing capacity over the previous parallel arrangement.

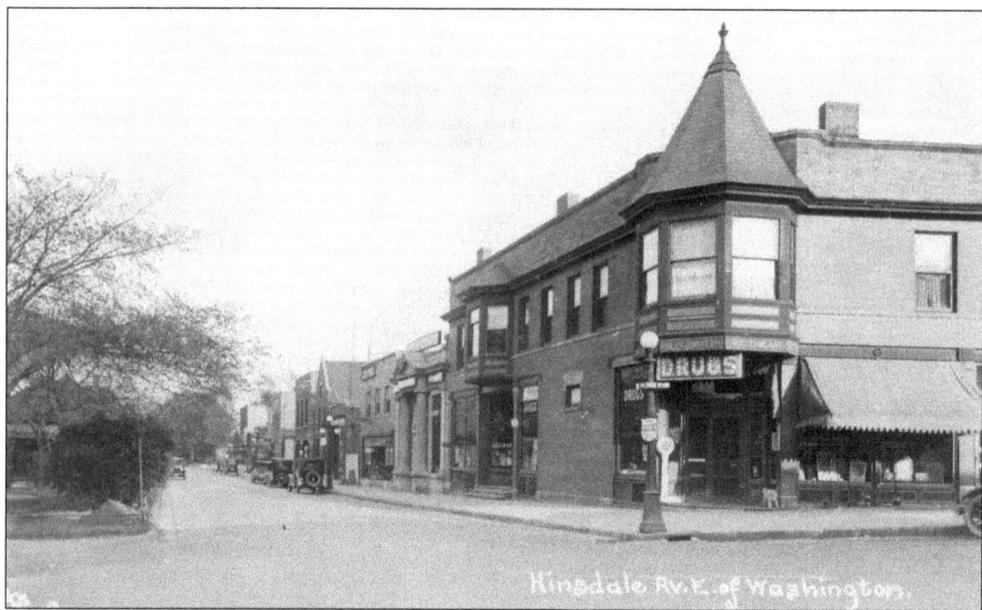

Hinsdale Avenue is immediately recognizable in this c. 1926 photograph. On the site of Hinsdale's first store and post office, this corner drugstore was built in 1900 by Hinsdale builder Adolph Froscher. A drugstore operated here for over 100 years until Starbucks sensitively rehabbed the building in 2005.

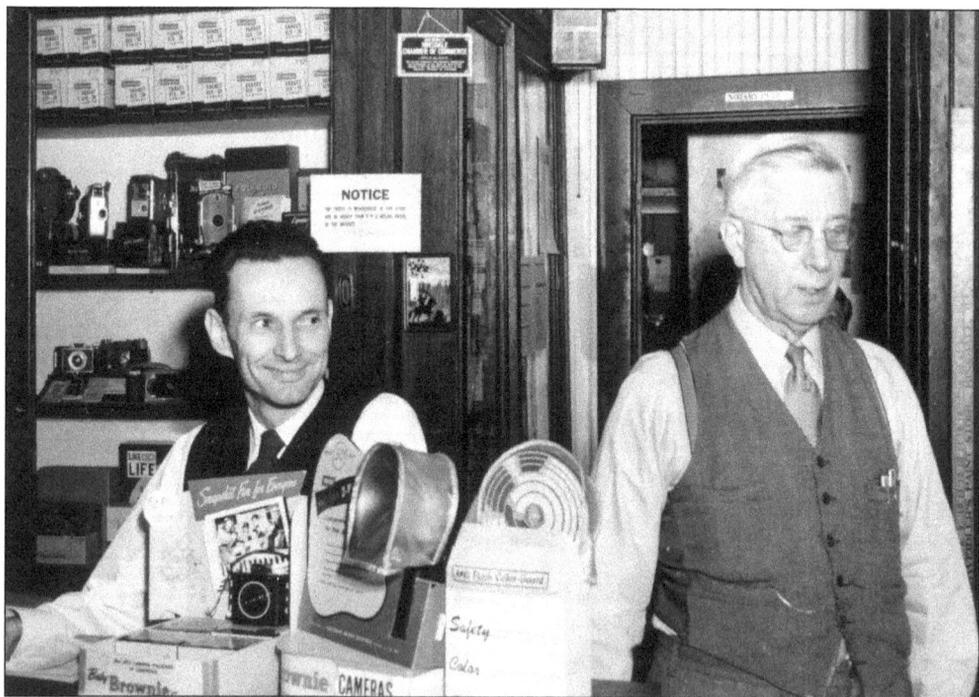

For decades, the Harner Photography Shop, shown here with L.C. Harner on the right, operated at the rear of the Froscher Building. Harner created an extraordinary historic record of Hinsdale through his photographs of the village in the 1920s and 1930s, several of which are included in this book.

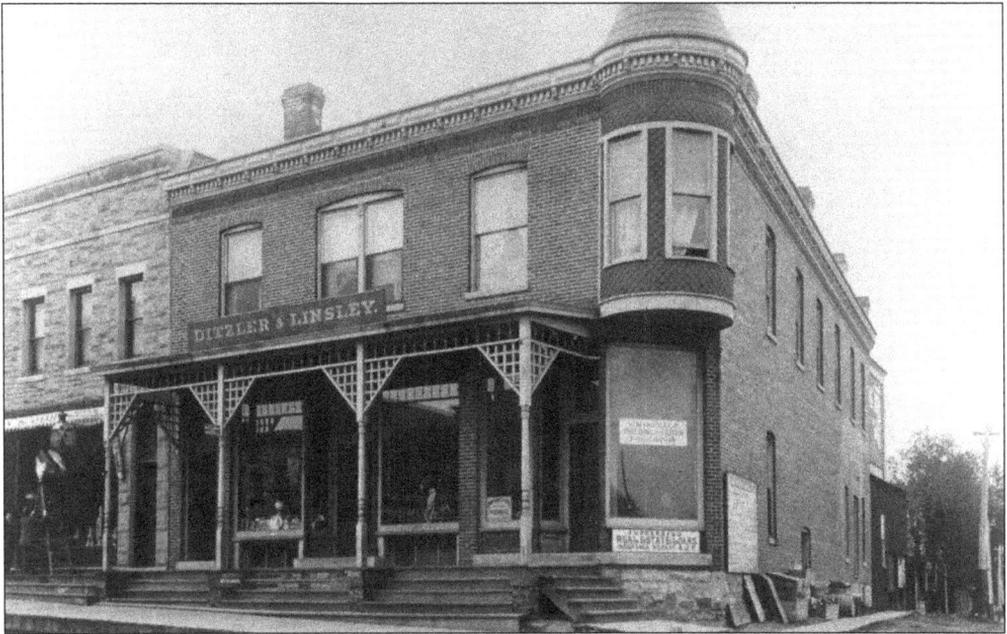

When the building on the southwest corner of Washington Street and Hinsdale Avenue burned in 1891, this structure, still standing today, replaced it. It housed the grocery of Ditzler & Linsley, successor to the long-standing Fox Brothers general store. This c. 1895 photograph reveals the building's original styling as well as the grocery and corner office of the Hinsdale Building & Loan.

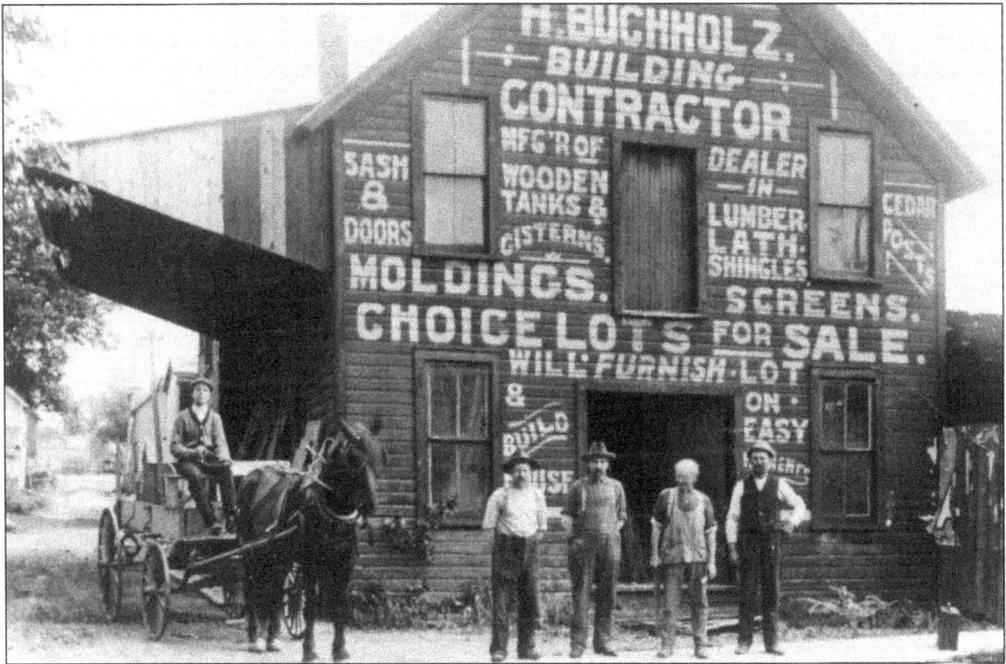

The home and business of Henry Buchholz was located on the southwest corner of Grant Street and Hinsdale Avenue, where a funeral home now stands. Behind his home was the barn that housed his carpenter shop, shown here. Between 1884 and 1921, Buchholz ran a contracting business responsible for the construction of an estimated 200 Hinsdale homes and businesses.

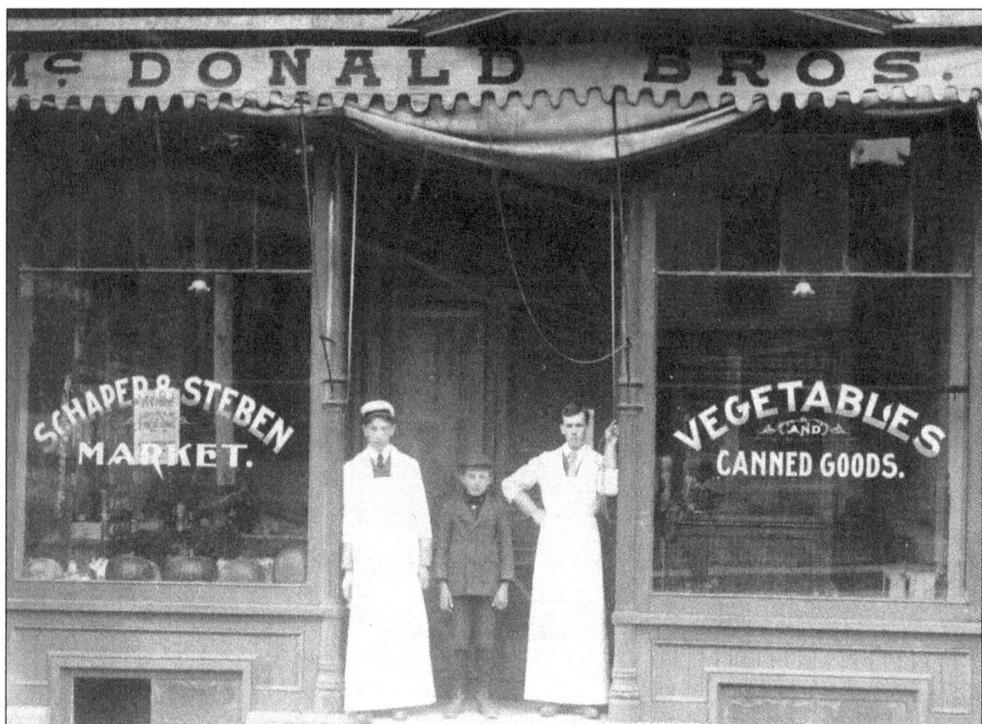

The retail core gradually spread to First Street with the construction of new commercial buildings and homes converted for retail use. One of the first new buildings here was built by Henry Buchholz at 13–15 West First Street in 1895. It housed many groceries over the years including McDonald Brothers Meat Market, shown here. In 1927, Steben's Grocery substantially remodeled the building, operating at this location until 1968.

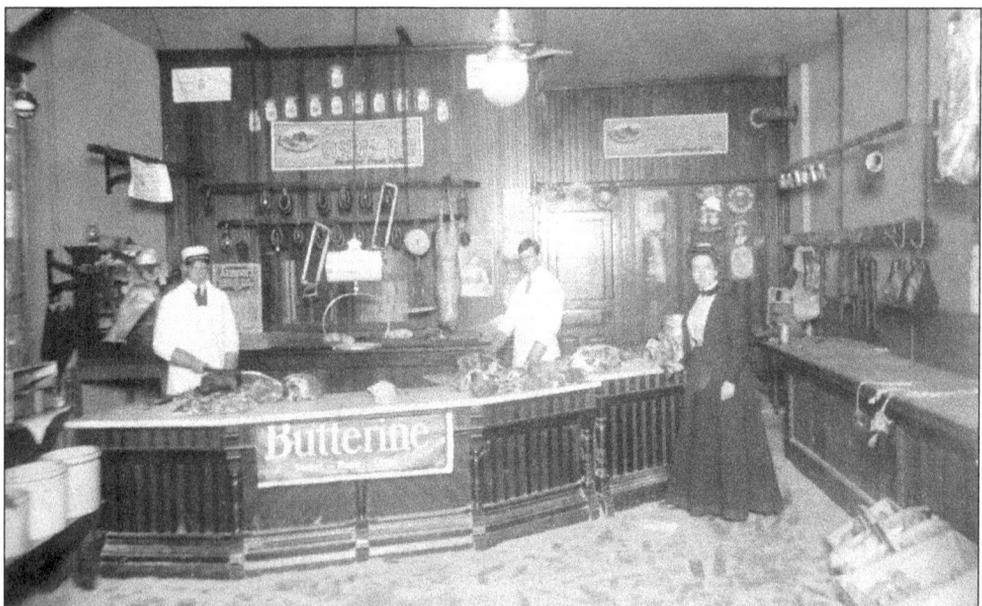

Sawdust-strewn Schaper & Steben's Meat Market, successor to McDonald Brothers, was run by partners Fred Schaper, left, and John Steben, shown waiting on a customer about 1902.

In this interesting view of east First Street in 1909, only the Hinsdale State Bank, built eight years earlier, is visible on the south side of the street. Just beyond the bank on First Street, construction activity can be seen on a safety deposit vault annex, "to be wired with a burglar alarm, the latest and best in bank protection." A new bank building, which still stands, replaced this one in 1927.

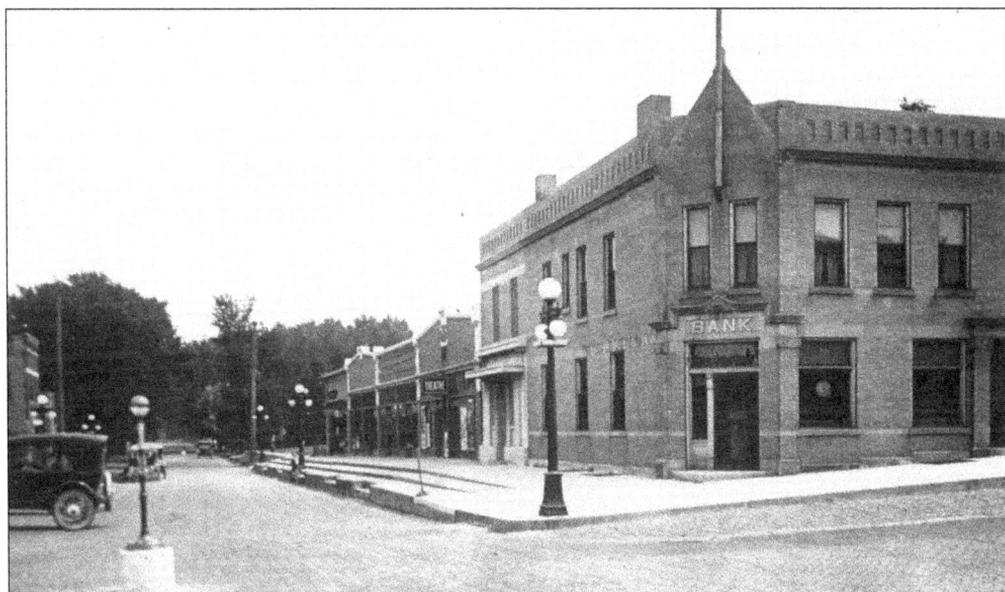

In this early 1920s photograph, First Street development appears fairly complete. The bank's vault annex is shown as well as the four-store retail block built in 1912. Included here is Hinsdale's first movie theater, boasting a seating capacity of 300. To appease concerns over new "moving picture exhibitions," residents were notified that "no picture will be shown until approved by a committee of Hinsdale citizens who will rigidly maintain strict censorship."

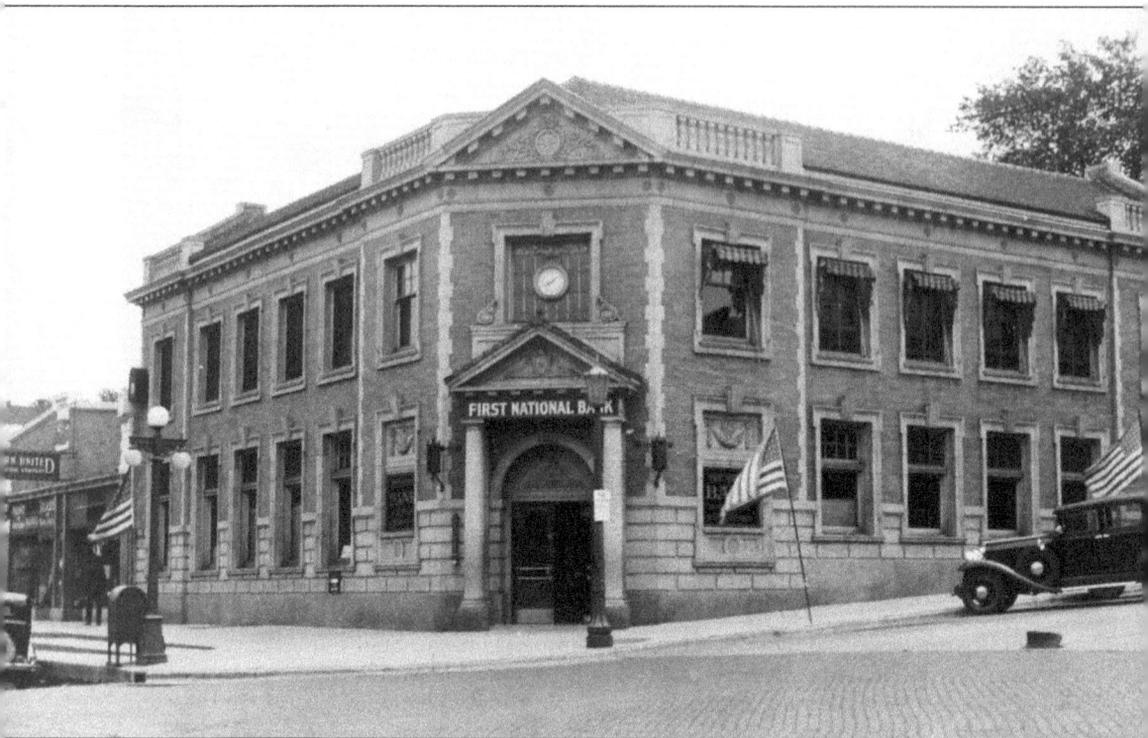

One of Hinsdale's most significant buildings, this was designed by Hinsdale architect William G. Barfield for the Hinsdale State Bank. Built in 1927, it served the bank for more than 40 years. Its striking Classical Revival design and terra-cotta detailing are matched by its exceptional interior. Press releases that introduced the bank highlighted various features including a storage room "built to accommodate those who wish to deposit silverware and household valuables during times of travel." During the Depression, Hinsdale was spared a bank failure with the consolidation of its two banks, Hinsdale State and First National. Orchestrated by bank director and village board member William Regnery, the banks merged in 1932, assuming the name First National Bank of Hinsdale. (Photograph by L.C. Harner.)

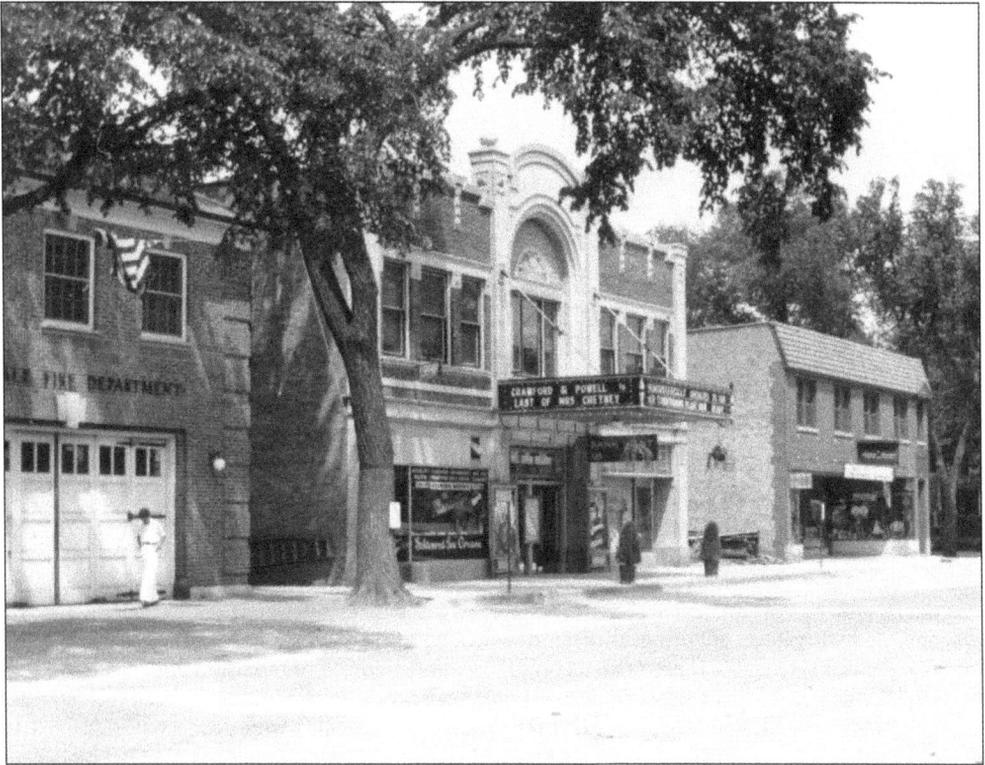

Another iconic Hinsdale building designed by William Barfield, the Hinsdale Theater was built in 1925. This photograph, taken in 1937, reveals its original marquee and remarkable terra-cotta trim. Complete with theater organ and orchestra pit, the theater hosted live performances and concerts as well as movies. Closed in 2003, the building has been remodeled as retail space. To the left of the theater, the 1935 fire station is visible.

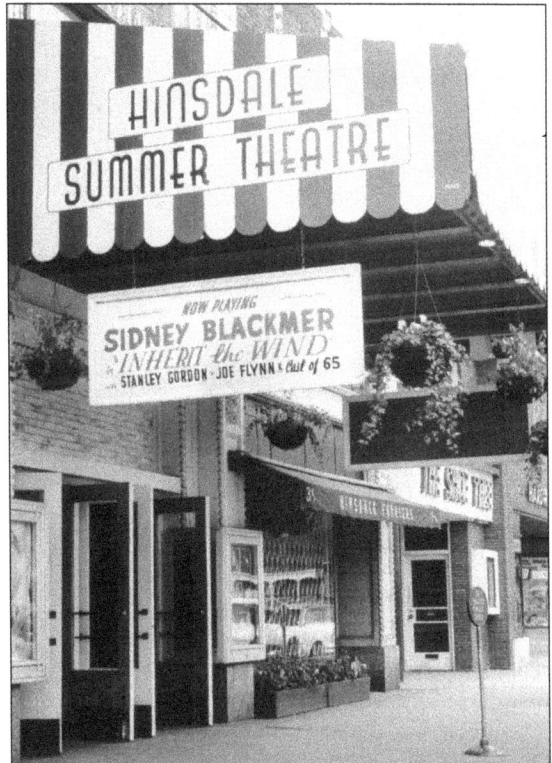

Hollywood came to Hinsdale from 1951 to 1962 when the Hinsdale Theater presented summer stock performances. The plays were produced by Sidney Blackmer, a well-known actor who called upon stars such as Charlton Heston, Debbie Reynolds, and Vincent Price to headline the shows. The stars enjoyed Hinsdale hospitality, staying in the homes of residents during the short runs, at times bringing their families.

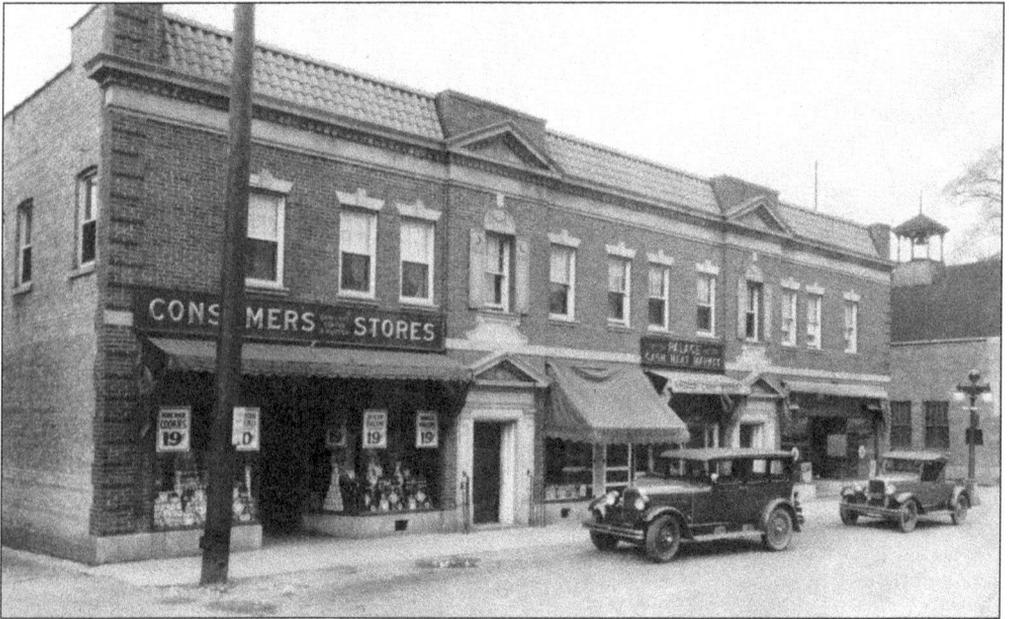

Ornamented with stone detailing, this symmetrical building at 11–21 East First Street was built in 1925. For years, teachers rented the second-floor apartments. This location afforded them the opportunity to live within a short walk to school, located where the Middle School now stands. At the time of this 1929 photograph, all three ground-floor tenants were grocery stores.

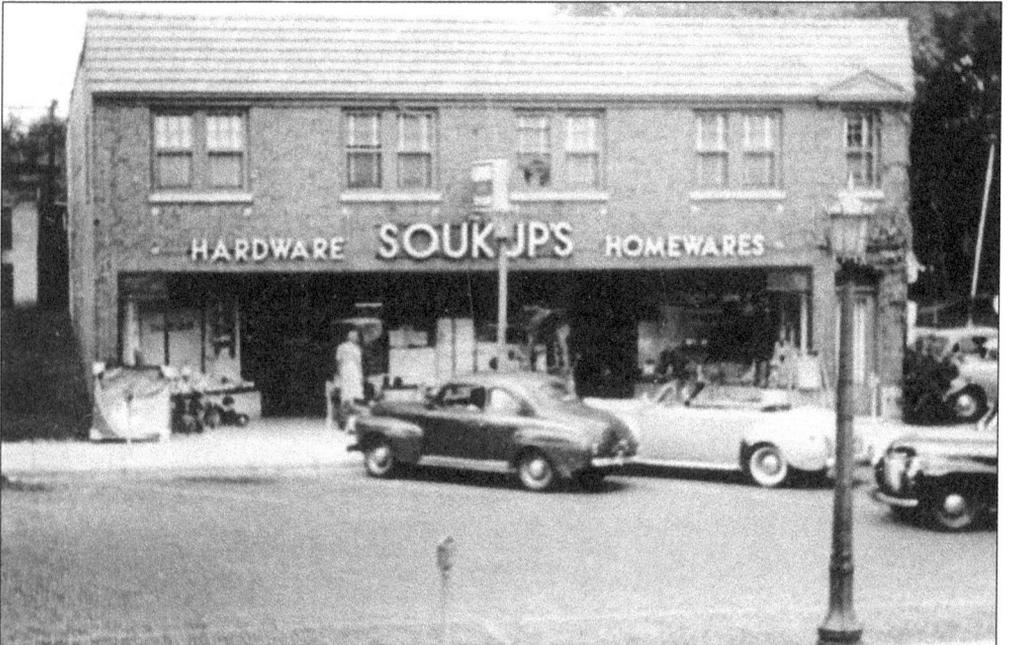

In 1929, this store was built at 35 East First Street for hardware dealer Ray Soukup. The business remained in the family for 63 years, later guided by his son Hank until 1992. With honest, friendly service, and expert "how-to" advice, the store carried every hardware and household item imaginable. Significantly remodeled, the building retains its facade and hardware tradition, now owned by Fuller's Home and Hardware. (Courtesy of Henry Soukup.)

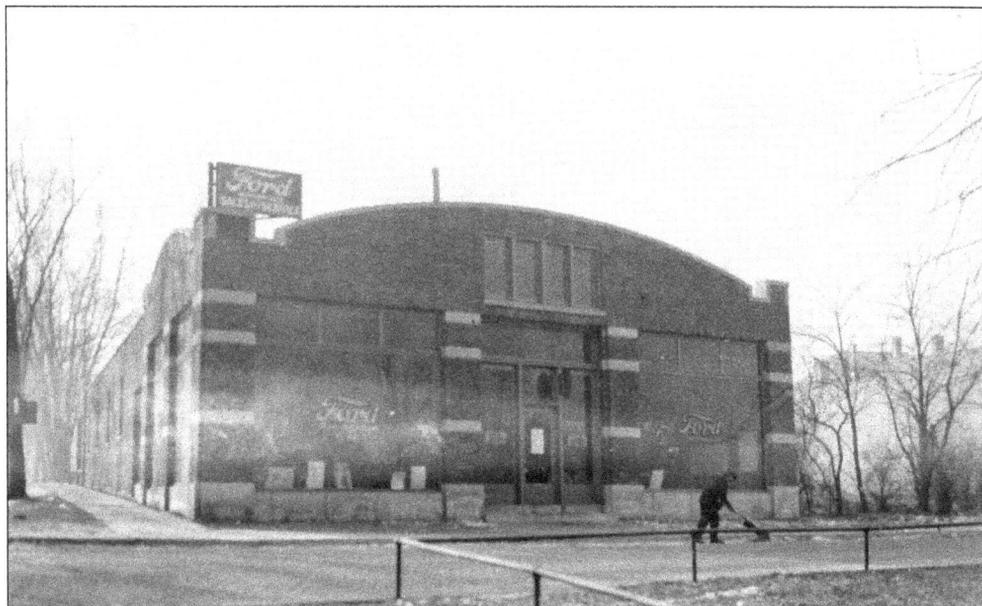

This was Hinsdale's first automobile dealership, a Ford agency built in 1917 at the southwest corner of Garfield and Hinsdale Avenues, operated by the multifaceted carpenter/contractor/realtor Henry Buchholz and his brother. Within months of opening, Henry Ford stopped for a spontaneous visit on his way to meet with International Harvester's Alexander Legge at his Hinsdale home.

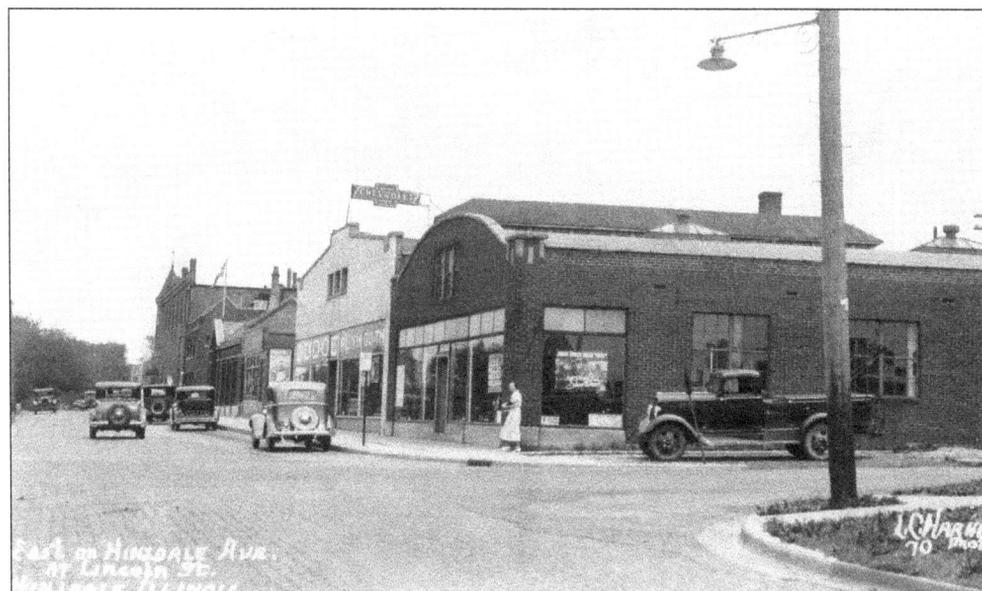

Other automobile dealerships followed in the early 1920s on the other side of town along Chicago Avenue at Lincoln Street. The site of the Chevrolet dealership is said to have been the location of an illegal beer depot years earlier. This photograph dates from about 1930. (L.C. Harner photograph.)

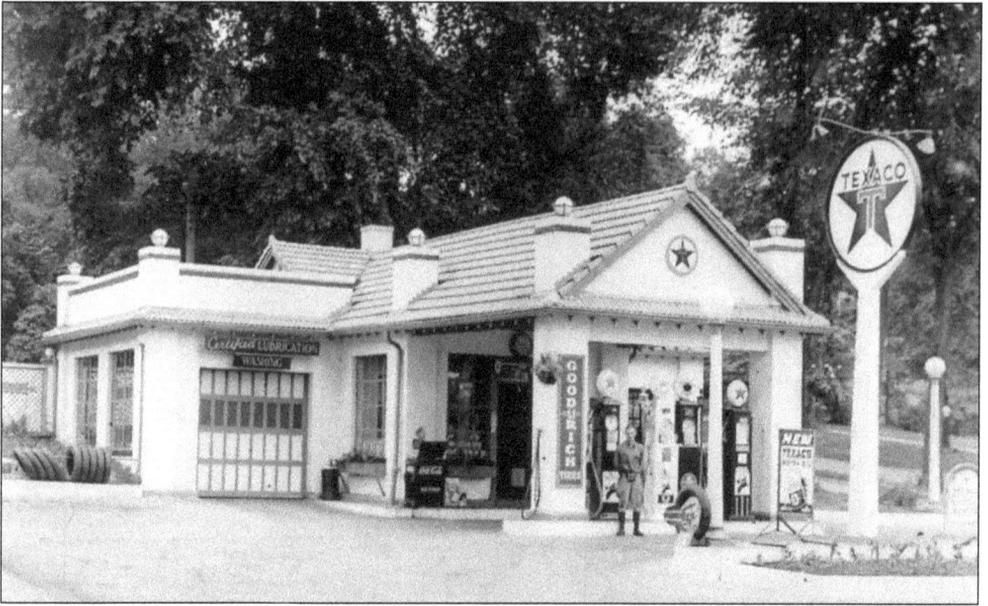

The booming auto industry generated complimentary businesses as well. This gas station was built in 1928 on the southeast corner of First and Lincoln Streets and operated until 1982, when it was sold and remodeled for use as a produce store.

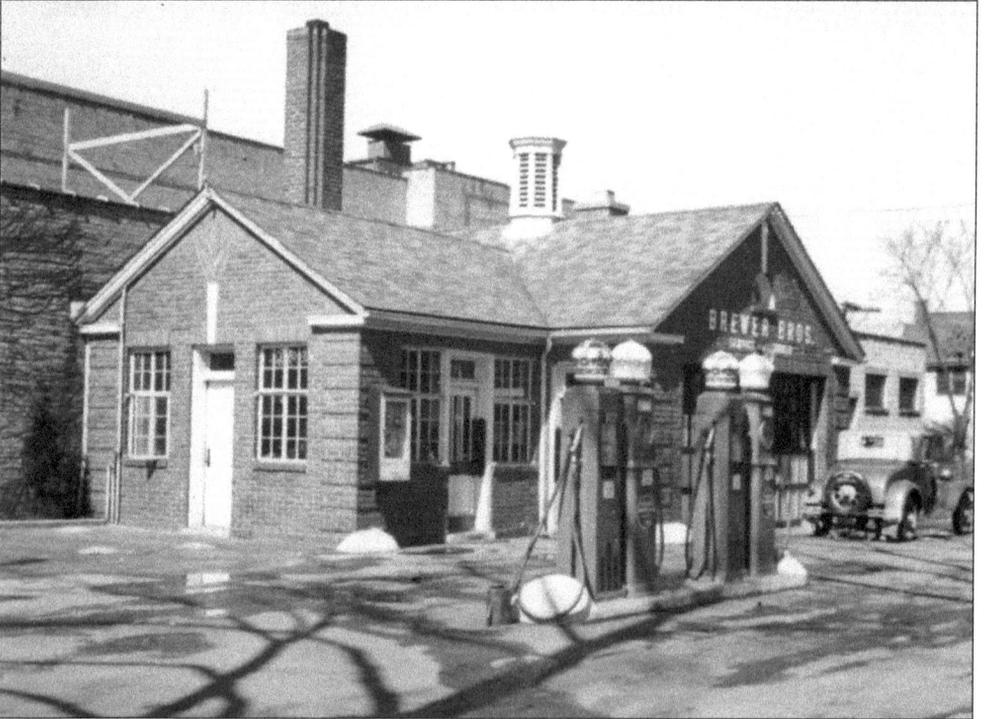

This 1930 station was built on the northwest corner of Garfield Avenue and First Street. Designed by Hinsdale architect R. Harold Zook, the station was built in the Georgian style encouraged at the time by the village plan commission. The station has recently been reinvented as a popular snack shop.

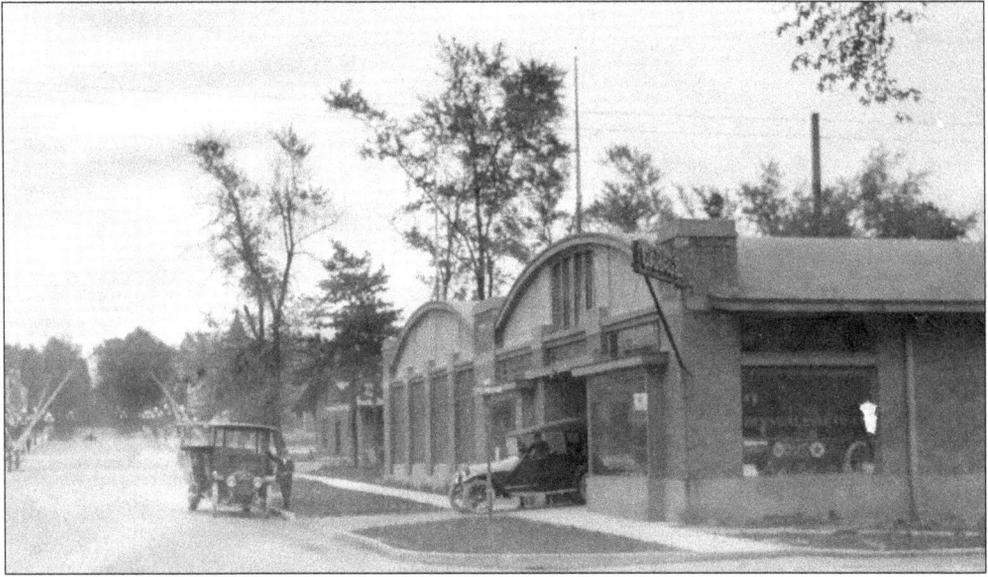

North of the tracks, on the southwest corner of Washington Street and Chicago Avenue, mechanical genius Alexander Keith opened this garage in 1912. Automobiles were a hobby for the celebrated inventor, who was also one of the first Hinsdaleans to own a car. Keith is recognized for developing automatic telephone switchboards, the dial telephone, and 40 other patents. Designed by Hinsdale architect William Barfield, the garage included a showroom and could accommodate 70 cars. (Photograph by L.C. Harner.)

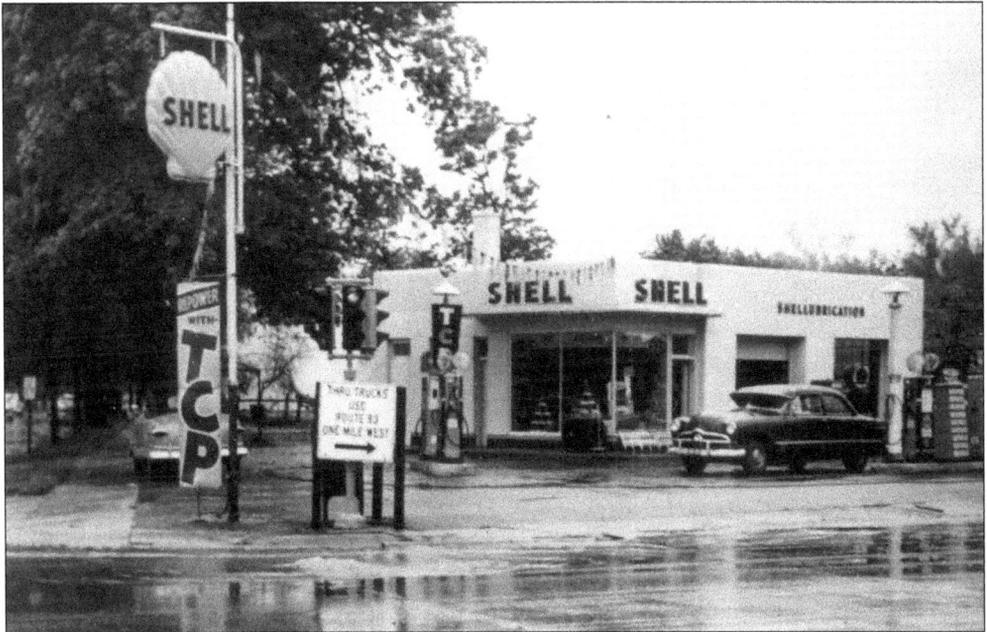

In 1946, Lloyd "Bob" Fuller, descendant of the Fullersburg Fullers, began business with a service station at York Road and Ogden Avenue with lube and car wash bays. Adding the Lincoln Street location in 1959, he installed the first tunnel car wash in the western suburbs, meticulously hand-drying each car. A legend in auto service businesses, the greatly expanded Fuller's Service Centers remain family owned. (Courtesy of Walter Fuller.)

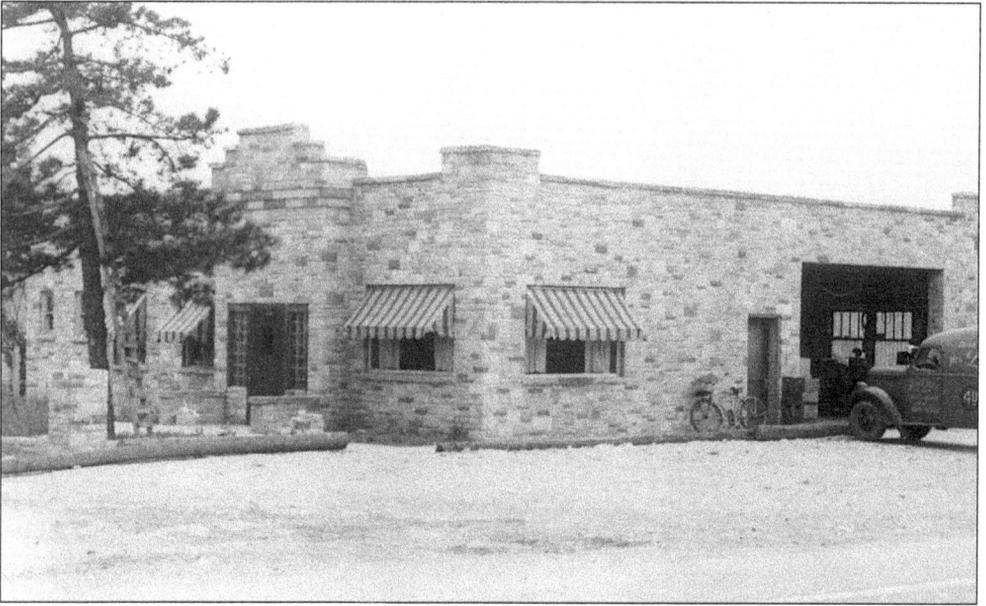

Established in the 1940s, the Cypress Inn on Ogden Avenue was located where liquor sales were permitted, outside Hinsdale village limits. The business began as a beer distributorship and grew to include a bar and restaurant, a retreat for thirsty residents of alcohol-free Hinsdale. Shown here about 1950, the restaurant expanded under various owners to become an area fine-dining option. Closed in 1996, the site is now occupied by Whole Foods.

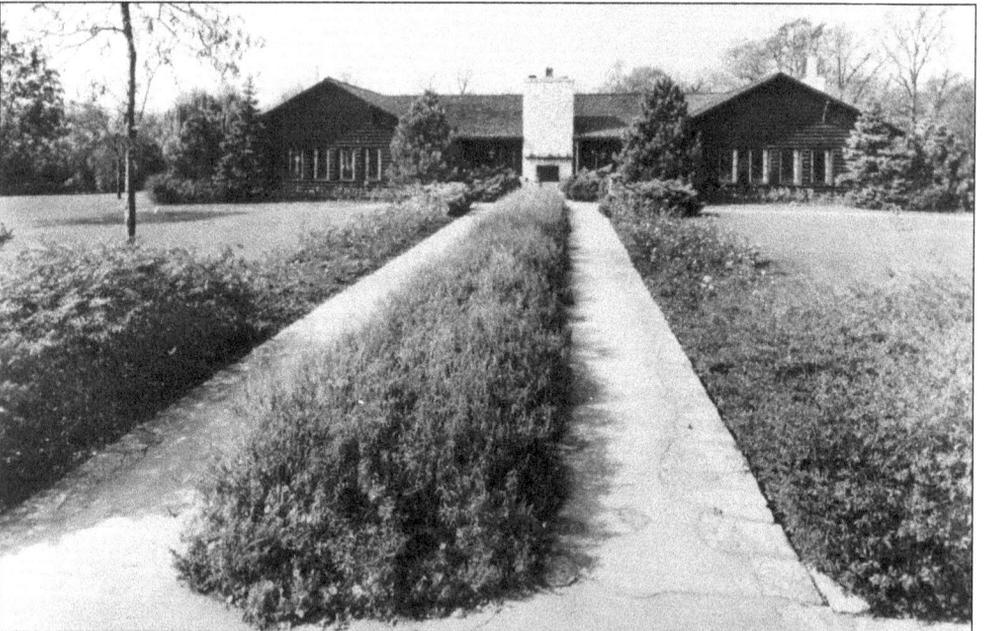

The original Old Spinning Wheel restaurant, located on Ogden Avenue just west of the tollway, was built in 1935 by Charles and Vacia Duncan. Expanding seven years later, this building replaced the original structure. The enormously popular restaurant was filled with antiques, surrounded by attractive gardens, and offered an elegant yet home-style menu. The Duncans sold the business in 1954; the restaurant closed in the mid-1970s.

Five

Farms and Flowers

While the village population had grown to 2,500 by 1900 and many fine homes had been built, Hinsdale was still a shipping point for milk from nearby farms. George Robbins, son of Hinsdale's founder, started a dairy farm along Salt Creek just north of Fullersburg, purchasing the 160-acre original Fuller claim.

About the same time, Hinsdale's Frank Butler purchased land north of Robbins's property for use as a country estate and farm. He named it Oak Brook Farm for the oak trees that lined the property's meandering creek. A large home and stables were built, and additional land was acquired. Over time, the Butler family accumulated about 3,700 acres. It was from this property that the village of Oak Brook was established in 1958 and the polo fields, sports facilities, nature center, and some residential areas were developed.

South of Hinsdale was Sedgeley Farm, established in 1889 by industrialist Enos Barton as a diversion from his business, Western Electric. In 1891, Barton imported Brown Swiss cattle, growing the herd in size and quality to one of the largest and finest in the country. The pride of the prizewinning animals toured state fairs and exhibitions, their transportation provided by local trains. The cows walked up Garfield Avenue from the farm to the Hinsdale freight station in the center of town.

Hinsdale's farms were matched by equally remarkable greenhouses. Orland P. Bassett, owner of a printing company, came to Hinsdale in 1887, later building a magnificent home on Sixth Street. His son-in-law, lumber dealer Charles Washburn, also lived on Sixth Street. To further Bassett's horticultural hobby and to glorify their neighboring views, they built a dome-shaped greenhouse across from their homes.

Village historian Otis Cushing described the surprising consequence of Bassett's leisure pursuit:

> The hobby proved so interesting they expanded the [greenhouse] building and imported manetti, a type of root, from Europe. To this root they grafted rose scions and produced American Beauty roses. So successful was this venture they enlarged the plant, operating greenhouses and a wholesale business. The firm of Bassett & Washburn became the first to produce American Beauty roses for the commercial market and flourished for many years.

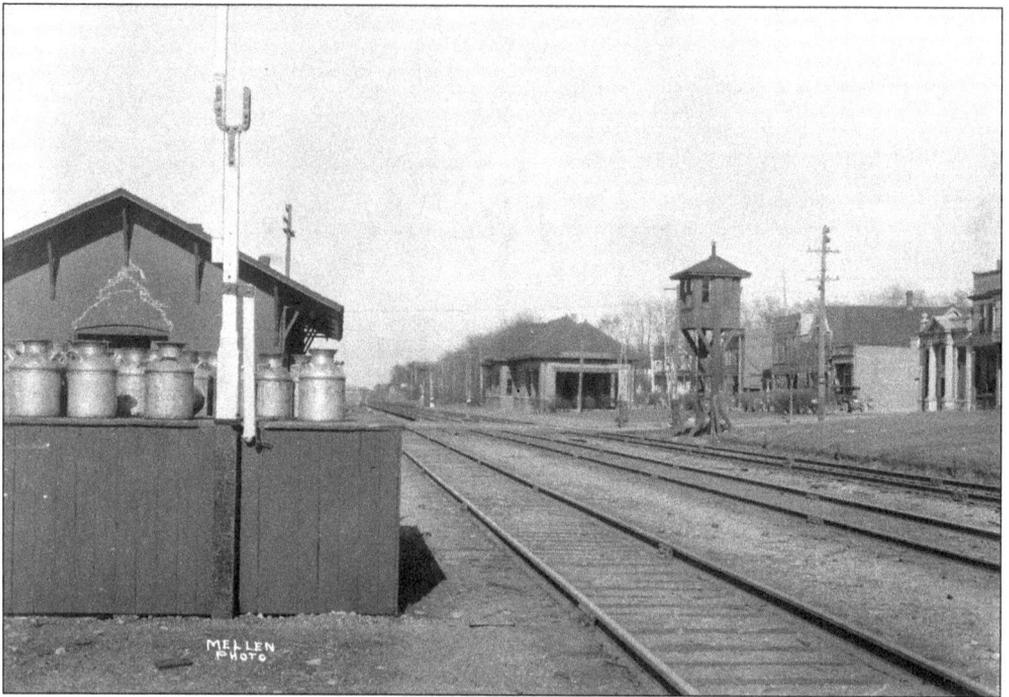

Looking east with Washington Street centered in this 1910 photograph, Hinsdale's train station can be seen in the background. The village's original station is at the left. After 1898, it was used only for freight, as illustrated by these milk cans. (Photograph by Mellen Photo.)

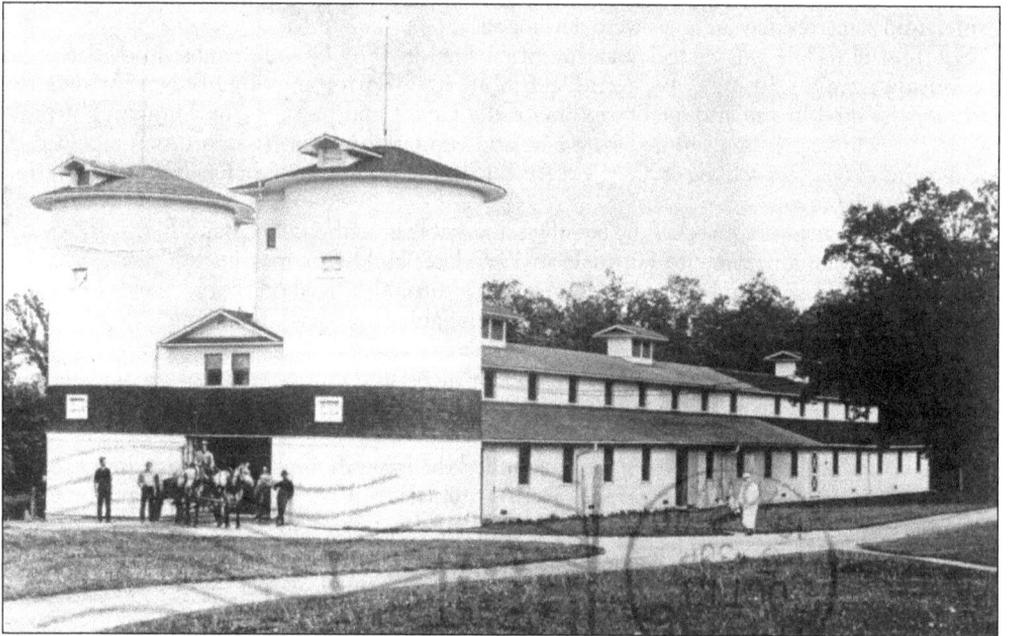

George Robbins named his north side farm "Natoma," an Indian word for "running water," and began importing cows from Britain, some of the first Guernseys in the country. Trade journals later recognized the impeccable farm as "the finest Guernsey dairy in Illinois." This postcard of the twin-silo dairy barn dates from 1905.

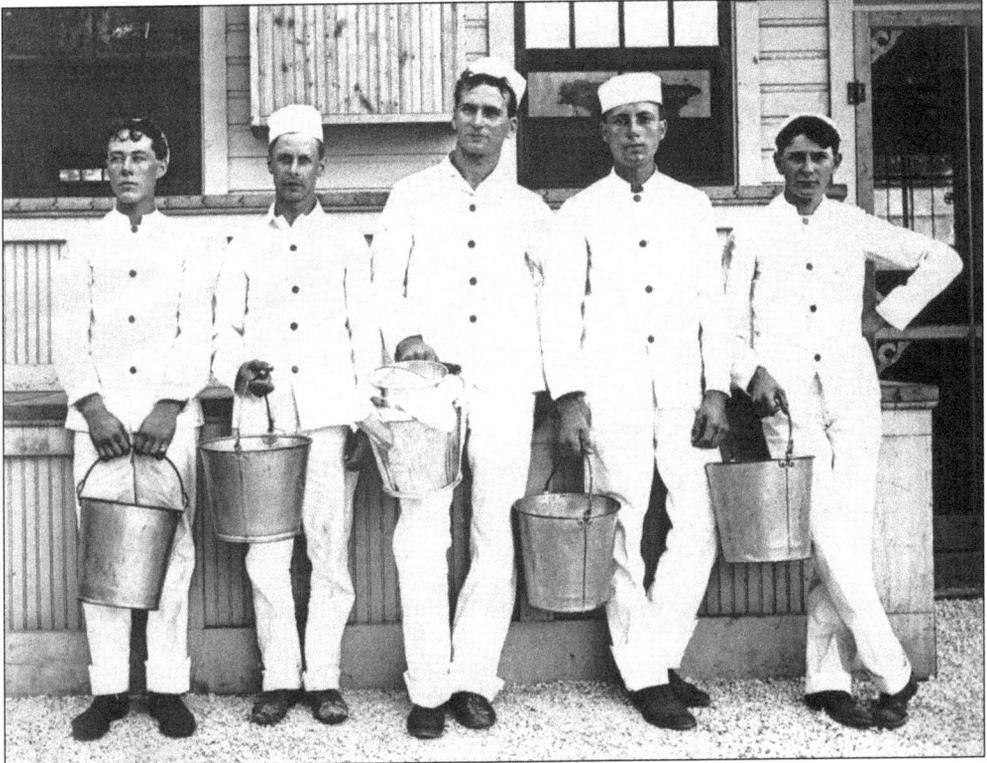

Natoma Farm was sold to F.O. Butler about 1906. Butler expanded the Guernsey herd to about 200 head, one of the largest in the country, and operated the sizeable business for 30 years. Some of Natoma's dairymen are shown here.

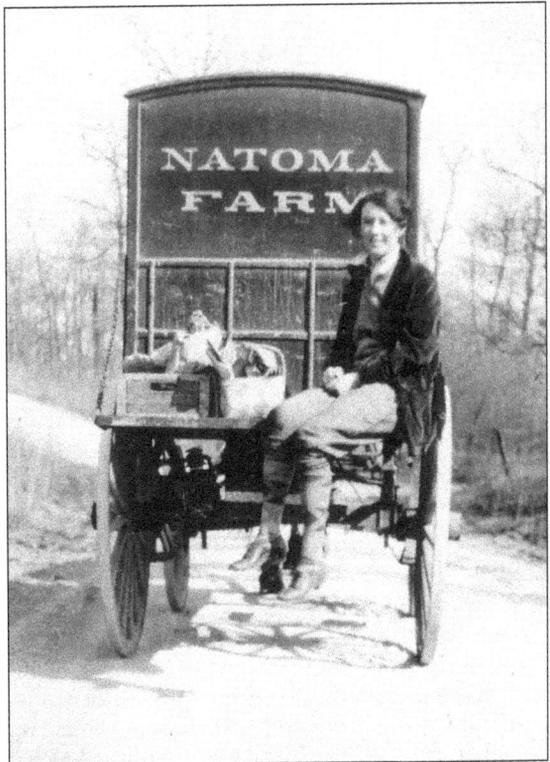

Horse-drawn wagons were gradually retired. By 1931, Natoma had 64 trucks delivering milk to the surrounding towns. The business was sold to Bowman Dairy in 1938, and the Oak Brook operation was discontinued.

The home and considerable grounds of Samuel Gregston at 114 South Stough Street included room for cows to graze. Gregston's larger pasture was north of the house, between Chestnut Street and Chicago Avenue. Owner of the Windsor Clifton Hotel in Chicago, Gregston insisted on serving the freshest dairy products. Milk from his herd was delivered at 4:00 a.m. every morning to Hinsdale's milk platform to be shipped to the hotel. (Courtesy of Aileen Blomgren.)

South of Fifty-fifth Street and east of County Line Road, Enos Barton, Western Electric's founder and president, had this Sedgeley Farm residence built in 1898. Barton's electrical capabilities destined the fine home to be the first in the area to have electricity. On land now owned by Suburban Hospital, the home was demolished in 2000. (Photograph by Sandra Williams.)

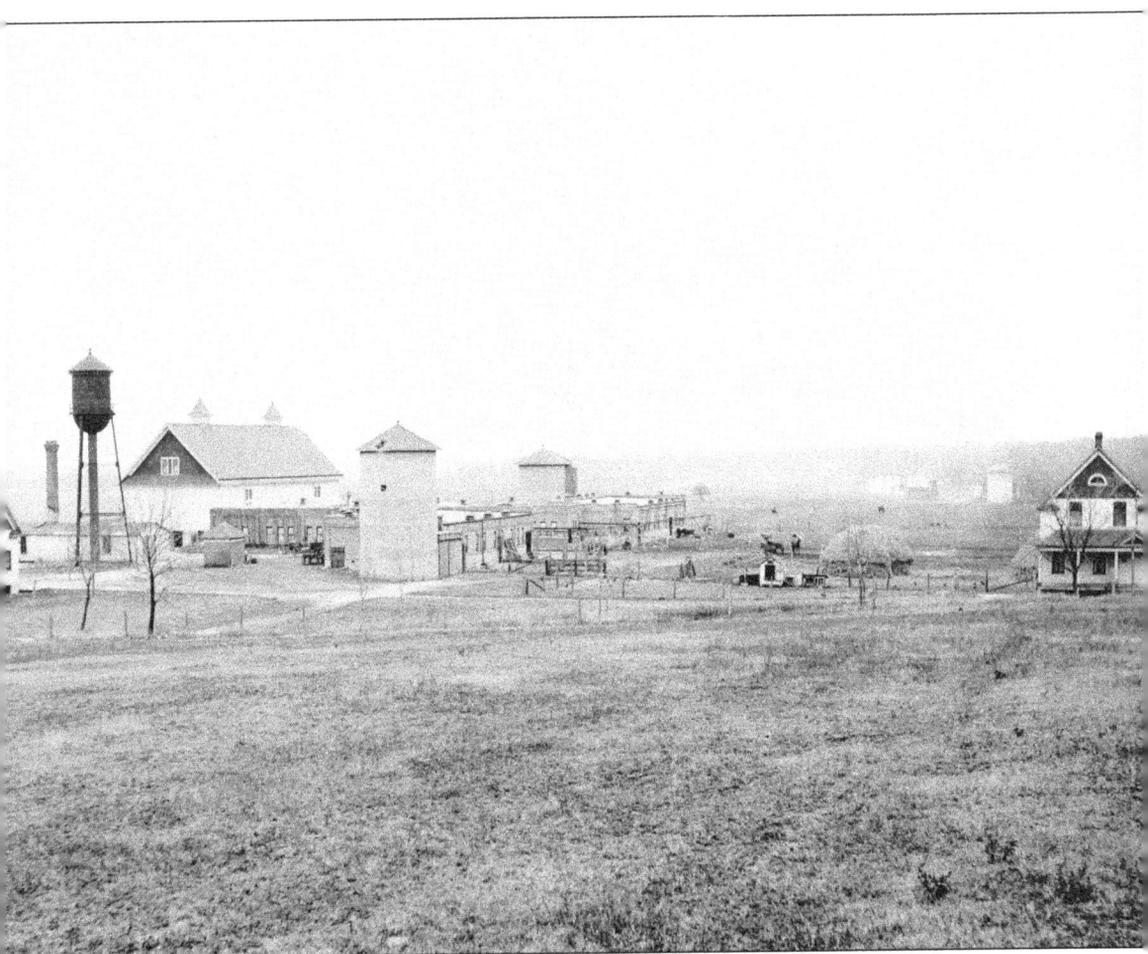

The barns and workers' homes at Sedgeley Farm, shown here about 1900, were also wired for electricity and fitted with prototypes of Western Electric devices. The original farm of 90 acres east of Madison Street grew to 1,100 acres, reaching beyond County Line Road. In addition to the 230-head model dairy, Sedgeley Farm raised champion French coach horses, stabling over 100 at its peak. In 1915, Sedgeley's cows contracted hoof and mouth disease and had to be destroyed, sparing only those away on exhibition. Barton, devastated by this and other personal tragedies, died the following year. Farm superintendent Emil Jensen was given the Sedgeley name and five of the remaining cows to continue the farm in Wisconsin. Chicago Guernsey Farm purchased part of the property, assembled a herd, and continued to supply Chicago's hotels, private clubs, and Hinsdale families. By the 1940s, Chicago Guernsey was operating solely as a bottling and distribution center, ceasing operation about 1977. (Courtesy of Lawrence Bjork.)

These are the greenhouses of Bassett & Washburn, some reaching 300 feet in length. (Some company background is mentioned in this chapter's introduction.) As the floral business grew, the greenhouses multiplied until they covered 40 acres between Seventh and Eighth Streets, Elm Street to County Line Road. The company became Hinsdale's largest employer, retaining 85 men who cultivated roses and shipped plants across the country.

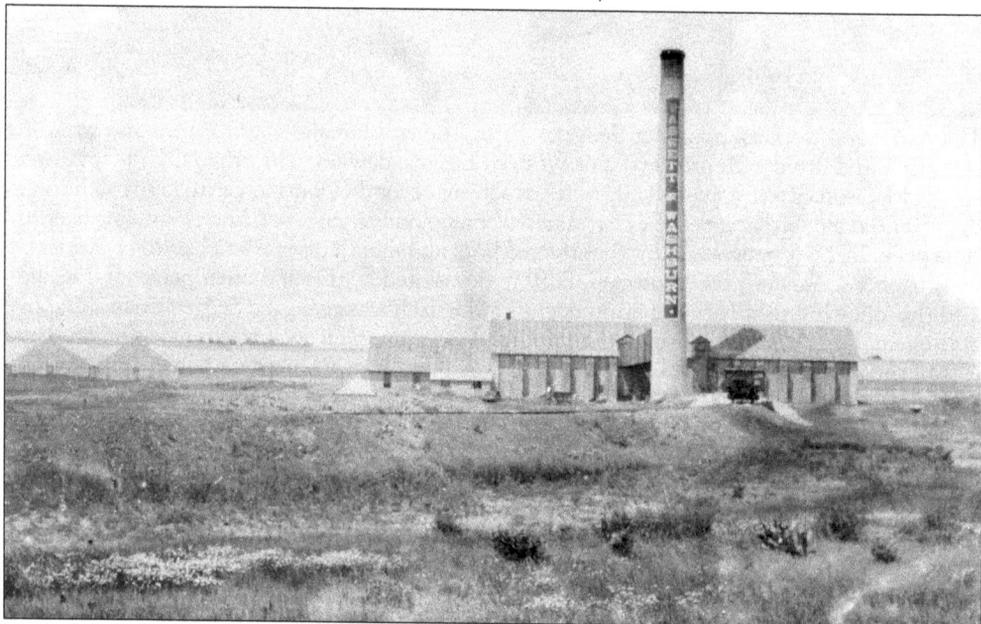

12,000 tons of coal were used annually to heat the Bassett & Washburn greenhouses. As Hinsdale expanded, the coal dust annoyed the encroaching neighborhood. About 1920, the company relocated to the site of a former brickyard in Westmont where the business continued until the 1930s.

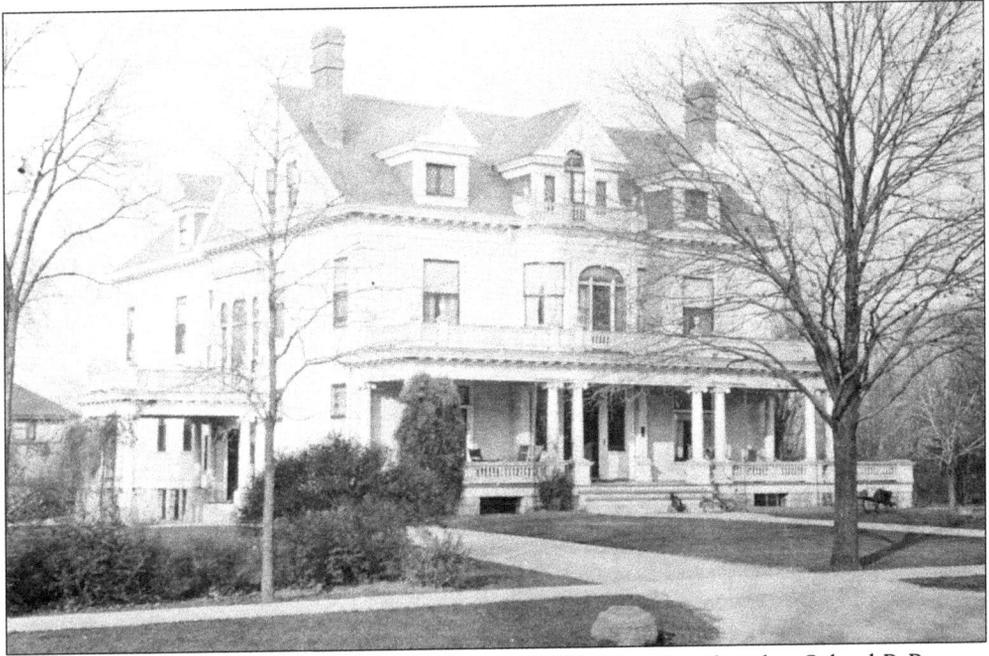

This, the Colonial Revival–style home of Bassett & Washburn's cofounder, Orland P. Bassett, was built in 1899. Bassett retired in 1907, passing the rose business to his son-in-law Washburn. Soon after, Bassett moved to California—Pasadena, of course. The house still stands at 329 East Sixth Street and is listed in the National Register of Historic Places.

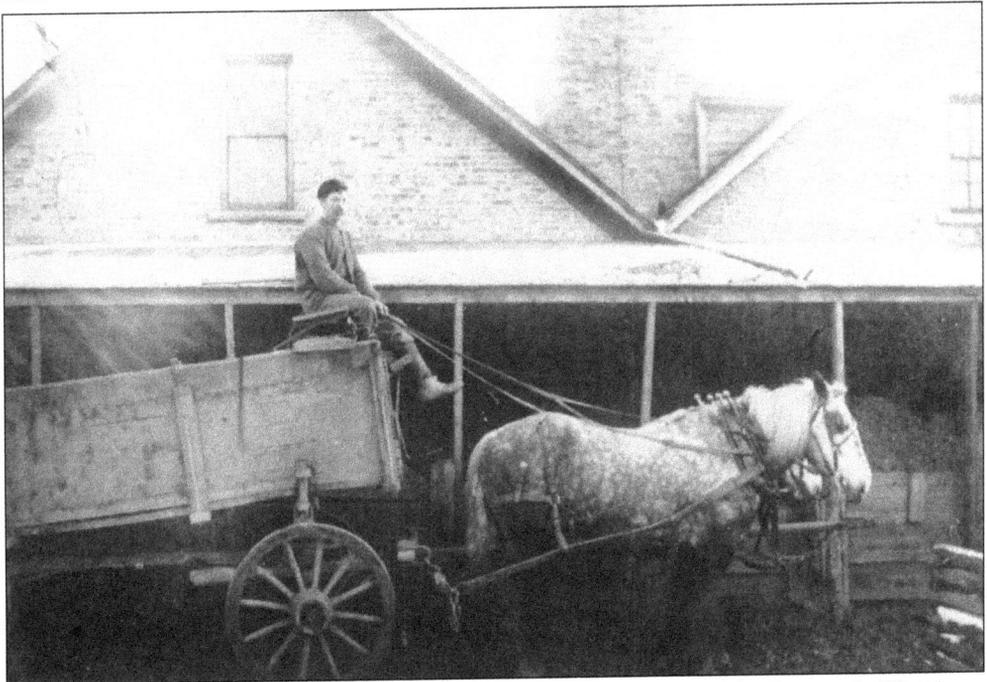

The home at 324 East Seventh Street is the only remaining trace of the Bassett & Washburn operation in Hinsdale. One of the boiler houses used to heat the greenhouses, this building was converted to the residence in 1927. Today, only this roofline is identifiable.

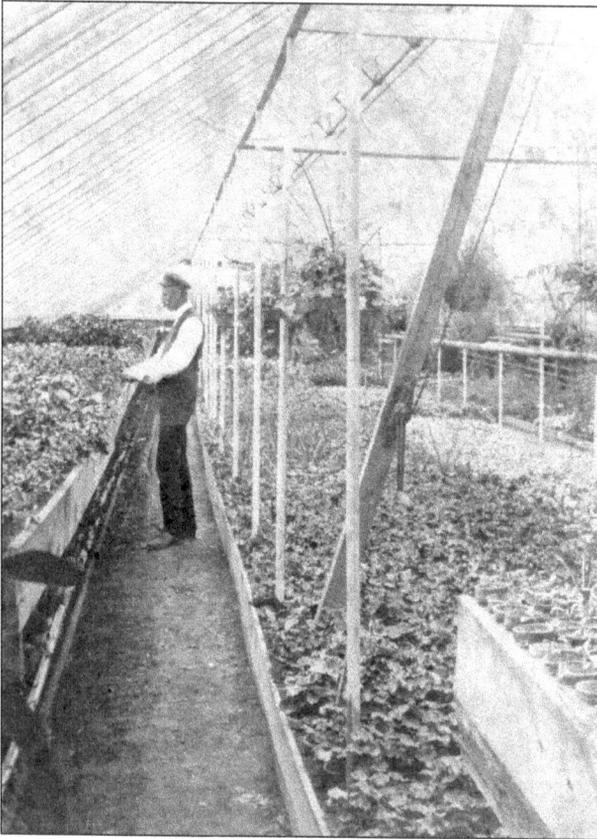

Englishman Fred Morris established Morris Florists in 1894. Shown about 1907 in the greenhouse near his home at Hickory and Grant Streets, Morris produced shrubs, vegetables, and herbs as well as flowers. When the government encouraged victory gardens during the war, Morris volunteered to teach residents proper planting methods.

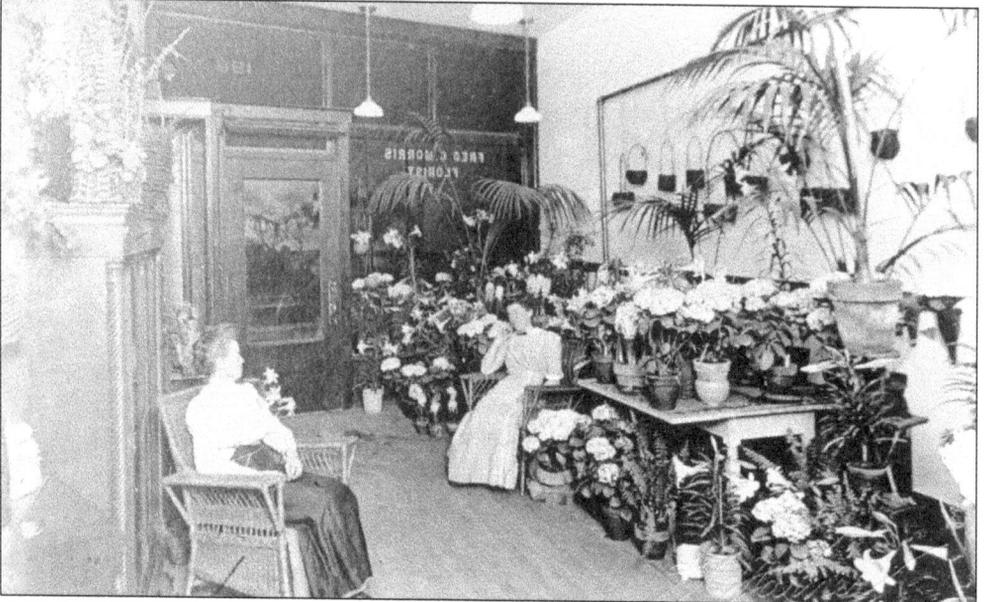

Hinsdale's need for an accessible florist in downtown Hinsdale was satisfied when Morris opened this flower shop on Hinsdale Avenue in 1902. Morris's business expanded to include six greenhouses on the corner of Monroe Street and Ogden Avenue and vast facilities outside Hinsdale.

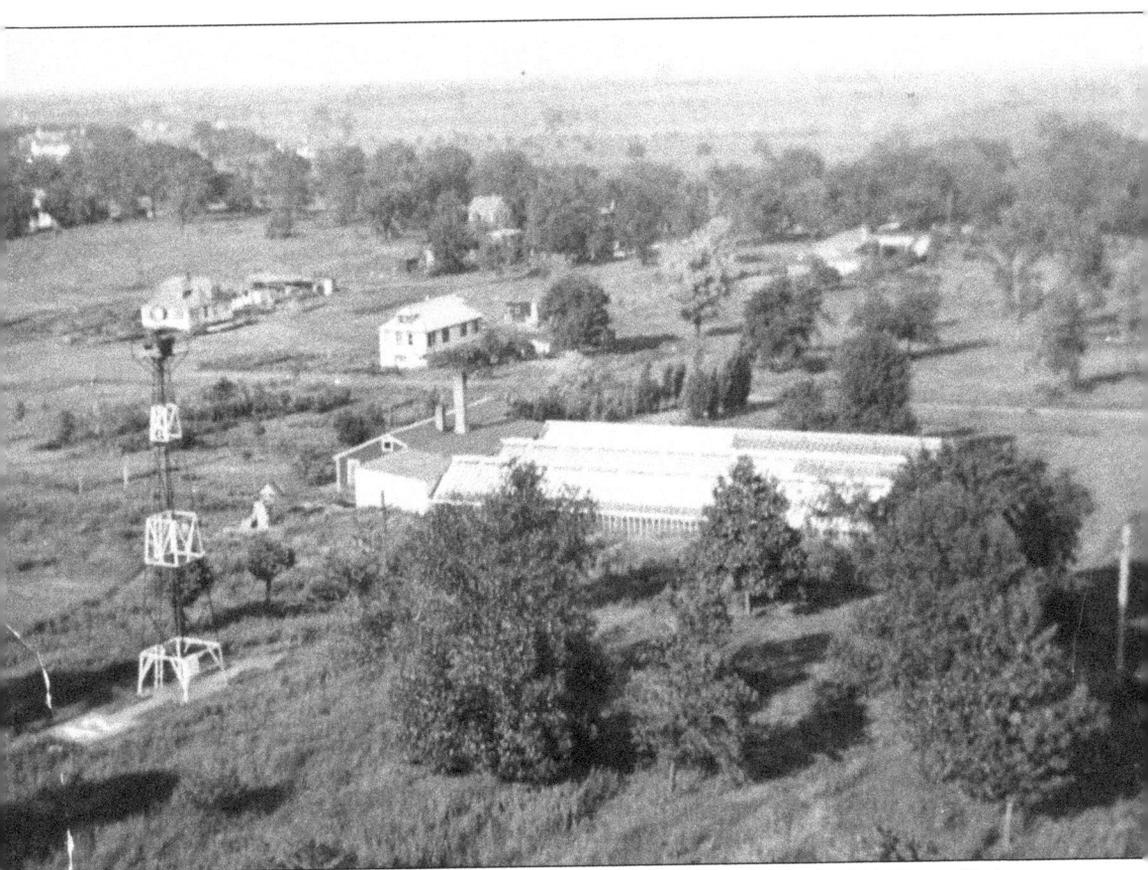

The Deerinck family built these greenhouses in 1919 on Oak Street south of Fifty-fifth Street. Today, the expanded property is owned by Vern Goers. In the left foreground of this 1930 photograph, a large arrow with the number "42" is visible on the ground at the base of the tower. Using the greenhouses and this arrow as visual references, pilots aligned their planes with the runway at Midway Airport. (Courtesy of Ann Kufrin Simonini.)

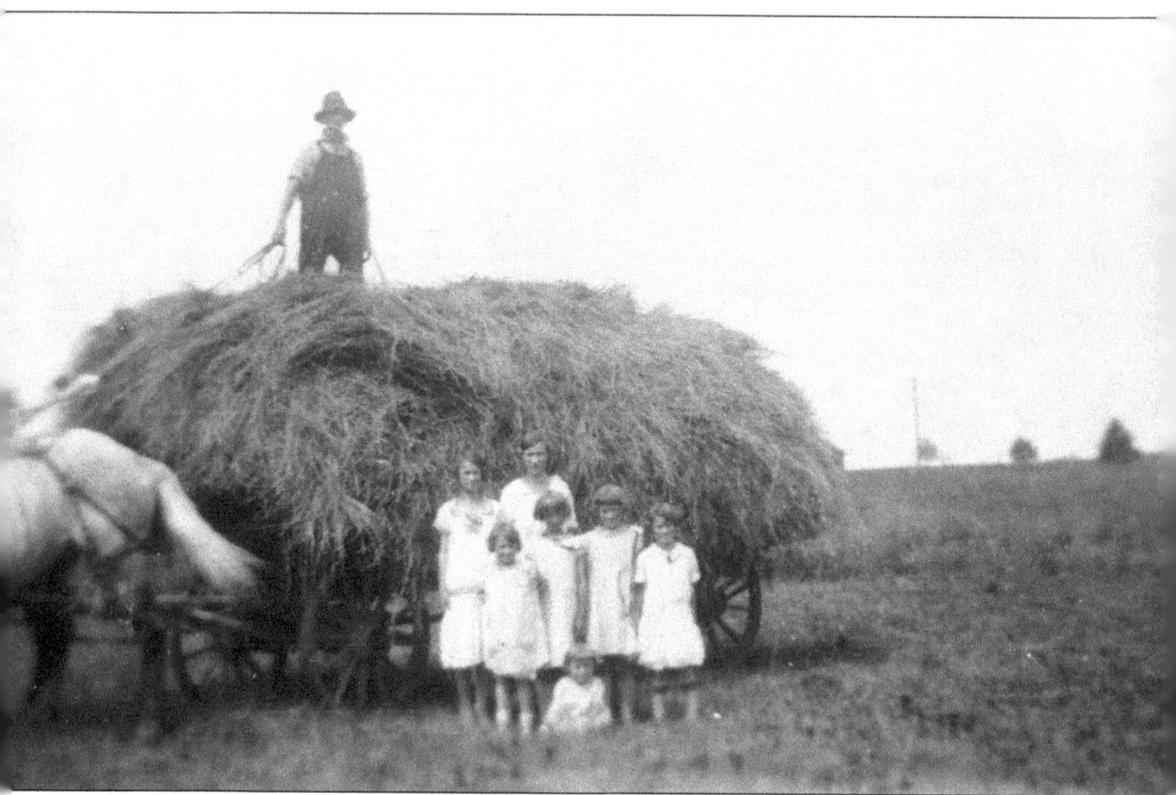

The Kufrin home and farm on south Oak Street is shown at the upper left of the previous image. This 1925 photograph shows Frank Kufrin on top of his hay wagon with his wife and six daughters posing proudly below. (Courtesy of Ann Kufrin Simonimi.)

Six

AT HOME

Homes and property in the new village sold rapidly. Less than a year after recording his initial plat in 1866, William Robbins made his first addition to Hinsdale, expanding east to the county line. The north side farms of Marvin Fox and Alfred Walker were gradually subdivided and sold. For those seeking country homesites after the Chicago Fire in 1871, Hinsdale was ready.

"The earlier houses were far apart and scattered over the entire area. Large backyards afforded ample room for flower and vegetable gardens, grapes and fruit trees. Until 1910, chickens were raised and cows and horses could be stabled within the village limits," Hugh Dugan wrote in *Village on the County Line*. "Then, as now, the houses were built of frame, some with cedar shingles. There were those of stone or brick, but frame houses predominated, with inside chimneys and 'caps' over the window frames in a plain or fancy design. Many of the early homes were designed without benefit of architect." From these humble beginnings grew a village of sophisticated and gracious homes.

Around 1900, architectural plans for popular housing styles were offered through catalogs. Most of Hinsdale's bungalows and foursquare-style houses were likely built using these available plans. At the same time, an impressive number of architect-designed, high-style homes were built for Hinsdale's prominent residents. Some of all types remain, lovingly maintained.

Other homes have not been so fortunate. Hinsdale has been hard hit by the teardown phenomenon; some reports indicate the trend began here. Since the village began keeping records in 1986, almost 40 percent of Hinsdale's housing stock has been demolished. In 1998, Landmarks Illinois named the entire village of Hinsdale as one of Illinois's Ten Most Endangered Historic Places noting, "Hinsdale is under siege. Explosive growth is taking its toll on the historic housing . . . threatening to homogenize this once beautifully eclectic historic community." Hinsdale has lost over 1,100 additional homes since the report was published.

Isaac Bush, real estate agent, merchant, and early village postmaster, was the first owner of this 1868 home at 137 North Lincoln Street. It was Bush who first suggested the name "Hinsdale" for the village, after the town in New York where he was born.

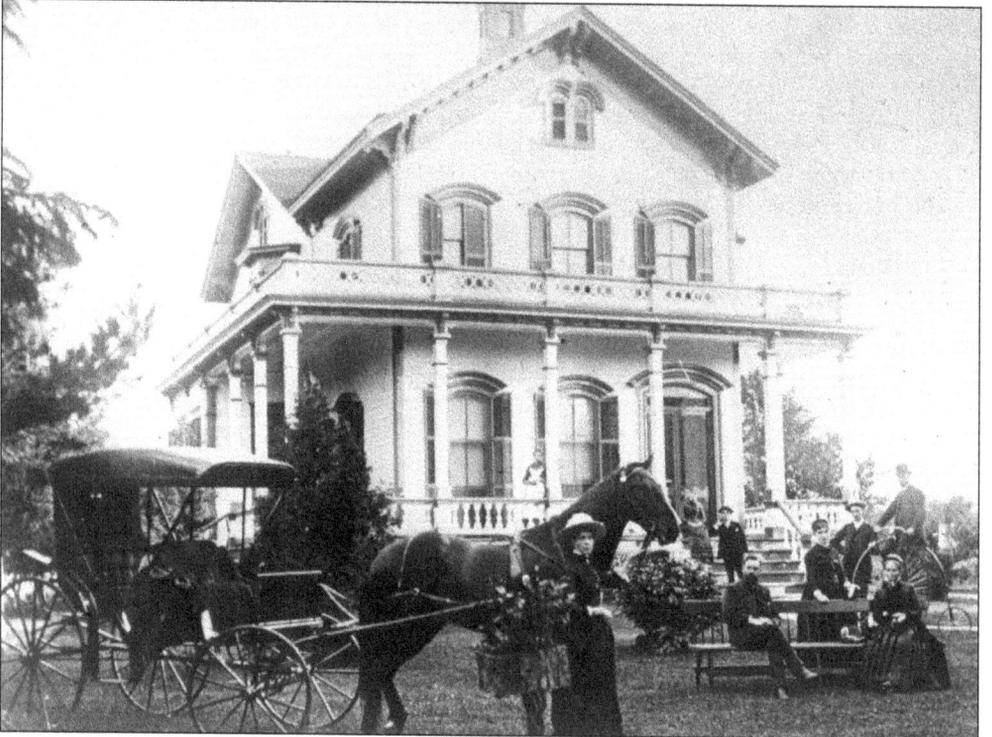

This Italianate home was built in 1869 at 142 East First Street. It was owned by William Whitney, the man responsible for coordinating the village's incorporation in 1873. Still standing, the home was the first in Hinsdale to be listed in the National Register of Historic Places.

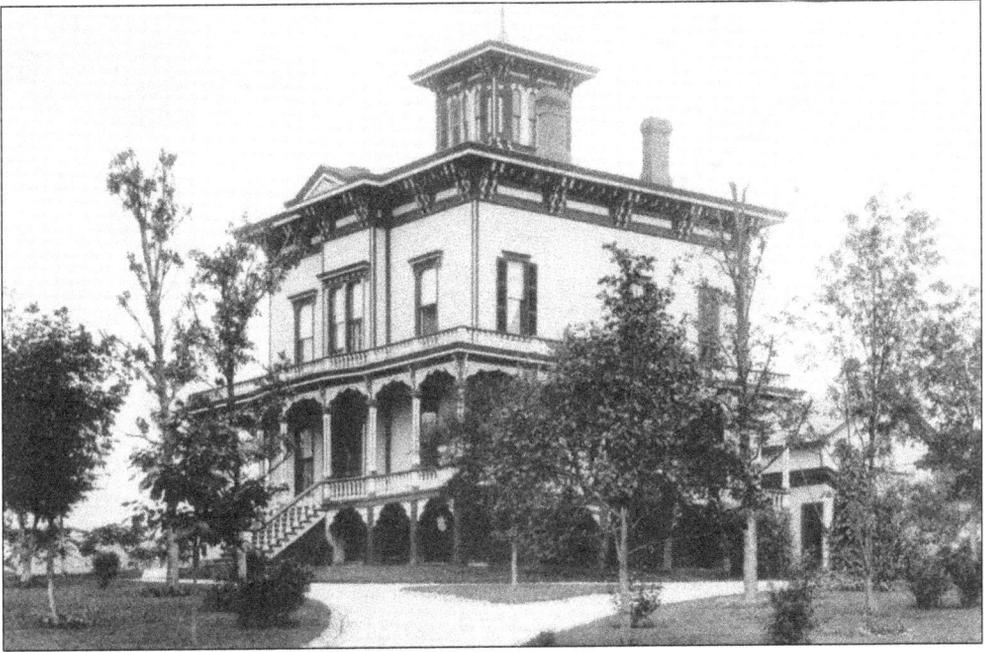

Built for C.T. Warren in the 1870s, this home stood on the site now occupied by the Memorial Building. Warren and his two brothers, all early Hinsdaleans, were partners in a Chicago grain business. In 1926, the vacant home was acquired by the village and demolished to allow for the construction of Hinsdale's landmark structure.

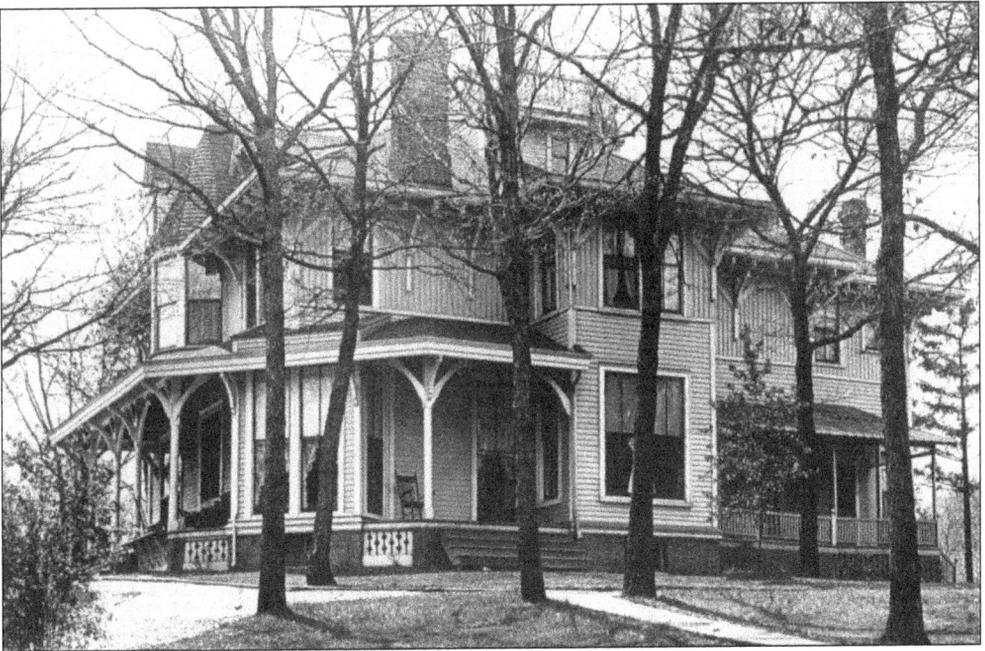

H.L. Storey, a successful piano dealer whose firm continues to this day, lost his Chicago home in the 1871 fire. One of several "fire refugees," he brought his family to Hinsdale and built this house, named Oaklawn, on the hill in Highlands Park just south of Highlands station. The 1872 home burned in 1914 and was never replaced.

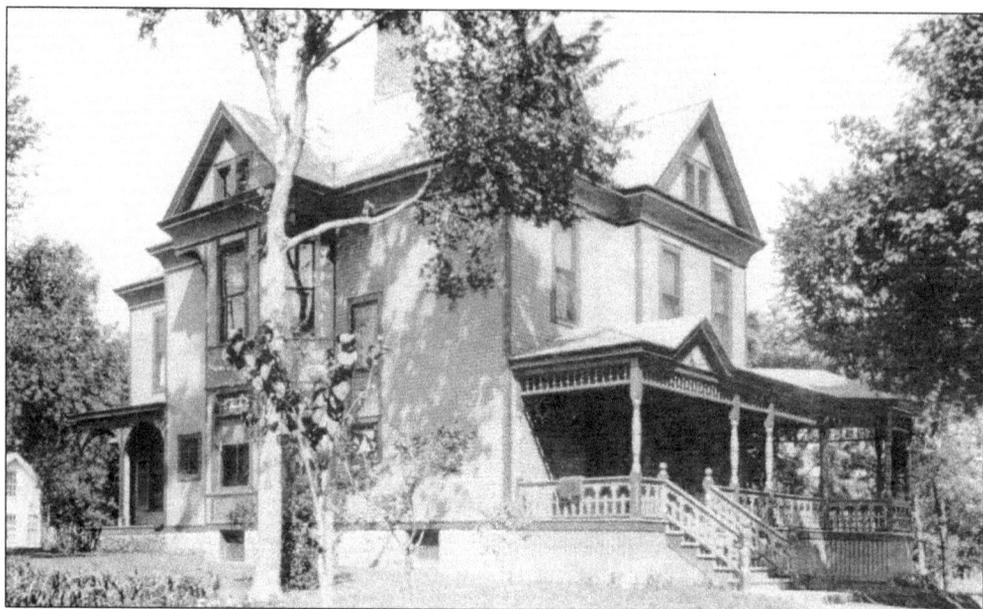

Public-spirited Deming Preston had this home at 219 East Third Street built in 1887. He noted an absence in his new prairie community—it had no squirrels. To rectify this, Preston and other residents purchased several dozen pair to populate the village. In addition to this successful effort, the resourceful Preston served as a local bank president, volunteer fire chief, founder of the library, and village president. The home was demolished in 1995.

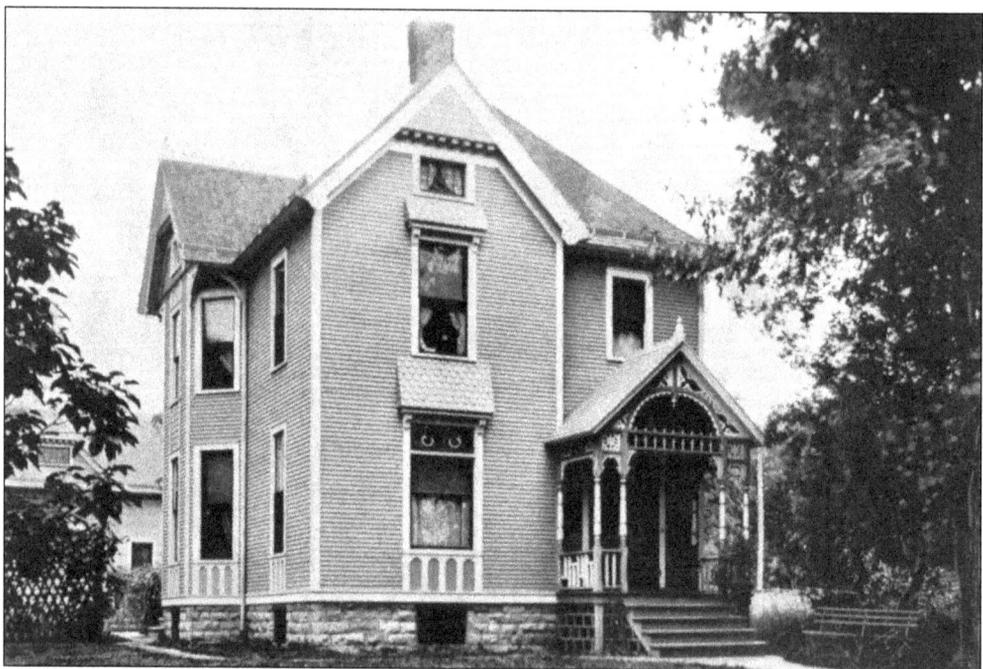

German-born building contractor Adolph Froscher arrived in Hinsdale in 1869. A talented craftsman, Froscher built commercial properties and fine homes for many prominent residents. This, his own home built in 1888 at 314 South Washington Street, still stands today, remaining in the family since the day it was built.

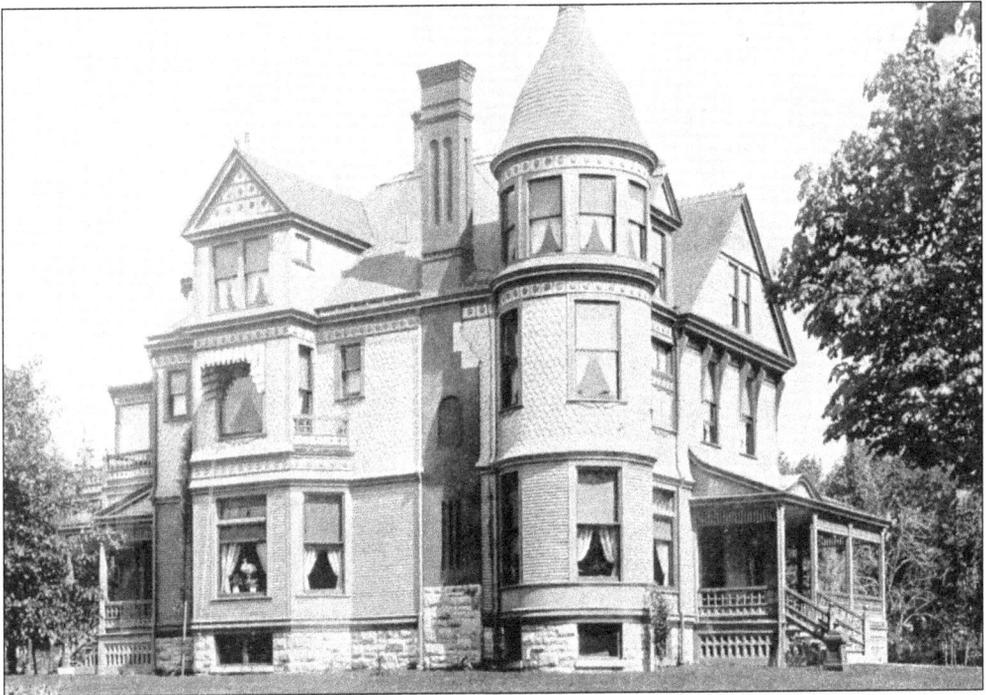

This home at 318 South Garfield Avenue was built in 1888 for Robert Childs, Civil War veteran, school principal, and attorney. Childs represented this district in the US Congress from 1893 to 1897. The Queen Anne home is listed in the National Register of Historic Places.

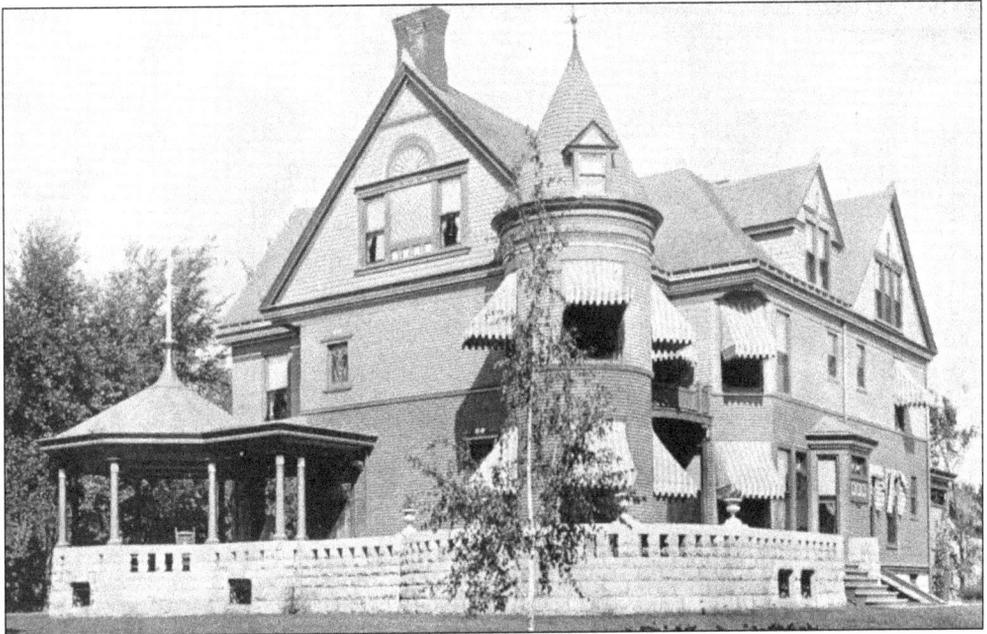

George Robbins, the son of Hinsdale's founder, had this Queen Anne home constructed in 1889 at 8 East Third Street. Francis Peabody, president of Peabody Coal, and Alexander Legge, president of International Harvester, have also owned the home, still standing and listed in the National Register of Historic Places. President Hoover was entertained here when the Legges owned the home.

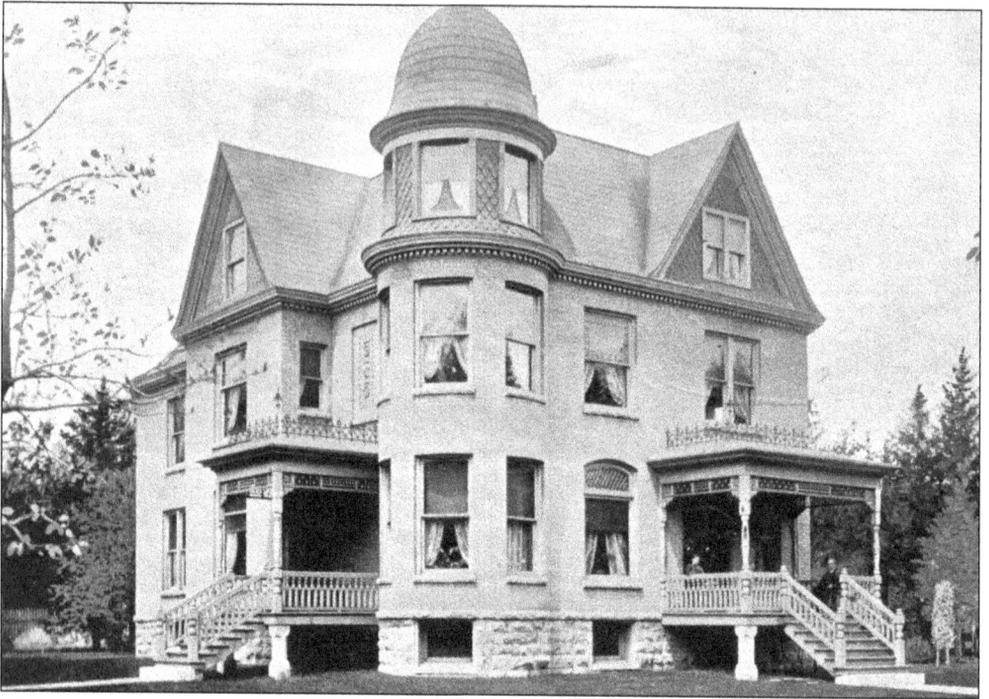

This 1890 Queen Anne–styled home at 206 North Washington Street was built for Heman Fox. Fox had grown up in Fullersburg, away at school in the winters and working his father's farm in the summers. After serving in the Union army, he joined his brother in a successful career as one of the early merchants in Fullersburg and Hinsdale.

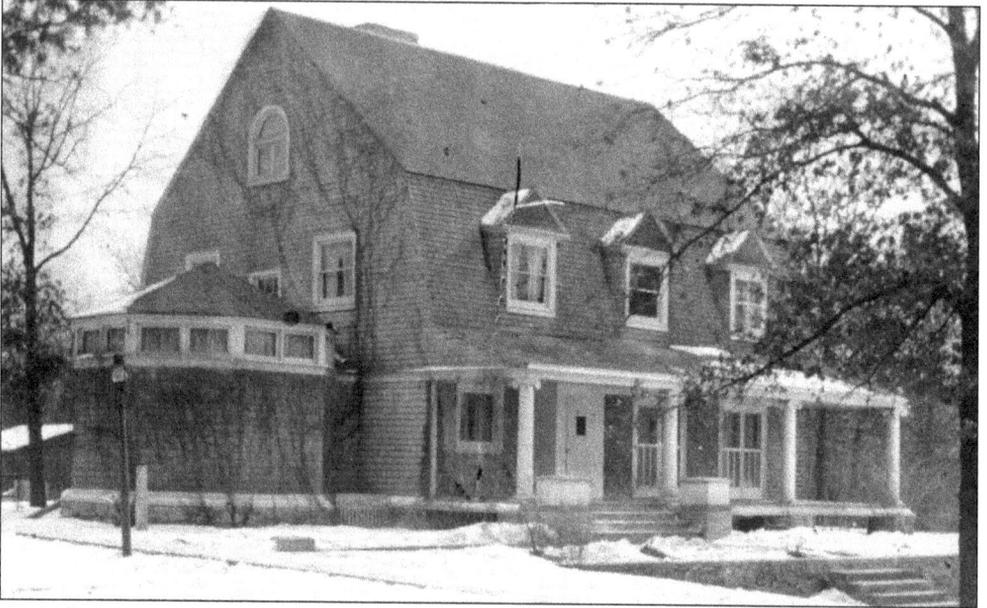

With the appearance of a grand Dutch Colonial, this home at 121 South County Line Road was designed by a young Frank Lloyd Wright in 1894. Owner Frederick Bagley, a marble merchant, commissioned the design, which includes marble details and an octagonal library. The floor plan is said to be very similar to that of Wright's own Oak Park home, built in 1889.

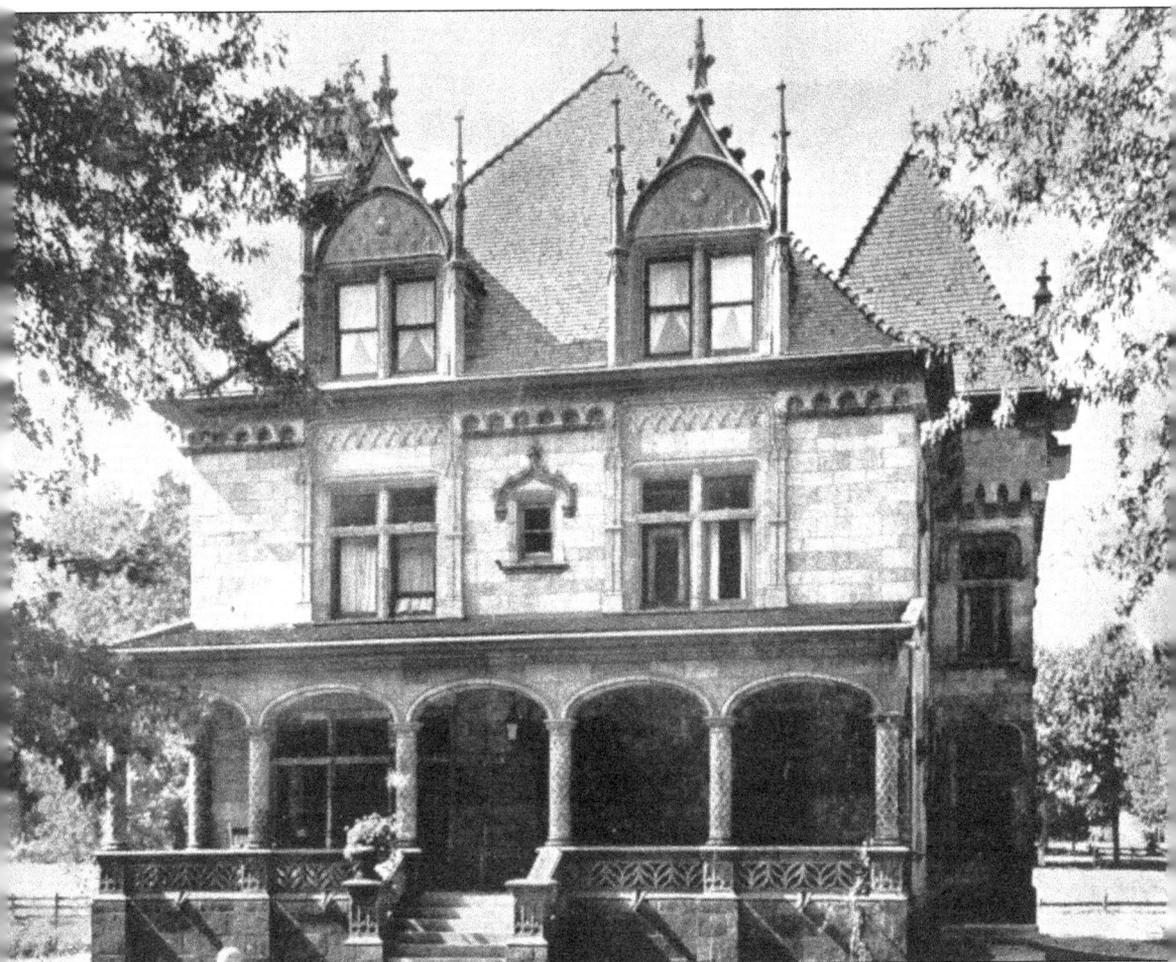

Inspired by a Loire Valley chateau, the prominent Chicago architectural firm of Jenney & Mundie designed this home at 314 North Lincoln Street. It was built in 1893 for William D. Gates, founder and president of the American Terra-Cotta Company. As a tangible testament to the product, almost every part of the exterior is made of terra-cotta. To support the building's weight, the basement is divided into rooms matching those of the floor above. The south yard, now occupied by another house, originally held gardens and a terra-cotta fountain.

This stately 1898 Colonial Revival residence at 230 East First Street was the boyhood home of Paul Butler, founder of the village of Oak Brook. The Butler family came to this area to establish a paper mill, the first in the Midwest. The home was designed for the Butlers in 1898 by G.W. Ashby, known for his school and library designs as well as private homes.

Prairie School architect George W. Maher designed this home at 306 South Garfield Avenue for William Coffeen in 1899. Coffeen, director of a baking powder company in Chicago, supplied the first local golf club with baking powder cans that were sunk into the greens for cups. The home was later owned by Samuel Dean, founder of Dean Milk Company.

Myrta Holmes, widow of serial killer H.H. Holmes (featured in Erik Larson's book *The Devil in the White City*), moved to Hinsdale with her daughter about 1896, the year her estranged husband was executed. Holmes taught third and fourth grades at the Hinsdale Public Schools for at least 15 years. She boarded at various homes in the village; in 1912, she lived here at 212 North Lincoln Street.

An excellent example of Prairie School design, this home at 231 East Third was designed by noted architect E.E. Roberts. Built for lumber executive A.W. True in 1908, the home features a low-pitched roof with broad eaves and bands of windows characteristic of the Prairie style.

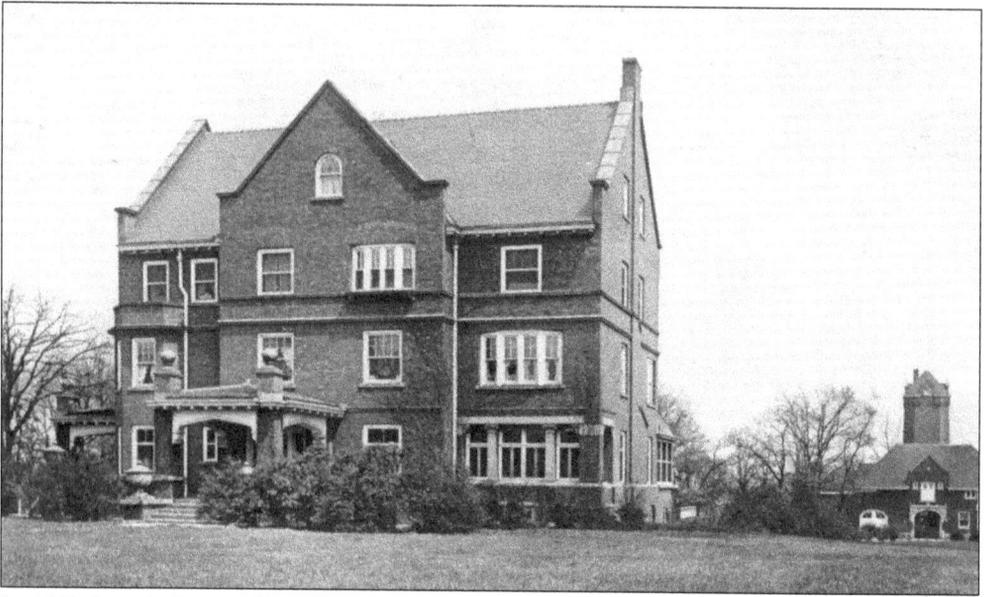

In 1901, Joseph Carson Llewellyn designed this 12-acre country estate at 505 South County Line Road for the family of real estate magnate Lemuel Freer. In this c. 1915 photograph, the carriage house, stable, and silo can be seen to the right of the commanding home. While the third-floor ballroom was removed in the 1930s, the home and a large portion of the impressive grounds remain.

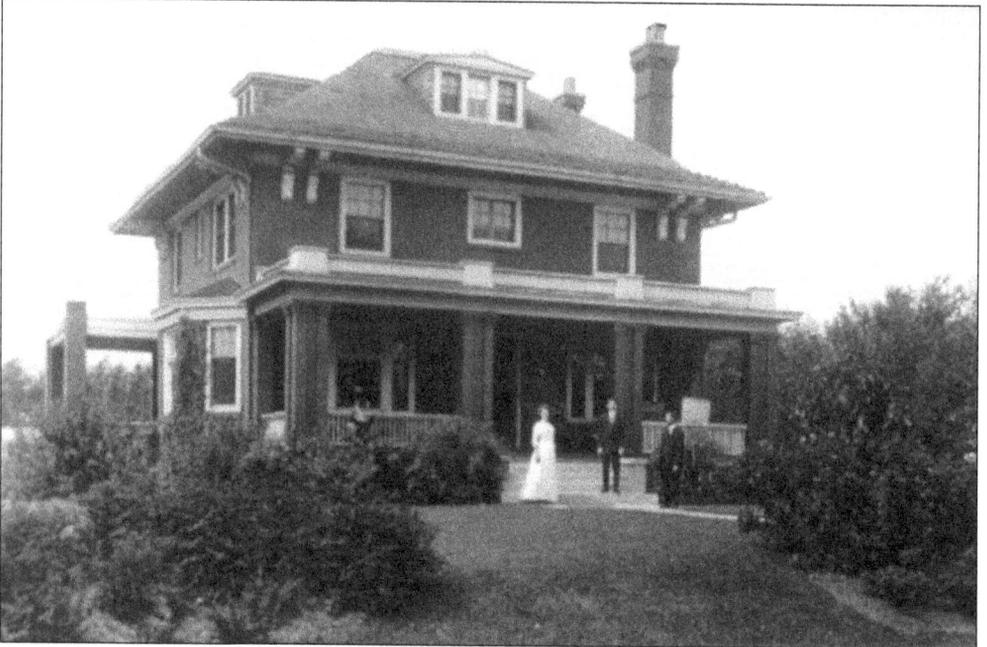

When built about 1910 for Moy Ming and his family, this home at 318 North Madison Street stood alone, centered on the block. Ming was a Chicago tea merchant and restaurateur who owned the "largest and most beautiful Chinese Café in the World" with a seating capacity of 2,000. The house and grounds were later owned and brilliantly landscaped by Mary Dynes, horticulture expert. The house was demolished in 2001.

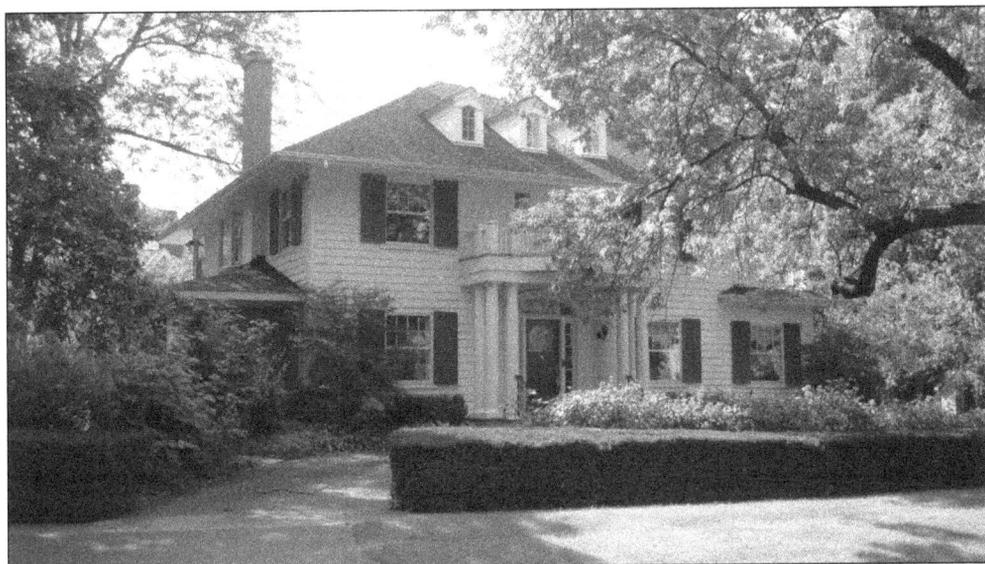

640 South Park was the home of Chicago Cubs president William Veeck from 1914 until his death in 1933. Bill Veeck Jr. was raised here, ever mischievous and excelling in sports. He went on to own three major league baseball teams, culminating with the Chicago White Sox. Veeck's showmanship and promotional stunts demonstrated his philosophy that baseball should always be fun. (Photograph by Sandra Williams.)

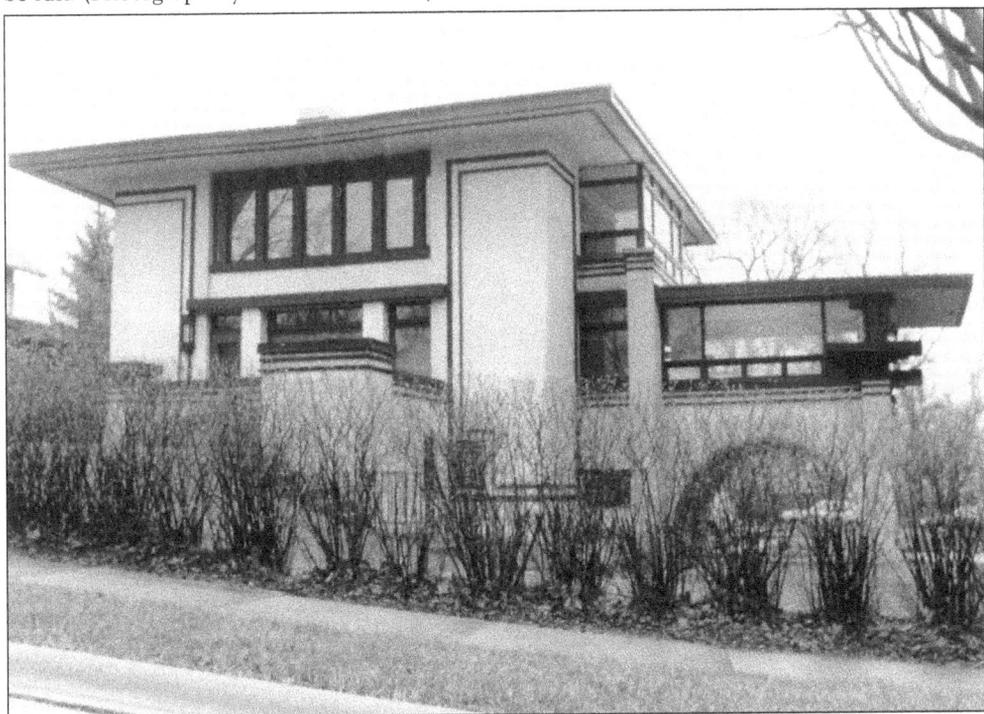

This Prairie-style home at 105 North Grant Street, often mistaken for a Frank Lloyd Wright commission, was designed by William Drummond in 1912. Drummond worked for Louis Sullivan and Daniel Burnham before becoming chief draftsman for Wright, leaving to establish his own practice in 1909.

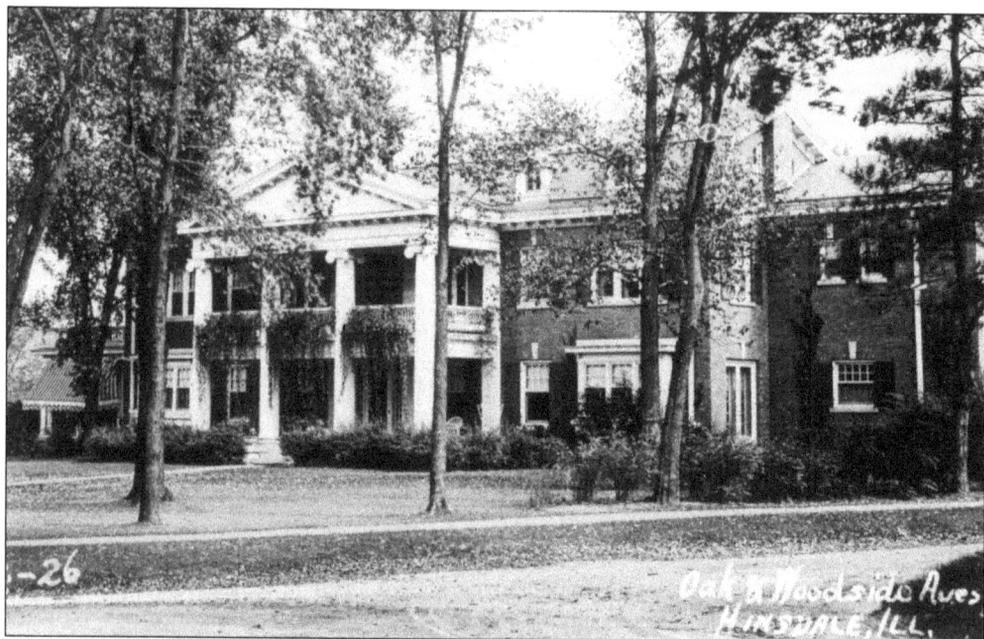

When built in 1912, the impressive Classical Revival home at 419 South Oak Street sat on five acres of land. This c. 1920 photograph was taken about the time it was purchased by Philip R. Clarke, prominent Chicago banker. Clarke served tirelessly for charitable and public projects, raising an estimated $2 billion over his lifetime. In Hinsdale, he led the campaign for the Memorial Building and its construction, his greatest village legacy. (Photograph by L.C. Harner.)

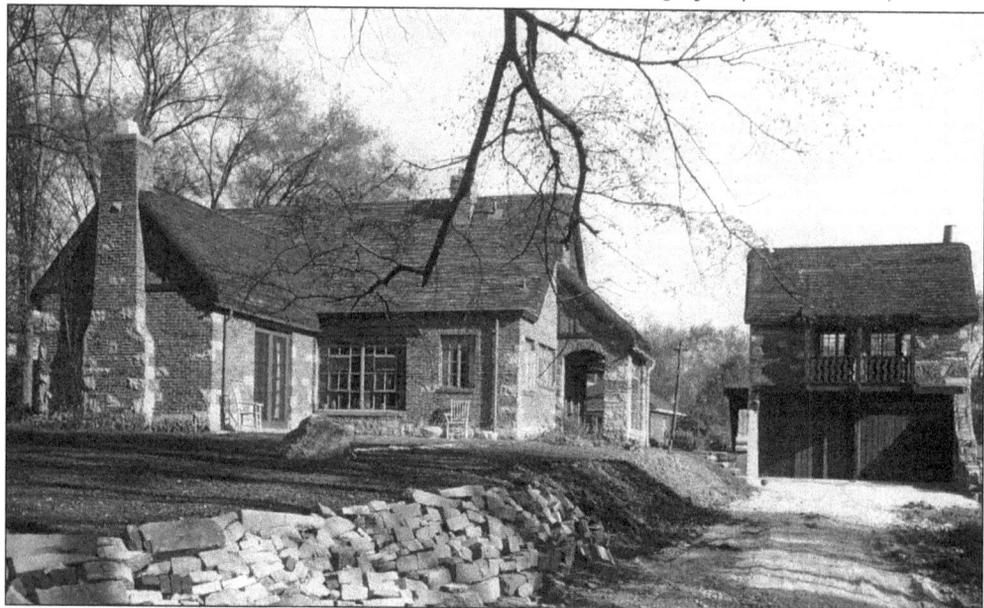

The home built in 1924 at 327 South Oak Street was designed by Hinsdale architect R. Harold Zook for his own family. It bears the architect's signature elements including an undulating thatched roof and rusticated stonework. Zook's studio is shown at the right, over the garage. Threatened with demolition, the Hinsdale Historical Society saved the home and studio, moving them to Katherine Legge Memorial Park in 2005.

This contemporary home at 740 South Elm Street was designed by Hinsdale architect Philip Duke West for the Bunker family in 1941. The house is built of concrete with steel beams, complemented by one of the first inground swimming pools in the village. In addition to other homes, West's Hinsdale designs include the Community House, Hinsdale Medical Center, and the current police and fire station. (Photograph by Hedrich-Blessing Studio.)

Dr. Billy Graham once lived at this address, 214 South Clay Street. Upon his graduation from the seminary in 1943, he was assigned to the Western Springs Baptist Church. The church found a four-room, furnished apartment for him and his wife on the second floor of this home.

FLOOR PLAN OF
LUSTRON MODEL HOUSE

Manufactured By

LUSTRON CORPORATION
CICERO 50, ILLINOIS

To help meet the need for post–World War II housing, Carl Strandlund developed the prefabricated Lustron home. The Ranch-style homes were made entirely of steel panels, 24-inch square and porcelain-coated. The panels were shipped to construction sites around the country where, in about 10 days, they were bolted together on concrete slabs. The much-heralded Lustron prototype, designed by Blass & Beckman of Wilmette, was built in 1946 at 7210 South Madison Street in Hinsdale. About 2,500 of these homes were built across America with orders for 20,000 more, but production faltered. The company declared bankruptcy in 1950. While Hinsdale's Lustron was razed in the 1990s, this identical home in southern Illinois still stands. (Above, photograph by Heather Munro; left, Lustron Corporation sales brochure.)

Seven

CHURCHES, CHRISTIAN EFFORTS, AND NOBLE CAUSES

Churches can offer important elements to life, social as well as spiritual. Even in its earliest days, Hinsdale was a church-going community, using the train station for the first services. By 1900, Sydney Collins reports:

> The Congregational, Presbyterian, and Episcopal churches were all located in the same block on the south side. The Swedish church stood on Fourth Street and the German Lutheran church at Third and Vine. The German Reformed Immanuel Church, a newcomer called the "pumpkin church" for the ball on its spire, had just been built at Third and Grant Streets. The spiritual needs of the southsiders were thus well provided for but the north side was not neglected. It had the Unity Church on Maple Street, the Presbyterian chapel in West Hinsdale, and another Swedish church at Stough's Hall.

All of these churches for a population of about 2,000—and more denominations followed, flooding the village with spiritual choice. As a reflection of Hinsdale's immigrant background, five of the early churches conducted their services in a foreign language. "Yet all of these churches were going concerns," Collins continues:

> Sunday to the Hinsdale kids meant both Sunday school in the morning and more church in the evening. Almost every Episcopal kid belonged, at one time or another, to the choir. In my day, it consisted of two dozen boys and a few men; practice was held twice a week. The boys were a spirited bunch, paid 25¢ per week with deductions for misbehavior. After attempts to lock out the choir master, stash smaller members in their lockers or hide in the darkened pews when the lights would fail, most choir members received 10¢ and knew they were lucky.

The churches and the community's benevolent spirit begat organizations of social reform. Throughout Hinsdale's history, village residents have volunteered their time and abilities, rallying behind efforts aimed at improving social ills. Two of the finest and farthest reaching were the Fresh Air Association and the Life Boat Rescue Home, detailed in this chapter. But religious institutions prompted other worthy causes, including the library and the Hinsdale Sanitarium. Most notably, perhaps, they reinforced the desire to be good citizens.

The railroad station served as Hinsdale's first church, hosting ministers of various denominations from surrounding communities. The Baptists were the first to build their own church, constructed in 1870 on land donated by William Robbins. Located on the southwest corner of Garfield Avenue and First Street, the splendid building proved too costly. Attempts at sharing the space were not enough to sustain the congregation, and the Baptists disbanded. The building became a community meeting place known as the "Music Hall." The wooden structure burned to the ground July 4, 1895.

In 1870, O.J. Stough donated land on Maple Street near Washington Street to establish a Unitarian church. Shown here is the congregation's second church, built in 1888. It is speculated that a young Frank Lloyd Wright played a role in designing the building, whose minister, William C. Gannett, was a close personal friend. (L.C. Harner photograph.)

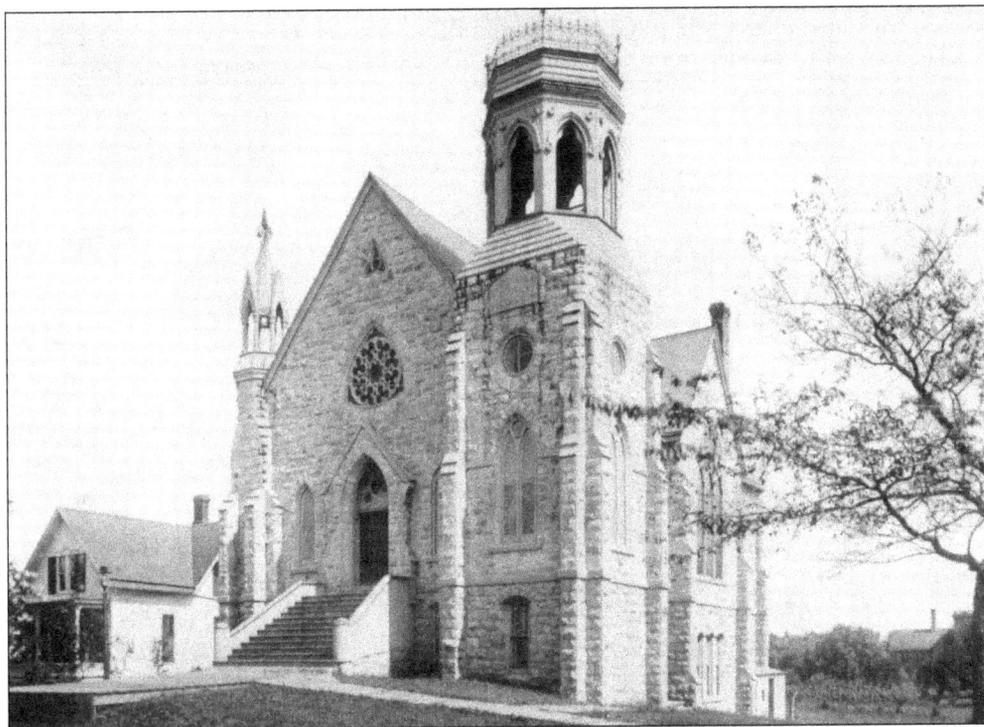

The Congregationalists were the first to organize in 1866 but delayed building until 1872. William Robbins donated land on the northeast corner of Third Street and Garfield Avenue for their church, but construction was slowed by funding difficulties. With only a foundation in place, the inventive congregants roofed it over and gathered for somewhat subterranean services. This continued for nine years until the building, pictured here, was completed in 1881. This building was razed in 1916 for the current church.

Formally organized in 1875, the Episcopal congregation gathered at the public school and other available churches until its own building was finished in 1886. William Robbins donated the lot, located where the church still stands at First and Blaine Streets. This 1890 photograph shows the building with a wooden front, not completed in stone until 1914.

On a lot just west of the Episcopal church, this Presbyterian church was built in 1893. In 1918, the congregation, together with some Unitarians, joined with the Congregationalists in forming Union Church. This building then served as the Episcopal Guild Hall and Sunday school.

Organized about 1889, the Swedish Evangelical congregation built this church at 18 East Fourth Street. At that time, summer school was also held here to teach biblical history and the Swedish language. The first service in English was offered in 1922; in 1935, Swedish services were discontinued altogether. A new church was built in 1931 at Fourth Street and Garfield Avenue, and a house replaced this structure four years later.

The first Zion Lutheran Church, built in 1888, stood on the northeast corner of Vine and Second Streets. Two years later, Zion's school was established with classes held in the sanctuary and the pastor serving as the instructor. In 1915, a new church, still standing, was constructed, and this building was used as the school until 1931.

Needing a church closer to their Hinsdale neighborhood, German Lutherans split from the Fullersburg congregation. In 1900, skilled congregants volunteered their labor and expertise to build this church at the corner of Third and Grant Streets. The congregation vacated the building in 1964. Saved from demolition, renovated, and reopened to the public, the building, renamed Immanuel Hall, is owned and operated by the Hinsdale Historical Society.

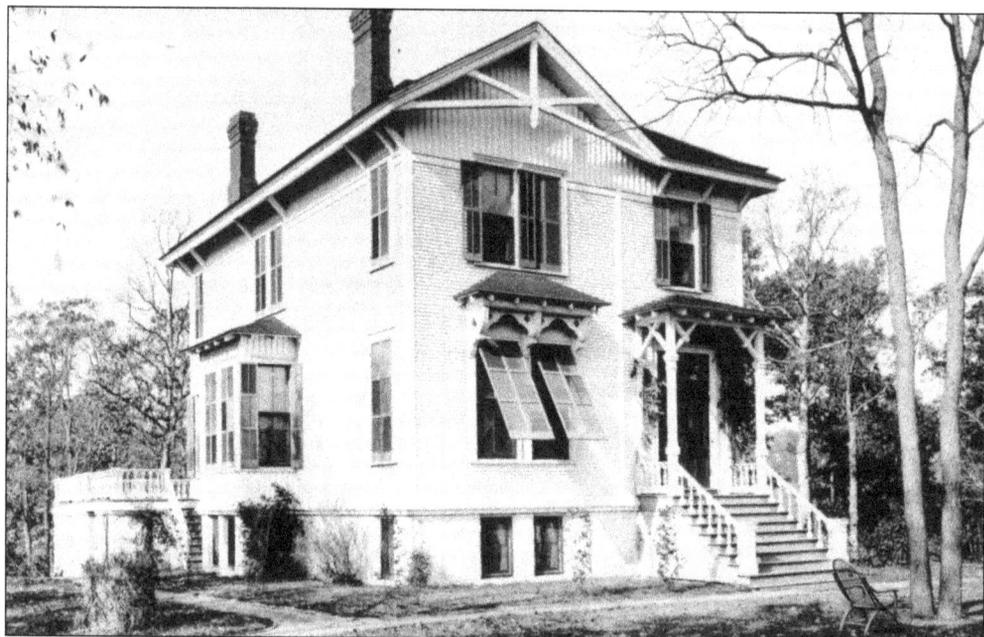

Troubled by chronic war wounds, Civil War veteran Charles Kimball was a patient of Dr. David Paulson, a Chicago physician associated with Michigan's Battle Creek Sanitarium. Kimball persuaded Paulson to open a branch of the sanitarium in Hinsdale on the former Beckwith estate, shown here. Located north of the railroad tracks near Oak Street, the 10-acre property was purchased by Kimball in 1904, who offered it to Paulson on generous terms.

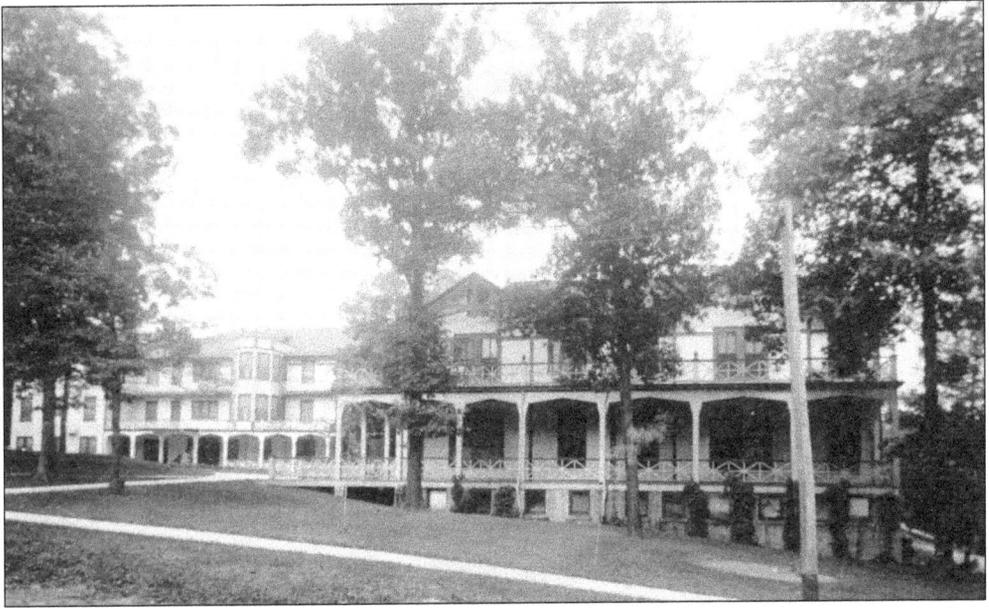

A 17-room addition was added to the existing home, and the Hinsdale Sanitarium opened in 1905. A healthy mind, physical therapy, diet, and spiritual wellbeing were considered vital to the healing process. The sanitarium's tranquil setting provided an ideal atmosphere for this approach. Families were encouraged to participate in treatment and often camped on the grounds.

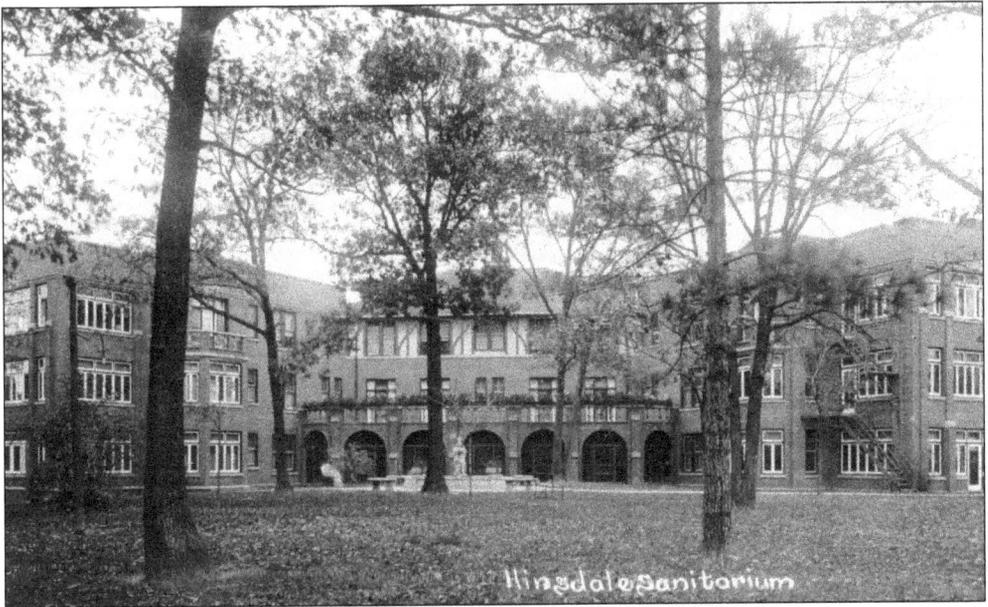

A nursing school was established in 1908 that graduated 1,196 registered nurses before the program closed 60 years later. Meanwhile, demand for patient rooms was continuous. The sanitarium expanded several times, adding this large brick addition in 1920 and others, culminating with the 2012 patient pavilion. (H.B. Brooks photograph.)

The Life Boat Rescue Home for unwed mothers and abandoned children was created and managed by the Hinsdale Sanitarium. Relocated in 1903 from Chicago to Hinsdale, the home was strongly supported by village residents, expanding in 1909 to the building shown here at 328 Phillipa Street. The home provided shelter, counseling, adoption placement, employment assistance, and the opportunity for a new life. After offering refuge to 1,363 young women and 1,500 children, the home closed in 1932. (Below photograph courtesy of Hinsdale Hospital.)

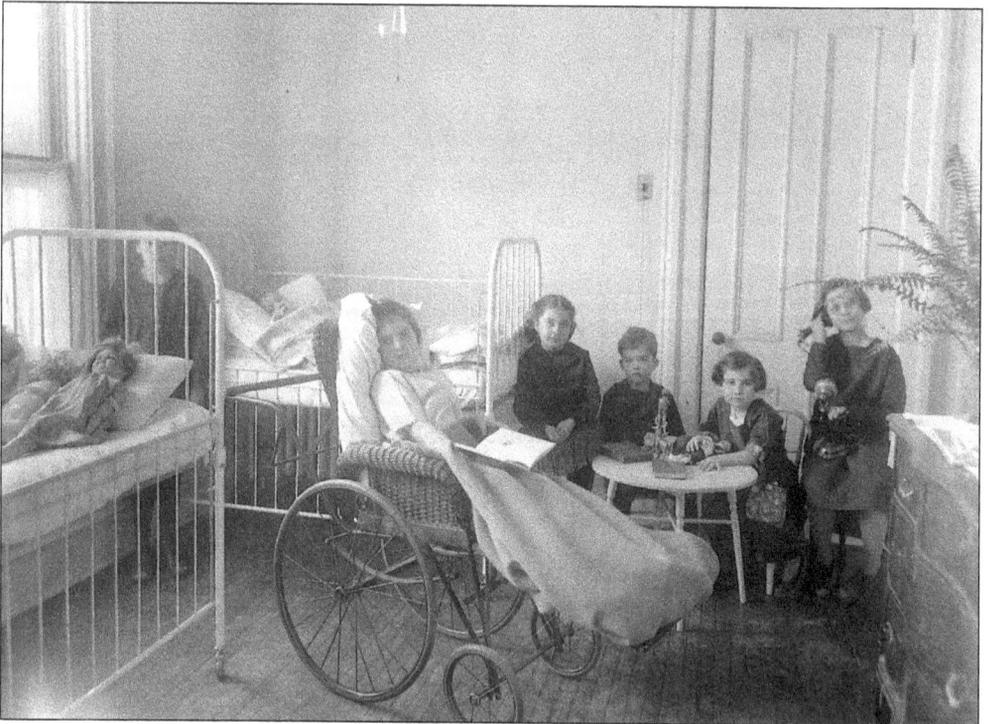

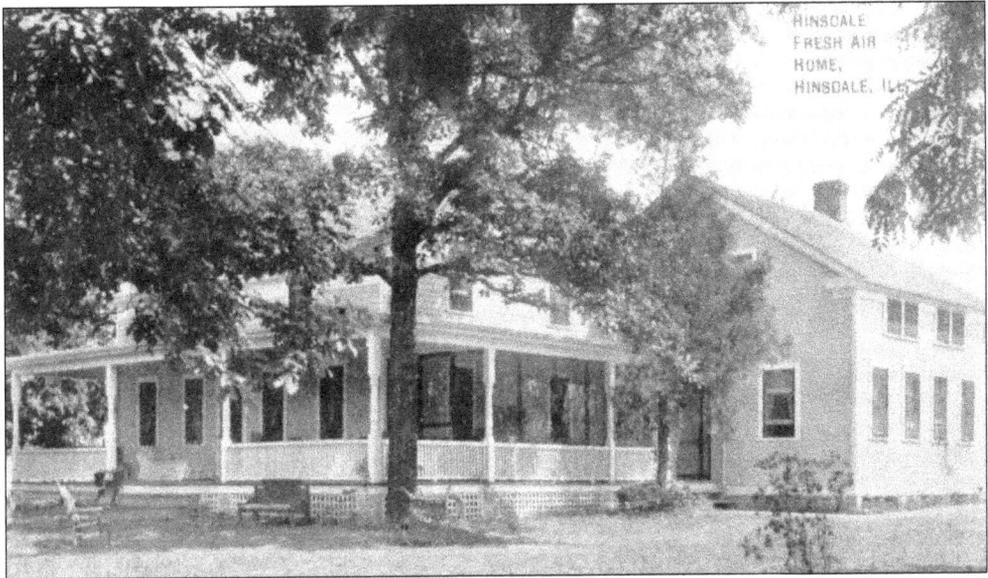

The Fresh Air Association was one of Hinsdale's most successful philanthropies. Begun about 1888 with inspiration from Unity Church, the association provided women and children from Chicago's poor neighborhoods "a vacation in the country." The former Marvin Fox home, still standing at 32 West Ogden Avenue, was loaned to the group, later becoming its permanent home. A unique and respected program, Jane Addams sent Hull House children to participate.

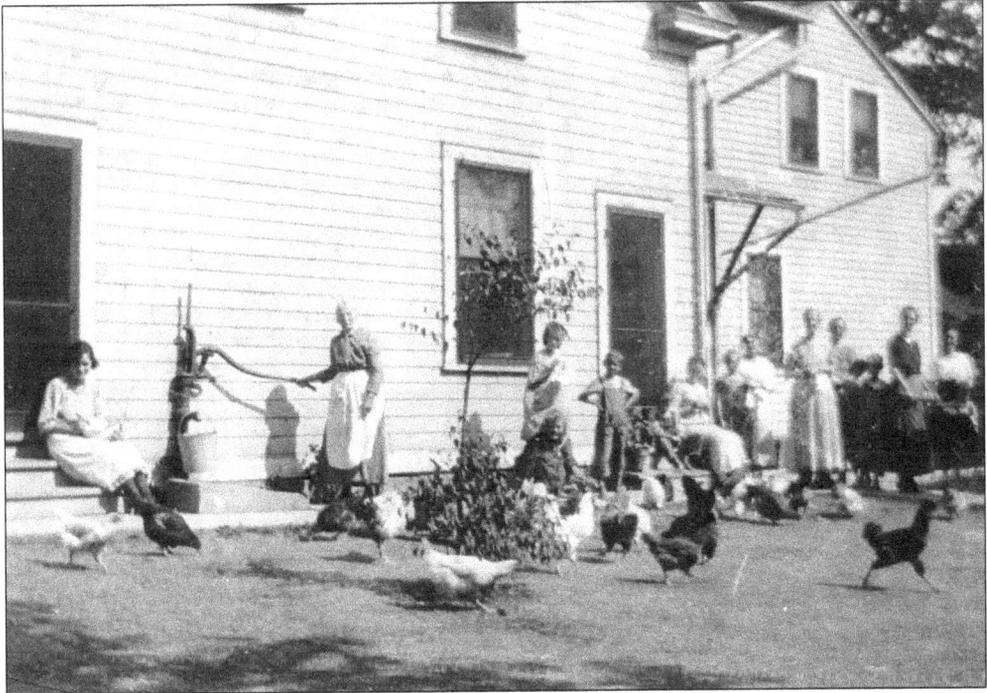

During their weeklong stay in Hinsdale, the visitors enjoyed nutritious food, outdoor recreation, fresh clothing, and "pure air." Village residents, doctors, tradesmen, and merchants provided all that was necessary to keep the association running for over 30 years, sharing their hospitality with over 4,000 guests.

A secular effort, nonetheless a noble cause, was Hinsdale's World War II canning operation. Organized in 1943 to preserve residents' victory garden produce, the Hinsdale Canning Association operated six days a week. James McAfee is shown with grandson James P. Brown in the family's large victory garden at 142 East First Street. (Courtesy of James Proctor Brown III.)

Donating one bushel of produce for relief purposes for each bushel processed, families brought their harvest to the village-owned site, prepared it, and filled the cans, as shown below. The association then completed the pressure-cooking, sealing, and labeling. 67,000 cans were processed the first year with 97,000 processed in 1944.

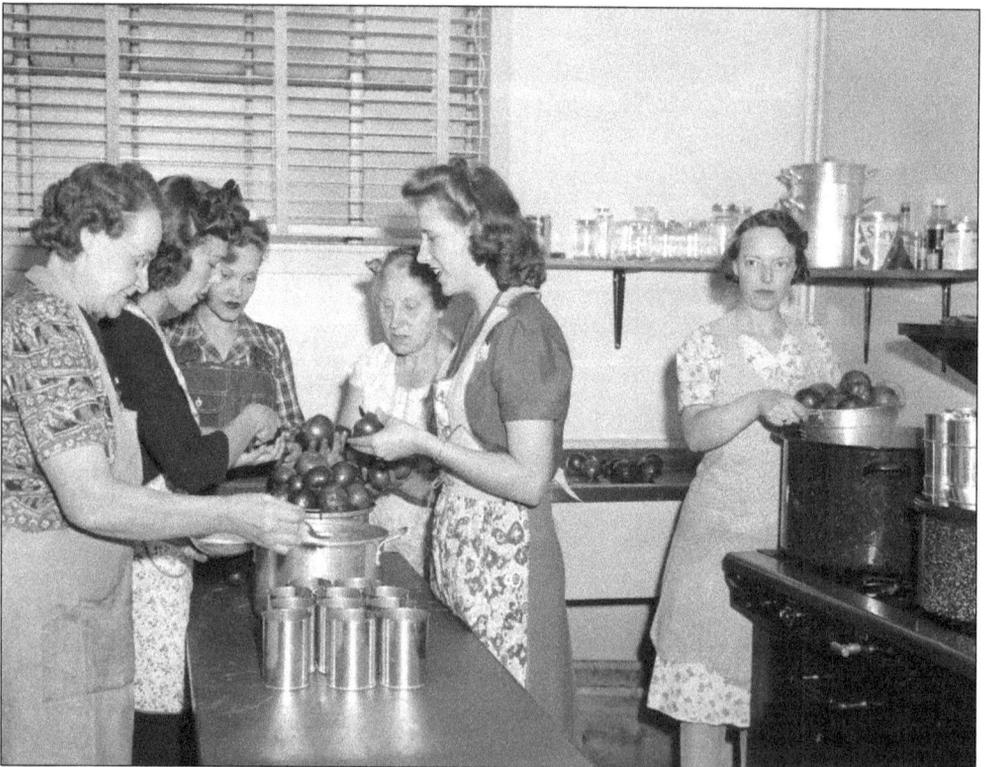

Eight

AT PLAY

Beyond Hinsdale's impressive bricks and mortar are the residents, the real community. While some of their noteworthy public efforts and achievements are mentioned in previous chapters, early Hinsdaleans had busy social lives as well. In those days, everyone was a pedestrian; everyone knew their neighbor. Personal interaction was inextricably woven into daily life.

As today, there was a myriad of clubs and organizations, sports and parties. There were also church suppers and socials, enthusiastically attended regardless of denomination. The outdoors was celebrated with picnics, bicycling, and games. Water recreation was provided by Salt Creek on the north side and Johnson's Slough on the south. Winter brought sleigh rides, sledding, and skating. A favorite sledding hill was Garfield Avenue from its crest near Third Street. A sled could go in either direction, but a ride toward town could almost reach the railroad tracks. After services at the Congregational (Union) Church, even the pastor was known to take part.

Athletics played an enormous role in village life. Baseball was played in the 1870s by town teams before it became the national pastime. Football also had its enthusiasts as Hinsdale competed against other towns along the Burlington route. Over the years Hinsdale has seen nine of its exceptional athletes participate in the Olympic games, from pole vault gold medalists Frank Foss and Laddie Myers in 1920 to pentathlon competitor Bob Neiman in 1988.

Most social activity after 1899 took place at the Hinsdale Club, a stately and spacious building on the southwest corner of Garfield and First Streets. Every major community function took place here—lectures, meetings, concerts, plays, politics, and parties. The club's New Year's Eve celebration was Hinsdale's premiere social event for more than 30 years. Distinguished and elegant, the club's amenities included a billiard room, lounges, auditorium with stage, bowling alley, and later, a swimming pool.

The Hinsdale Club began to lose its pivotal role when automobiles, telephones, radios, and movies changed the nation's lifestyle. The Depression and World War II accelerated its demise. In 1943, the club's remaining assets were turned over to the newly founded Community House organization; the club building was torn down 10 years later.

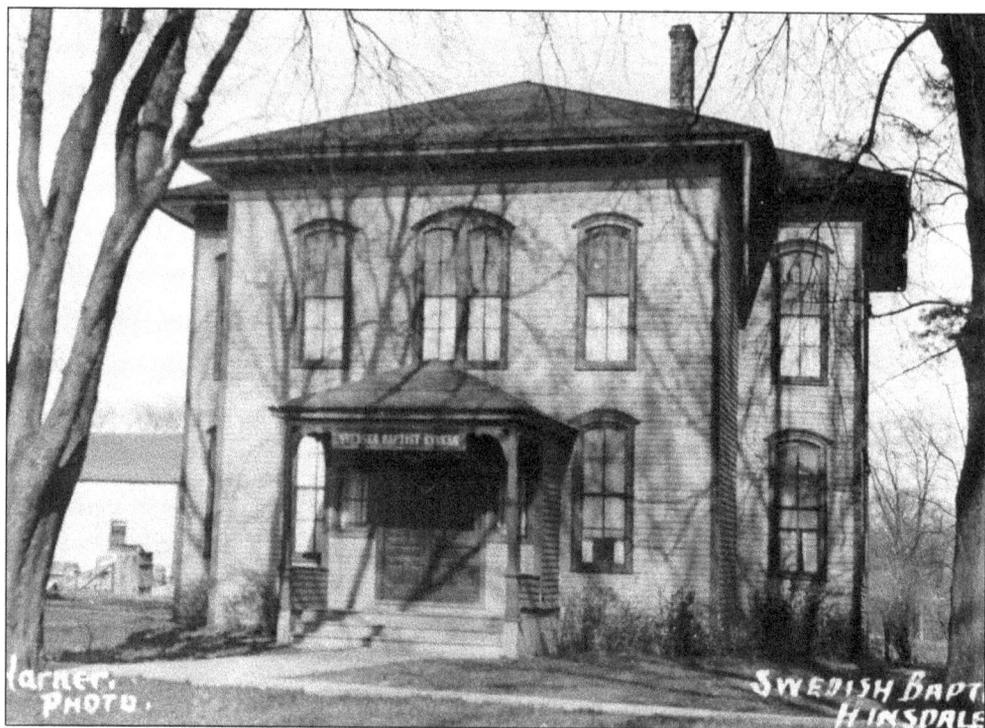

In 1872, O.J. Stough had this building constructed at 11 North Lincoln Street with a school on the first floor and a meeting hall upstairs. Until surpassed by the Hinsdale Club, Stough's Hall was the social and civic center of Hinsdale. This photograph was taken after 1904 when the building was purchased by the Swedish Baptist church. (Photograph by L.C. Harner.)

A Chicago newspaper in 1873 announced, "A masquerade ball is to be given by Mr. and Mrs. O.J. Stough next Wednesday evening. A train will leave Chicago at 7 o'clock and return from Hinsdale at 2 o'clock in the morning." Special trains for social events were customary at the time, evidently any day or hour. This 1881 program indicates Stough's Hall as the location of another event.

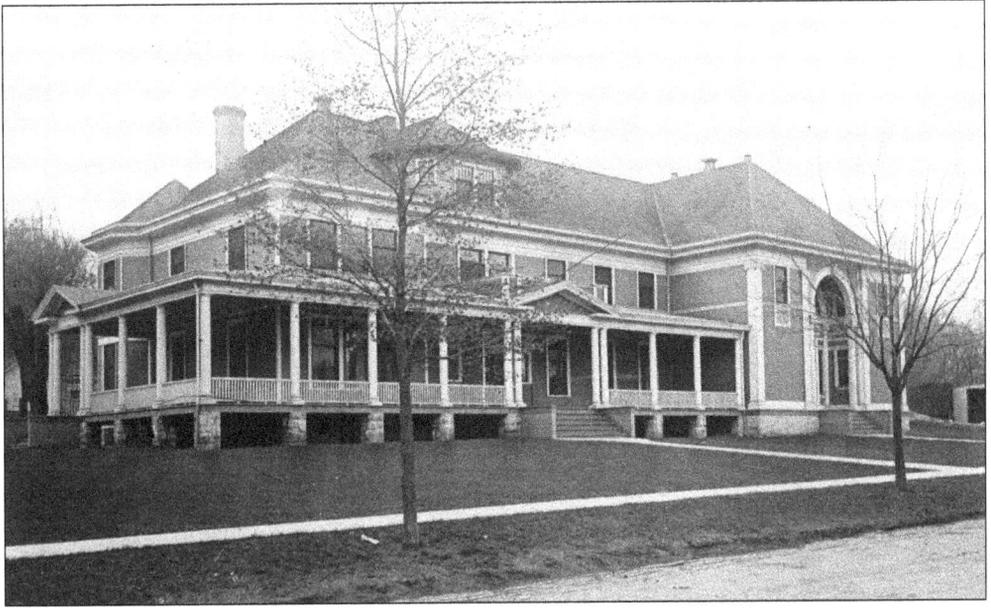

The Hinsdale Club was founded in 1888, initially an informal men's group that met above a local store. With rapid growth in membership and prominence, the club had this building constructed in 1899 at the southwest corner of Garfield Avenue and First Street. This was the center of village social life from that point forward, hosting club meetings, dancing classes, political rallies, performances, card parties, balls, and village celebrations. Membership was open to all village residents. The interior photograph of the club shows the second-floor billiard room.

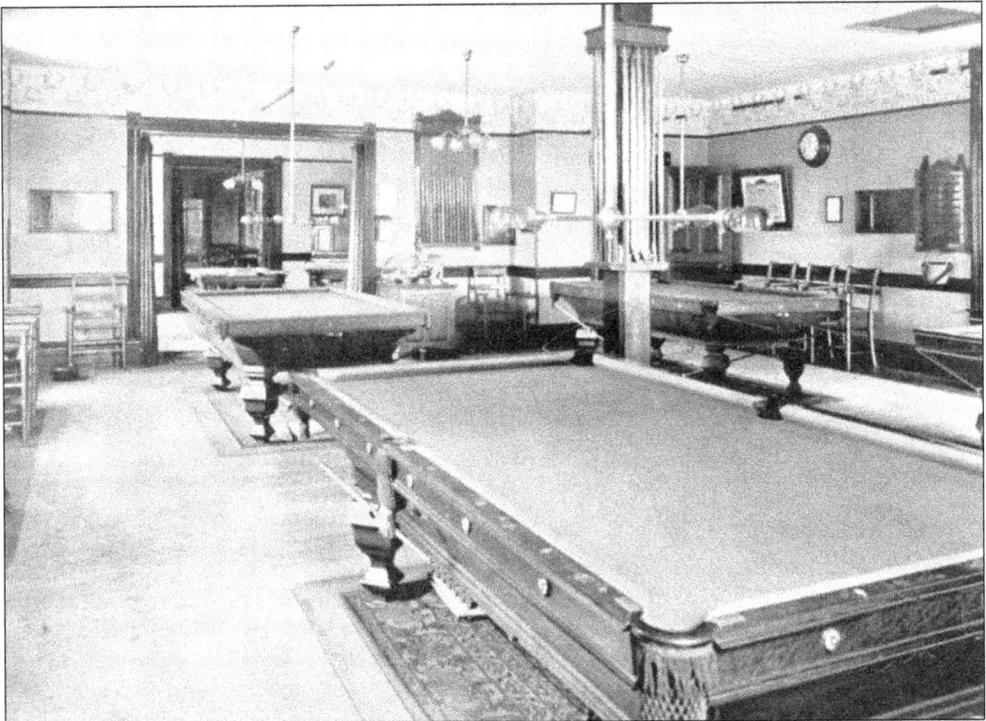

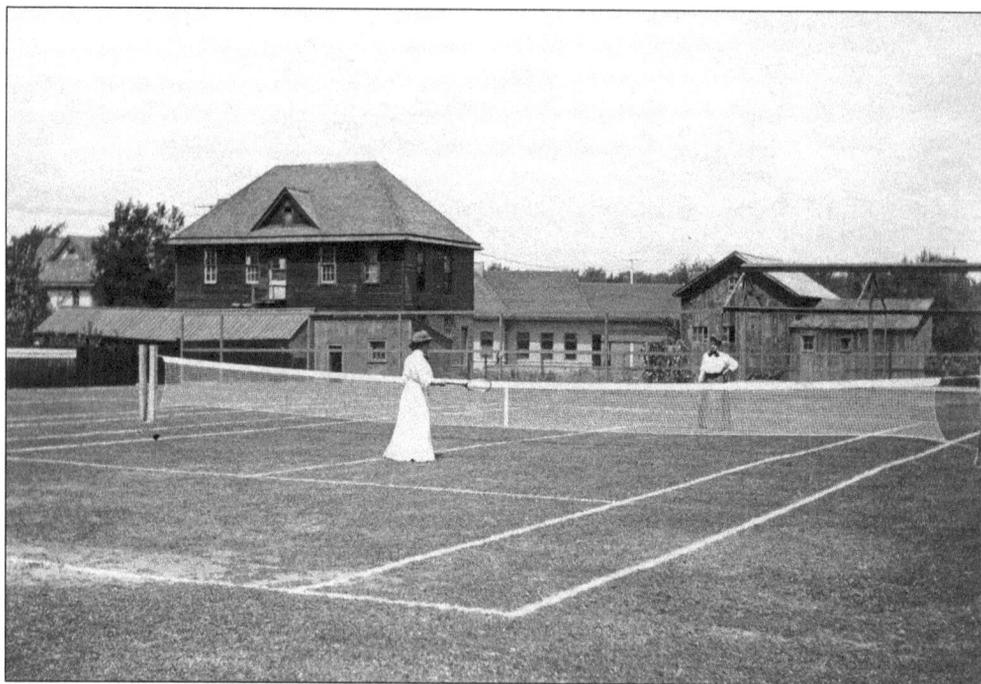

The Hinsdale Country Tennis Club was located across the street from the Hinsdale Club on the northwest corner of Garfield Avenue and First Street, the site now occupied by Fuller's Home & Hardware. This c. 1900 photograph also shows the new (current) railroad station in the center background.

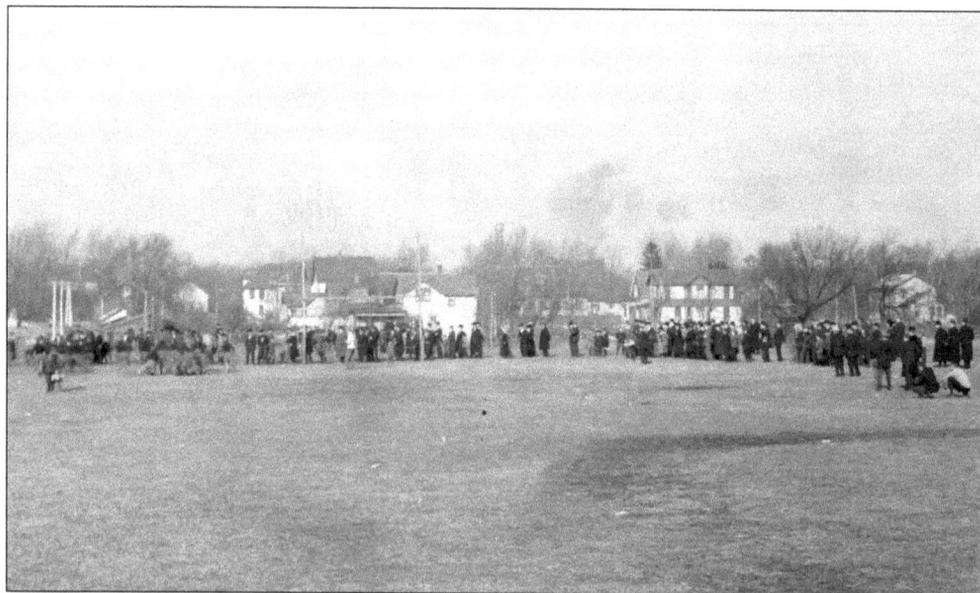

Baseball and football games were played here, a large vacant area bounded by Washington, Lincoln, Seventh, and Eighth Streets—"the village's Coliseum and Circus Maximus" as an early Hinsdalean recalled. Town teams, high school teams, and pick-up games all used this field, referred to simply as "at the end." Located at what was then the south end of Washington Street, this unofficial park also hosted Fourth of July and other village celebrations.

Shown here, the Hinsdale football town team plays Downers Grove in 1913 "at the end." Only one player on the Downers team is wearing the optional leather helmet, the model of the era.

The town baseball team about 1923 is shown "at the end." There were American Legion teams and church teams as well. Union Church fielded a team, as did the Lutherans. During the summer months, men's teams practiced every night of the week for weekend games that had a few hundred Hinsdaleans turn out to watch.

The high school state basketball championship was won by this Hinsdale team in 1909. The "largely self-coached" team had a season 22-3 record, outscoring their opponents 838 to 498. From left to right are (first row) Fred Bahlman and Woodbury Melcher; (second row) Fred Cortis, Gilbert Keith, and Preston Davidson; (third row) Frank Dean and Arthur Collins.

Girls also participated in high school sports. This is the 1905 women's basketball team, possibly the first, dressed in uniforms of wool bloomers, high-collared blouses, and long black stockings.

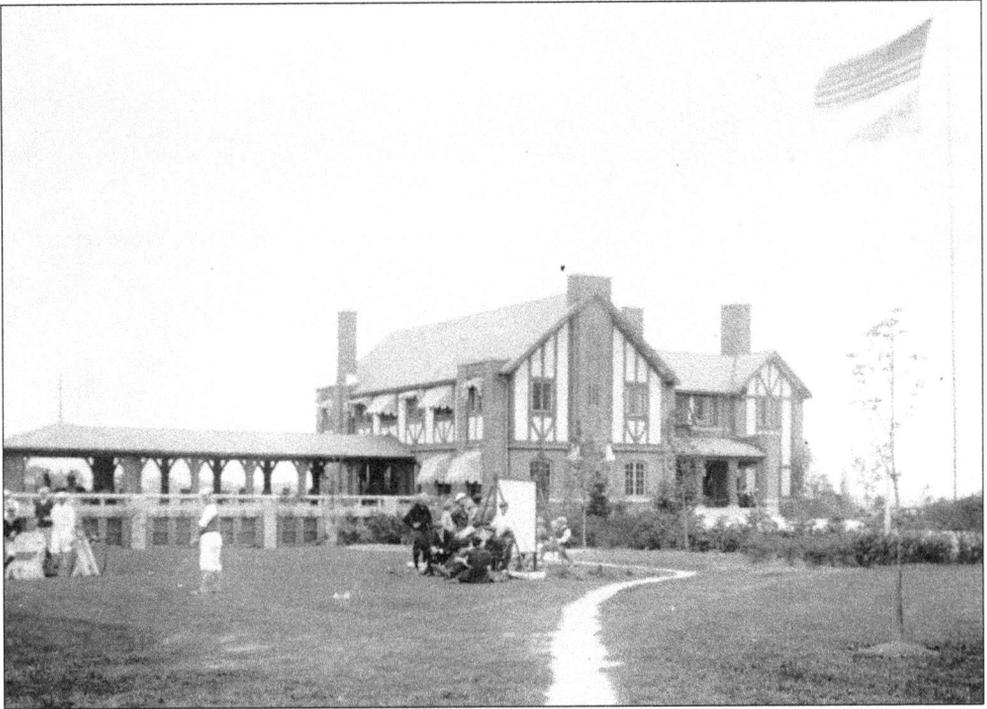

Golf was first played in Hinsdale in the 1890s on a six-hole course laid out along Ayres Avenue near Lincoln Street. In 1898, the Hinsdale Golf Club was founded, located just east of its present Chicago Avenue site. The 1923 clubhouse, shown here, has been expanded and continues to serve the membership.

Ruth Lake Country Club, shown about 1940, was founded in 1922 by some younger men in the village who had used this site along South Madison Street for hunting, camping, and skate sailing. The club was named for Linus Ruth, a boyhood friend of the founders who lost his life in World War I.

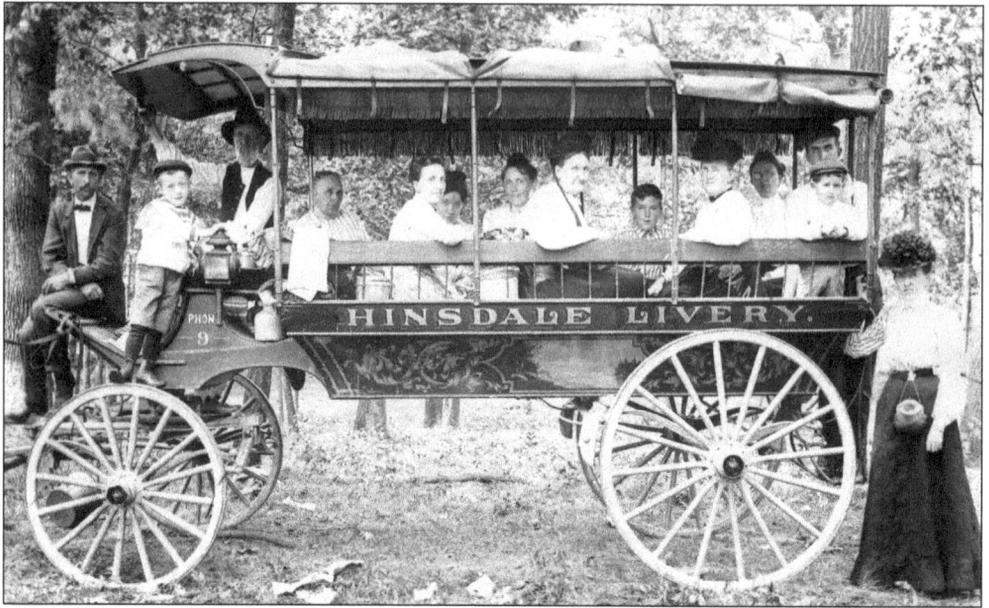

The livery stable was situated just north of the tracks, west of Washington Street. Liveries met all trains and 10 ride tickets could be purchased for $1. Some villagers boarded their horses at the stable, others rented buggies for special occasions. This horse-drawn bus was rented for the day for a family picnic.

The biggest fad to impact Hinsdale in the late 1890s was the bicycle. Used for transportation as well as recreation, the ubiquitous two-wheeler was pedaled by young and old, men and women alike. Sadie Noble is shown with her new ride in 1897. Weekdays saw almost 100 bicycles parked at the train station with nearly as many at churches on Sunday. Weekly races were run; a popular course ran along Chicago Avenue to La Grange.

Camping, picnicking, and fishing were popular pastimes. This 1903 photograph shows the women from Hinsdale's Evernden family preparing a meal at their elaborate campsite, likely along Salt Creek. The family scrapbook reveals that the men were at the creek, successfully fishing for dinner.

After a hard freeze, Salt Creek offered wonderful ice skating all the way to Elmhurst. Warmed by fires built along the shore, some skaters enjoyed picnics brought from home. While hockey was popular by day, a moonlit evening could find 200 or 300 skaters covering the ice.

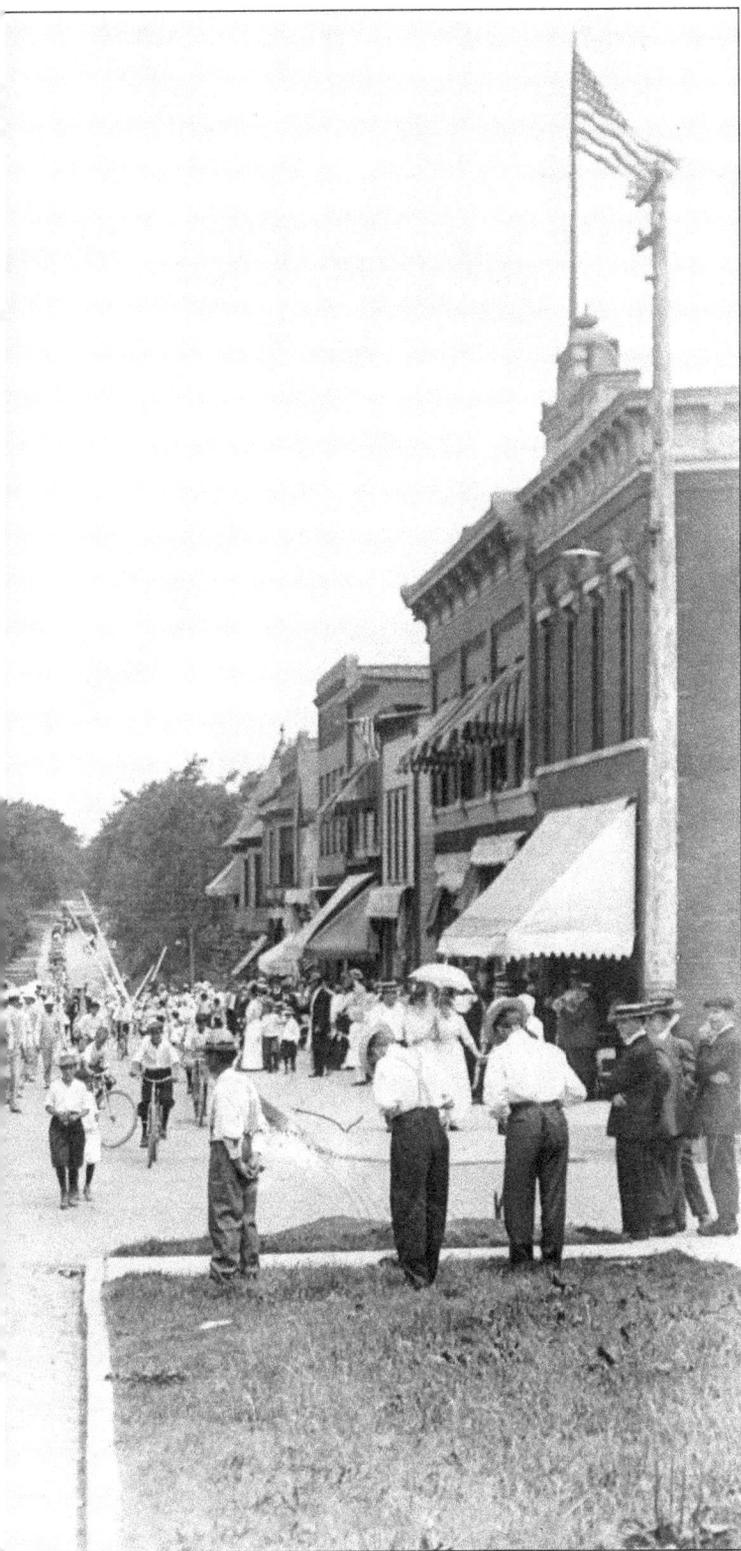

The village's celebratory spirit has always been enthusiastic; Hinsdale's Fourth of July celebration is legendary. This 1913 Washington Street photograph reveals that parades of the past were equal to today's popular patriotic displays.

DISCOVER THOUSANDS OF LOCAL HISTORY BOOKS FEATURING MILLIONS OF VINTAGE IMAGES

Arcadia Publishing, the leading local history publisher in the United States, is committed to making history accessible and meaningful through publishing books that celebrate and preserve the heritage of America's people and places.

Find more books like this at
www.arcadiapublishing.com

Search for your hometown history, your old stomping grounds, and even your favorite sports team.

Consistent with our mission to preserve history on a local level, this book was printed in South Carolina on American-made paper and manufactured entirely in the United States. Products carrying the accredited Forest Stewardship Council (FSC) label are printed on 100 percent FSC-certified paper.

MADE IN THE USA

www.ingramcontent.com/pod-product-compliance
Lightning Source LLC
Chambersburg PA
CBHW050633110426
42813CB00007B/1793